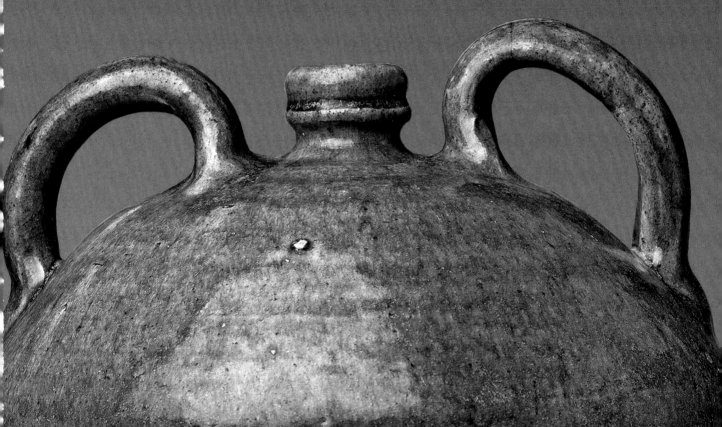

HEAR ME
NOW

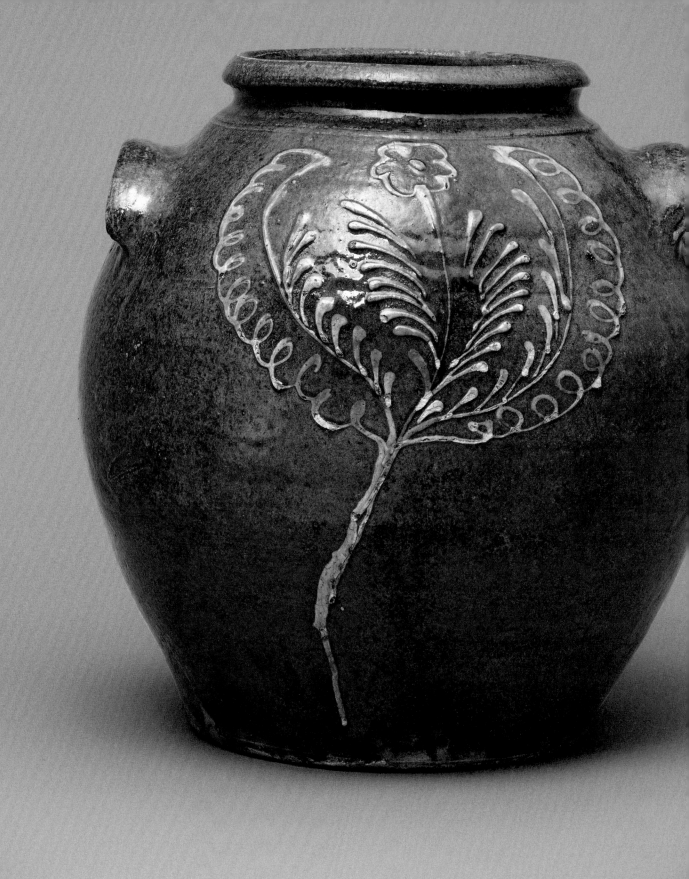

HEAR ME NOW

The Black Potters of Old Edgefield, South Carolina

EDITED BY **Adrienne Spinozzi**

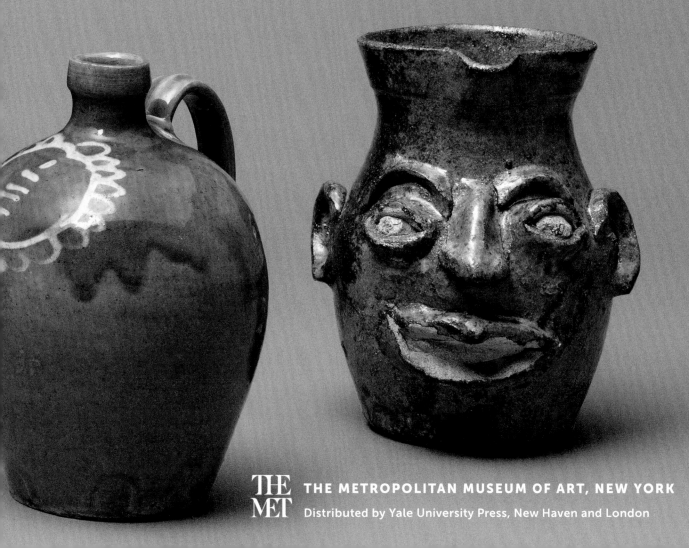

THE METROPOLITAN MUSEUM OF ART, NEW YORK

Distributed by Yale University Press, New Haven and London

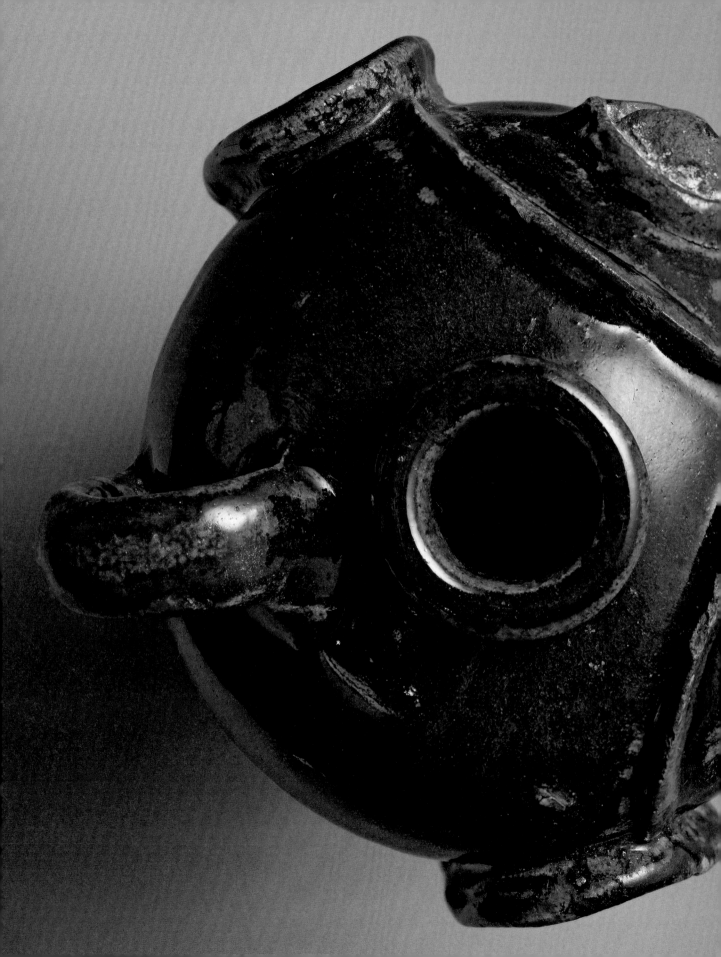

CONTENTS

DIRECTOR'S FOREWORD

The works presented in *Hear Me Now: The Black Potters of Old Edgefield, South Carolina*—by and large the products of industrial slavery in the decades before the Civil War—attest to creative triumph under unimaginable circumstances. As the first exhibition in The Met's American Wing to highlight the work of enslaved makers, this project marks a pivotal moment for the institution.

In 2017 the Museum installed a large nineteenth-century stoneware storage jar alongside paintings and sculpture from the same period. The object provided a critical counterbalance to the works of art made by White American artists, foregrounding the work of an enslaved potter who incised poems on large jars and signed them "Dave" at a time when literacy was illegal for enslaved people, his very act of creation a deliberate and subversive statement. This display signaled the Museum's commitment to telling a more inclusive and expansive story of artistic expression, both past and present. In *Hear Me Now*, this jar accompanies other significant works by Dave and other enslaved potters, revealing the breadth of stoneware production in Edgefield, South Carolina. These remarkable vessels are complemented by contemporary works that resonate with or are inspired by the Edgefield tradition, and which serve as powerful reminders that creative expression is an enduring tool of communication and activism.

The curatorial team—led by Adrienne Spinozzi, Associate Curator in the American Wing at The Met, in close partnership with Ethan W. Lasser, John Moors Cabot Chair of the Art of the Americas Department at the Museum of Fine Arts, Boston, and Jason R. Young, Associate Professor of History at the University of Michigan, Ann Arbor—has embraced the challenges and sensitivities at the center of the project. Their collaborative approach exemplifies the kind of serious cross-disciplinary study that welcomes new voices and leads to new interpretations. From its inception, *Hear Me Now* has been shaped by numerous contributors who have challenged existing scholarship and forged novel paths forward. I thank them, as well as the many lenders, both institutional and private, who have enriched this presentation with their generous contributions. It is a honor to organize this exhibition with the Museum of Fine Arts, Boston, and I am grateful for their support of

this important effort as well as that of our additional venues, the University of Michigan Museum of Art, Ann Arbor, and the High Museum of Art, Atlanta.

Sincere thanks are also due to those who supported this project financially, including Kathryn Ploss Salmanowitz, The Met's Fund for Diverse Art Histories, the Terra Foundation for American Art, and Anthony W. and Lulu C. Wang. I extend my gratitude to The Peter Jay Sharp Foundation and the Henry Luce Foundation for their wonderful support, as well as to Thelma and AC Hudgins. The Decorative Arts Trust's grant during the exhibition's research stage helped shape the project from the beginning, and for that we are profoundly appreciative. Support from Esther Goldberg is also gratefully acknowledged. This landmark catalogue is a result of the enduring generosity of the William Cullen Bryant Fellows of The Metropolitan Museum of Art, who make possible so many American Wing publications. Bridget and Al Ritter have my gratitude for their additional support.

Max Hollein
Marina Kellen French Director
The Metropolitan Museum of Art

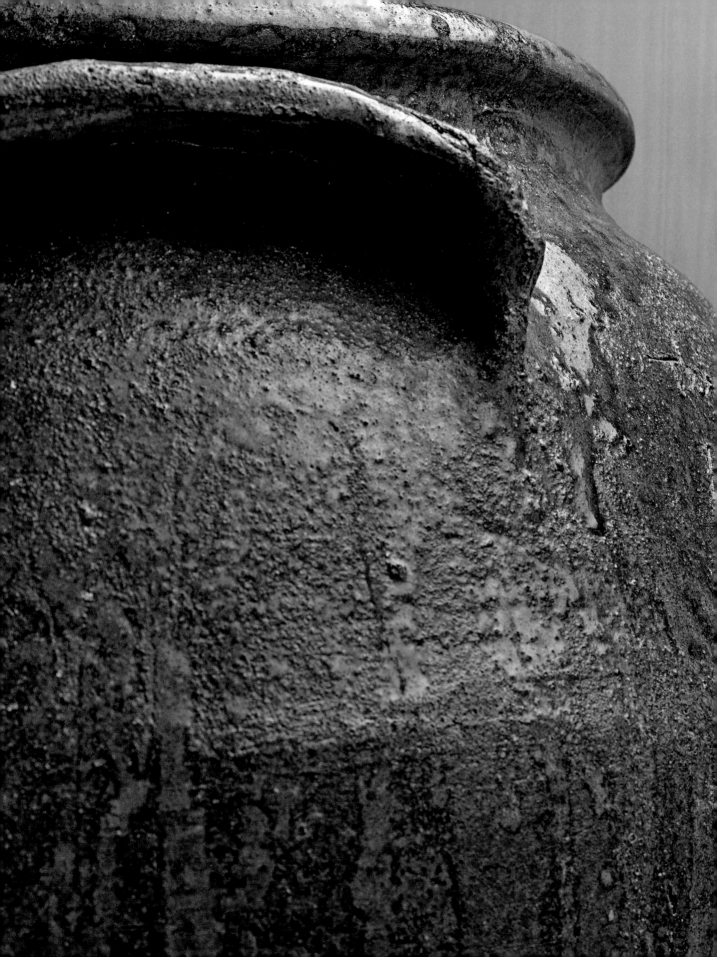

PREFACE

Adrienne Spinozzi

E dgefield stoneware is perhaps best understood as a confluence of economic, industrial, political, social, and artistic developments in nineteenth-century South Carolina. These objects—the majority durable, functional vessels essential for food preparation and storage in the rural South—are manifestations of both natural resources and human-made institutions. They speak to the ingenuity and skill of the potters, but they also symbolize the forced labor behind their creation, which underpinned most of the economy before the Civil War. The story of Edgefield stoneware is therefore multifaceted, incongruous, and complex. *Hear Me Now: The Black Potters of Old Edgefield, South Carolina* is a reexamination of this important body of work, highlighting the contributions of Old Edgefield's Black potters and an oft-overlooked area of American industrial enslavement.

Enslaved people were involved with the manufacture of stoneware in Edgefield from its inception, and they bore responsibility for many aspects of the labor-intensive craft: mining and preparing clay; throwing vast quantities of ware; decorating and glazing vessels; gathering fuel for and overseeing firing; building, loading, and unloading kilns; and transporting wares to markets across the region. As the consumer need for stoneware increased over the nineteenth century, so too did the enslaved workforce required to sustain its production. Only some of the many potters have been identified so far. Representing one interpretive path, this project aspires to bring critical attention to this relatively little-known body of work by connecting the objects with the people—known and unknown—behind their creation, and in so doing, illuminate one of the darkest chapters in our country's history.

Both the exhibition and this publication follow in the wake of several previous efforts; however, they differ by consciously making space for other interpretations and new paths of inquiry. The following essays confront and question conventions for understanding objects made by enslaved makers, reframe the historical narrative, and broaden the perspectives presented. Together they expand the current scholarship and provide a framework for understanding Edgefield stoneware within a larger art historical context.

Over the last hundred and fifty years, Edgefield stoneware has experienced an unprecedented trajectory—from its ubiquitous presence in Southern kitchens and

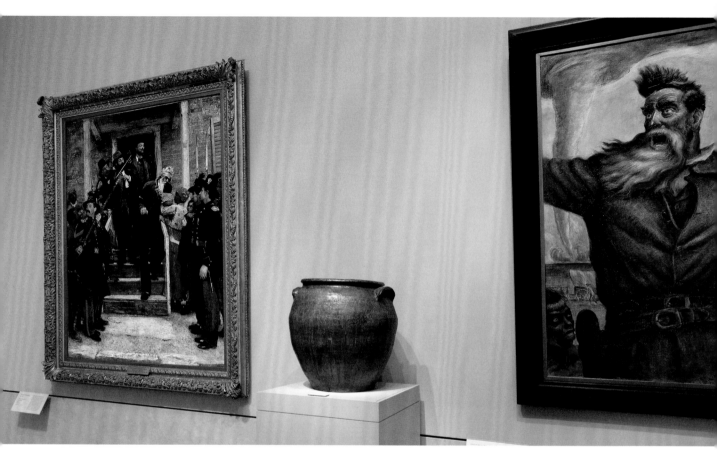

FIG. 1. Installation view of the Civil War and Reconstruction Eras and Legacies gallery (Gallery 762), American Wing, The Metropolitan Museum of Art, New York, showing David Drake's 1858 storage jar (pl. 33) between Thomas Hovenden's *The Last Moments of John Brown* (1882–84) and John Steuart Curry's *John Brown* (1939), 2022

smokehouses to white pedestals in galleries (fig. 1). Outside of institutions that display it as examples of regional craftsmanship, most of the country's museums had not actively collected Southern stoneware in the past, but today many are pursuing Edgefield vessels for their collections. The goals of such efforts are manifold yet largely shared: to expand the narratives they present, to foreground stories that have gone untold, and to welcome audiences who aspire to see their histories reflected in the galleries.

Museums have stepped into this space at a moment of introspection and revision, when they are more readily acknowledging how their collections and practices reflect their histories and hierarchies. For many, particularly those that were established in the late nineteenth and early twentieth centuries, their very origins are inextricable from White supremacy; more specifically, these institutions were "enabled by a systemically racist financial system founded with the colonial slave trade."[1] Their

donors, collections, traditions, and hierarchies have historically been linked to racist policies and practices, still evident in permanent holdings as well as in the vestiges of this framework that permeate every aspect of museum practice.[2]

What does it mean, then, for these same museums to acquire and present objects made by enslaved craftspeople? What does it mean to elevate objects made by forced labor and celebrate them as creative masterworks? How can artistic agency be understood in this context? How can we give space and a voice to these objects and the people who made them? And who is telling these stories? These questions are at the core of this investigation of Edgefield stoneware, which has been thrust into the center of discussions on ethical practices for display, interpretation, exchange, and ownership. While *Hear Me Now* will not provide the final word, its impact should be measured by the issues it brings to the fore and its ability to facilitate challenging discussions and new opportunities for engagement, understanding, and restorative practice.

In the century and a half since these objects were made, the story of Edgefield has almost always been presented from the perspectives of White scholars and collectors, and what is known must be considered critically with that in mind. A growing number of Black scholars, collectors, artists, and thought leaders—from poet Kwame Dawes and conceptual artist Glenn Ligon to author, naturalist, and professor J. Drew Lanham, educator and activist David F. Mack, and contributing authors Michael J. Bramwell, Vincent Brown, and Jason R. Young—are being recognized for their vital engagement with this material. Their contributions are actively reshaping not only the scholarship but also discussions around ownership and redress, accountability and justice.

Edgefield stoneware is a uniquely American story, one that stands today at the intersection of our country's history of enslavement, the power of artistic expression, and the dire ramifications of racism on our cultural landscape. *Hear Me Now: The Black Potters of Old Edgefield, South Carolina* presents an opportunity to elevate histories that have been silenced for too long.

CONTRIBUTORS

Michael J. Bramwell is a visual artist, doctoral candidate at the University of North Carolina at Chapel Hill, and the Linde Curator of Folk and Self-Taught Art at the Museum of Fine Arts, Boston.

Vincent Brown is the Charles Warren Professor of American History and Professor of African and African American Studies at Harvard University, Cambridge, Mass.

Katherine C. Hughes is a doctoral candidate in public history at Middle Tennessee State University, Murfreesboro, and the Curator of Cultural Heritage and Community Engagement at McKissick Museum, University of South Carolina, Columbia.

Ethan W. Lasser is the John Moors Cabot Chair of the Art of the Americas Department at the Museum of Fine Arts, Boston.

Simone Leigh is an internationally acclaimed artist based in New York and the U.S. representative at the 2022 Venice Biennale, where she was awarded the Gold Lion.

Adrienne Spinozzi is Associate Curator in the American Wing at The Metropolitan Museum of Art, New York.

Jason R. Young is Associate Professor of History at the University of Michigan, Ann Arbor.

LENDERS TO THE EXHIBITION

Chipstone Foundation, Milwaukee, Wisconsin
Colonial Williamsburg Foundation, Virginia
Crystal Bridges Museum of American Art, Bentonville, Arkansas
Greenville County Museum of Art, Greenville, South Carolina
High Museum of Art, Atlanta
Matthew Marks Gallery, New York
McKissick Museum, University of South Carolina, Columbia
The Metropolitan Museum of Art, New York
Museum of Early Southern Decorative Arts at Old Salem, Winston-Salem,
 North Carolina
Museum of Fine Arts, Boston
National Museum of American History, Smithsonian Institution, Washington, D.C.
Philadelphia Museum of Art
South Carolina State Museum, Columbia
University of Illinois, Urbana-Champaign
University of Michigan Museum of Art, Ann Arbor
White Cube, London

PRIVATE COLLECTIONS

Beamer Collection, Greenville, South Carolina
Collection of Larry and Joan Carlson
Collection of Joseph P. Gromacki, Chicago
Dr. Fred E. Holcombe Family Collection, Cary, North Carolina
Hudgins Family Collection, New York
April L. Hynes, Washington Crossing, Pennsylvania
Mr. and Mrs. John LaFoy, Greenville, South Carolina
Collection of Glenn Ligon
William C. and Susan S. Mariner Private Foundation
Collection of George H. Meyer, Bloomfield Hills, Michigan
Collection of Carl and Marian Mullis, Atlanta
Collection of C. Philip and Corbett Toussaint
David and Jon Ward, Greenville, South Carolina
Collection of James P. and Susan C. Witkowski, Camden, South Carolina
Private collectors who wish to remain anonymous

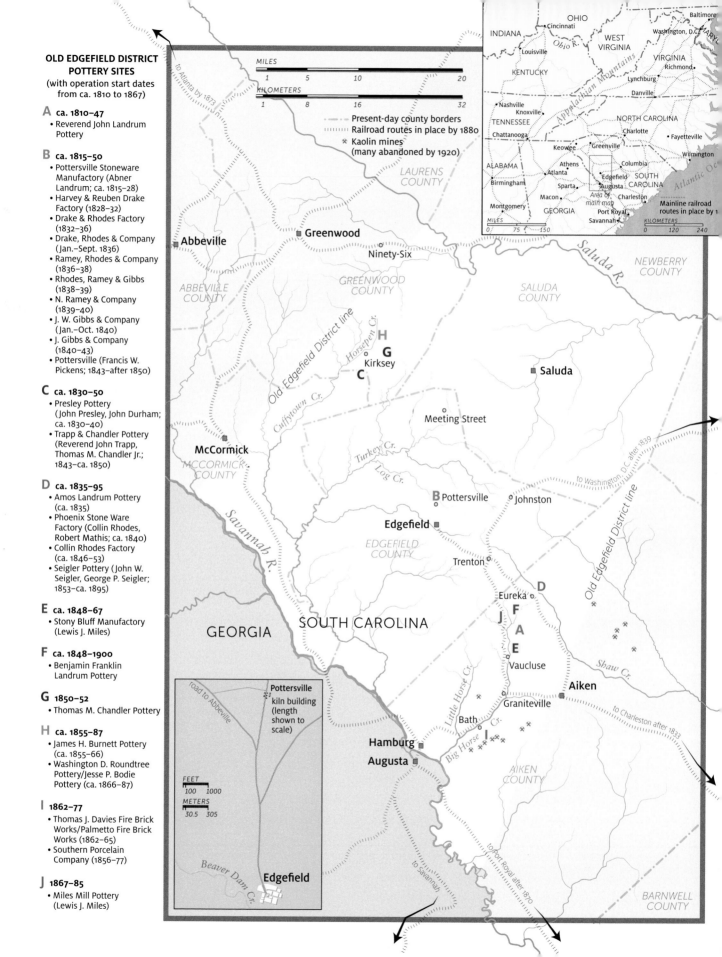

OLD EDGEFIELD DISTRICT POTTERY SITES

(with operation start dates from ca. 1810 to 1867)

A ca. 1810–47
- Reverend John Landrum Pottery

B ca. 1815–50
- Pottersville Stoneware Manufactory (Abner Landrum; ca. 1815–28)
- Harvey & Reuben Drake Factory (1828–32)
- Drake & Rhodes Factory (1832–36)
- Drake, Rhodes & Company (Jan.–Sept. 1836)
- Ramey, Rhodes & Company (1836–38)
- Rhodes, Ramey & Gibbs (1838–39)
- N. Ramey & Company (1839–40)
- J. W. Gibbs & Company (Jan.–Oct. 1840)
- J. Gibbs & Company (1840–43)
- Pottersville (Francis W. Pickens; 1843–after 1850)

C ca. 1830–50
- Presley Pottery (John Presley, John Durham; ca. 1830–40)
- Trapp & Chandler Pottery (Reverend John Trapp, Thomas M. Chandler Jr.; 1843–ca. 1850)

D ca. 1835–95
- Amos Landrum Pottery (ca. 1835)
- Phoenix Stone Ware Factory (Collin Rhodes, Robert Mathis; ca. 1840)
- Collin Rhodes Factory (ca. 1846–53)
- Seigler Pottery (John W. Seigler, George P. Seigler; 1853–ca. 1895)

E ca. 1848–67
- Stony Bluff Manufactory (Lewis J. Miles)

F ca. 1848–1900
- Benjamin Franklin Landrum Pottery

G 1850–52
- Thomas M. Chandler Pottery

H ca. 1855–87
- James H. Burnett Pottery (ca. 1855–66)
- Washington D. Roundtree Pottery/Jesse P. Bodie Pottery (ca. 1866–87)

I 1862–77
- Thomas J. Davies Fire Brick Works/Palmetto Fire Brick Works (1862–65)
- Southern Porcelain Company (1856–77)

J 1867–85
- Miles Mill Pottery (Lewis J. Miles)

MILES
1 5 10 20

KILOMETERS
1 8 16 32

- · - · Present-day county borders
......... Railroad routes in place by 1880
✕ Kaolin mines (many abandoned by 1920)

LAURENS COUNTY

OHIO
INDIANA Cincinnati
WEST VIRGINIA Baltimore
Louisville Washington, D.C. MARYL
KENTUCKY VIRGINIA Richmond
Lynchburg
Nashville Knoxville Danville
TENNESSEE NORTH CAROLINA
Chattanooga Charlotte Fayetteville
Keowee Greenville Wilmington
ALABAMA Athens Columbia
Birmingham Atlanta SOUTH CAROLINA
Edgefield Augusta Charleston
Sparta Area of Atlantic Oce.
Macon main map
Montgomery GEORGIA Port Royal
Savannah
MILES Mainline railroad
0 75 150 routes in place by 1
KILOMETERS
0 120 240

Abbeville

Greenwood

Ninety-Six

GREENWOOD COUNTY

SALUDA COUNTY

NEWBERRY COUNTY

Saluda R.

ABBEVILLE COUNTY

Old Edgefield District line

Horsepen Cr.

H
G
Kirksey
C

Cuffytown Cr.

Saluda

Meeting Street

McCormick

MCCORMICK COUNTY

Turkey Cr.

Log Cr.

to Washington, D.C. after 1839

Savannah R.

B Pottersville
Johnston

Edgefield

EDGEFIELD COUNTY

Trenton

Old Edgefield District line

D
Eureka

J
F
A
E

GEORGIA

SOUTH CAROLINA

Vaucluse

Aiken

Graniteville

Shaw Cr.

to Charleston after 1833

Little Horse Cr.

I

Bath

Hamburg

Big Horse Cr.

Augusta

AIKEN COUNTY

BARNWELL COUNTY

to Atlanta by 1873

road to Abbeville

Pottersville kiln building (length shown to scale)

FEET
100 1000

METERS
30.5 305

Beaver Dam Cr.

Edgefield

to Savannah

to Port Royal after 1870

NOTE TO THE READER

Throughout the era of slavery, the names of enslaved makers of ceramic vessels were often unrecorded. Both during slavery and in its immediate aftermath, African Americans often underwent several name changes, sometimes by choice and sometimes not. As a result, the politics of naming for enslaved men and women was, and continues to be, incredibly fraught. The authors acknowledge the uncertainties, indignities, and even the impossibilities of naming.

Where possible, we identify the makers of signed objects, including the body of work inscribed "Dave," by the name incised on the vessel. In some cases, the potter known as Dave is referred to as "David Drake," the name that was recorded in official documentation post-emancipation, with the understanding that Drake was the name of one of his enslavers and the circumstances of its adoption by Dave are unclear.

Some authors have chosen to avoid using the word "slave" when referring to enslaved individuals, while others have employed the term. All decisions have been made with the aim of foregrounding the humanity and dignity of the people discussed in these pages.

The nationality of all makers is American and the location of all potteries is Old Edgefield District, South Carolina, unless otherwise noted.

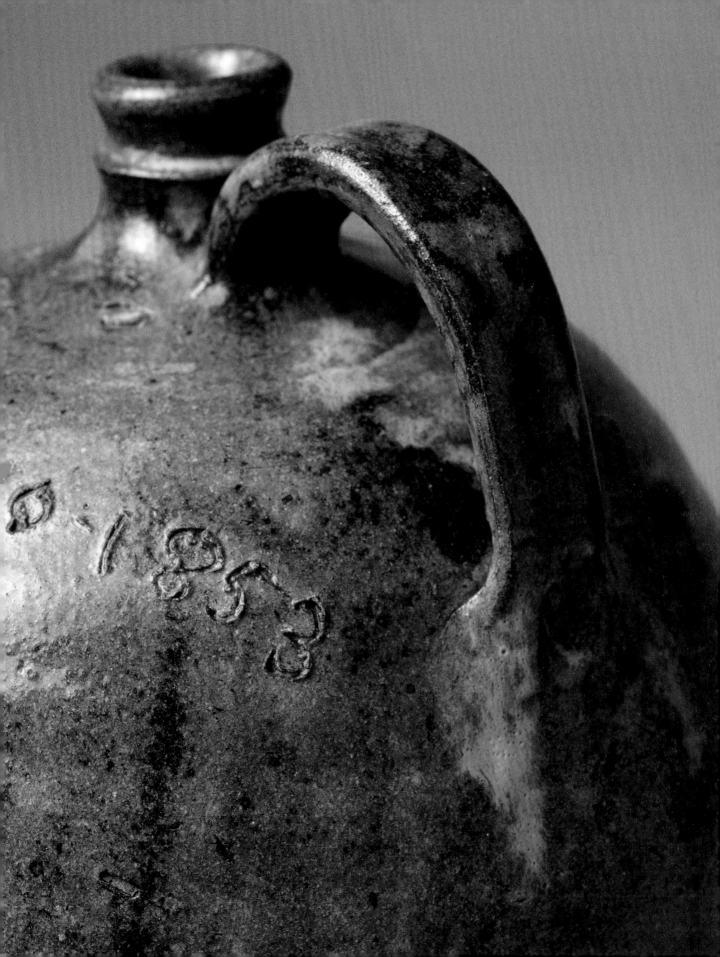

THE ART OF
ENSLAVED LABOR

Vincent Brown

This noble jar had me in my feelings. On its own terms, it is an impressive object. Solid, heavy, with elegant curves rising from a sculpted torso out to broad shoulders that support a handsome full-lipped mouth. It looked as strong as the muscles it took to make it. I wanted to touch it, run my fingers around the rim, hold it up and test my strength against its weight, but I didn't dare. Not because of how formidable the object was, but because the spirit of its maker gave me a shiver. This vessel was formed by David Drake, a nineteenth-century slave. It is a sacred object. In its presence I felt awe, pride, inspiration, but also shame (fig. 2).

Why shame? I'm a bit ashamed to admit the feeling. Some might suppose it is because I am the descendant of slaves, conquered and dishonored people made to serve the will of others. But I have always believed that the will to domination and the exploitation of others is more shameful than defeat and endurance. No, what had me feeling slightly embarrassed was the designation of this great work as *art*. The word feels awkward, mismatched. It is at once too lofty and too unappreciative. Arrogant and condescending, art gazes down to bestow favor on a kneeling supplicant when it should be looking skyward for grace.

In that, it is something like the way I think of David Drake's name itself. Art historians and museums respectfully refer to him as David Drake, but throughout his life he always signed his pieces simply, "Dave." In his own time, he was widely known as "Dave the Potter," or more rudely, "Dave the Slave." The first reference to him in print was in a Civil War–era editorial extolling the virtues of buttermilk (fig. 3). The promotion referred to "DAVE POTTERY" mockingly as "the grandiloquent old dar-key," expressing a faint resentment at even having to acknowledge that anyone Black should be held in high esteem.[1] Slaves were generally dishonored persons who didn't merit last names.[2] Dave first appears as David *Drake* after his emancipation, in the 1868 voter registration list for Edgefield County, South Carolina. It is thought that he had taken the name of a previous owner, Harvey Drake, perhaps in an attempt to remove the stigma he bore his entire life.[3] Acknowledging his surname can be seen as a post-humous act of repair, like exhibiting his work in fine art museums.

Deciding upon his rightful name and place of honor, we may hope to seize and discard generations of insult. But perhaps we should be hesitant to overrule the

humility of his signature. Indeed it might be key to understanding the relationship between the abuses Dave suffered, the injuries that burdened his life, and the work of his own hands. To grasp the significance of such grand creations by such a humble servant, we need a delicate grip. A lighter touch might bring insights on how labor meant to degrade human beings could, paradoxically, and against the committed will of enslavers and oppressors, become a source of self-esteem and public admiration.

The celebrated contemporary artist Theaster Gates has called Dave "one of the most important craft figures in American history," and his pots are the centerpiece of this exhibition of Edgefield stoneware at The Metropolitan Museum of Art.[4] The show harnesses a growing interest among cultural institutions and the public not only in Dave's work but also in many of the crafts that have been ignored or excluded by fine art museums because of the low social origins of their creators. The art of the oppressed has gained new attention, and this project offers an opportunity to reconsider our view of the place of slavery in art history.[5]

APPRAISING EDGEFIELD

Edgefield was colonized by the British during the second half of the eighteenth century. Considered the backcountry, wooded with pine, oak, and hickory, the region contained rich clay soils that proved ideal for growing cotton—and for making ceramics.

FIG. 2. Dave (later recorded as David Drake; ca. 1801–1870s), Stony Bluff Manufactory (ca. 1848–67). Storage jar, 1858 (detail of pl. 31)

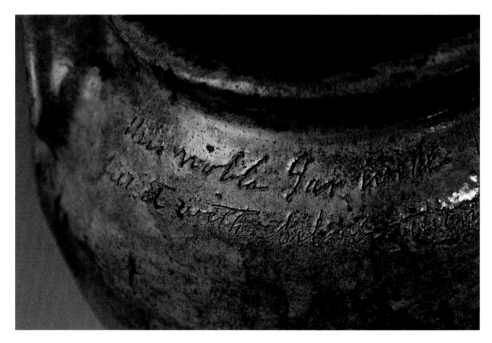

tends to increase our satisfaction with the present arrangement.

Buttermilk.

Good buttermilk is said to be a great promoter of health. It is certainly a very pleasant drink, and, in the absence of lemonade and other acid preparations, is calculated to give comfort to the physical man. One day in years gone by we happened to meet DAVE POTTERY (whom many readers will remember as the grandiloquent old darkey once connected with a paper known as the *Edgefield Hive*) in the outskirts of his beloved hamlet. Observing an intelligent twinkle in his eye, we accosted him in one of his own set speeches: "Well, uncle DAVE, how does your corporosity seem to sagutiate?"—"First rate, young master, from top to toe—I just had a magnanimous bowl-full of dat delicious old beverage, buttermilk." Who has not often felt his buttermilk as DAVE did. We know a gentleman who never touches coffee if he can get buttermilk. He says he enjoys double the health under the buttermilk regime. Dr. HALL would give you the reasons for this—we only give the fact, and exhort everybody to the free use of buttermilk.

Mendacity.

Gen. NEIL Dow has written a letter from Pensacola to some friend in Glasgow, Scotland, where-

FIG. 3. "Buttermilk," *Edgefield Advertiser*, April 1, 1863

Enslaved laborers did most of the cultivating and potting through the Civil War. For much of the nineteenth century, Edgefield craftspeople—called turners—produced alkaline-glazed stoneware pottery for the regional economy. Their storage jars were highly prized and the scale of the stoneware operations at Edgefield was expansive. Pottery from those kilns continues to impress, its monumental size and technical complexity surpassing most of what could be found elsewhere at the time (fig. 4). It is a testament to the skill and creativity of Black potters, though most of the turners are unrecorded.

This artwork—or is it merely craft?—poses a problem. It is elegant, but rough-hewn; imperfections and spontaneity are indeed part of the pottery's appeal. Yet these are vessels made for practical purposes. According to a tenacious classical idea held by much of the public and more than a few art historians and curators, when something earns the name of art, it is supposed to have the capacity to transcend its circumstances. It speaks to us across the ages, suggesting something timeless about human existence. Can it do so when it is so clearly a utilitarian product of its place and time? Should it be evaluated without consideration of its humble origins

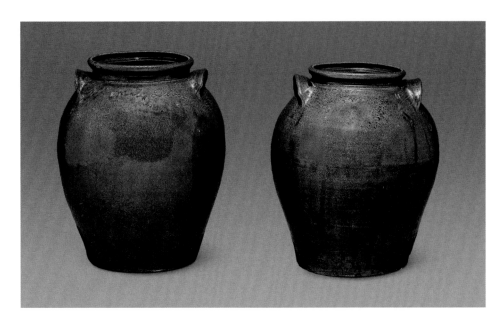

FIG. 4. Dave (later recorded as David Drake; ca. 1801–1870s), Stony Bluff Manufactory (ca. 1848–67). Storage jars, 1849. Alkaline-glazed stoneware, left: H. 16½ in. (41.9 cm); right: H. 15½ in. (39.4 cm). Left: Colonial Williamsburg Foundation, Virginia, Museum Purchase, The Friends of Colonial Williamsburg Collections Fund (2016.900.2); right: Reeves Museum of Ceramics, Washington and Lee University, Museum Purchase with Funds Provided by the Herndon Foundation, the Family of Elisabeth S. Gottwald, and John Goadby Hamilton '32 (2019.18.1)

and the cruelty endured by its creators, or can these vessels instead be seen as conduits between their context and our own?

There is a long history of viewing European, Asian, and African ceramics as art (fig. 5). They signify cultural traditions, embody histories of civilization, and exemplify transformations in technique and mastery of craft. But the creations of American slaves do not usually epitomize Western civilization. They speak instead to its underside. Is it special pleading, then, to consider this work alongside other civilizational achievements? Or is it patronizing to focus too much on the tragic circumstances of their creation? As much as one can vindicate these objects and redeem them from the historical condescension of racism, the denigration cannot be wished away. Its aura remains part of the work, and it continues to shadow the exhibition, shaping viewers' basic assumptions and standards of value. We should acknowledge the presence.

Does knowing that these workers were enslaved mean that they cannot also be considered artists? It certainly raises difficult questions about the relationship between creativity and coercion. We often think of art as the product of individual inspiration and vision. External compulsion runs against our very notions of what it means to be an artist. We might acknowledge an artist's poverty or their need for

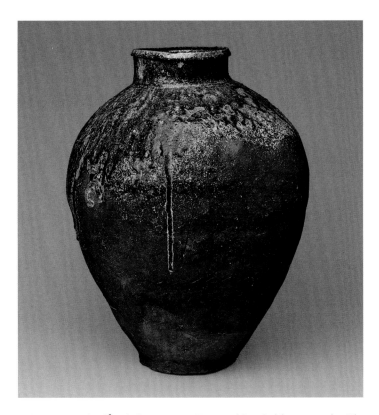

FIG. 5. Storage jar (Ōtsubo). Japanese, Muromachi period (1392 – 1573), 16th century. Ash-glazed stoneware (Tokoname ware), H. 21½ in. (54.6 cm). The Metropolitan Museum of Art, New York, Mary Griggs Burke Collection, Gift of the Mary and Jackson Burke Foundation, 2015 (2015.300.275)

patrons, but our impulse is to valorize the creative genius of an individual's labor. And yet, when that labor is coerced, and the laborer enslaved, the question takes on an uncomfortable urgency. How can we best admire the skill, imagination, and even devotion that went into the making of these vessels when they were the direct product of a bloody system of oppression?

TURNING LABOR INTO WORK

Dave was born around 1801, at a time of upheaval and tyranny. The United States, barely a decade into its existence as a nation-state, was on the verge of a great expansion. South Carolina was recovering from some of the most brutal and disruptive campaigns of the American Revolution. Consolidating their hold on the state's economy and society, South Carolina's planters were voraciously importing enslaved Africans into the port of Charleston in anticipation of the scheduled end of the legal Atlantic slave trade in 1808.[6] Eighty thousand captive Africans arrived in the Carolinas during the first decade of Dave's life.[7] In Edgefield, the enslaved population tripled in

the first three decades of the century. Meanwhile, the United States was overrunning the Louisiana Territory, purchased from France in 1803. The new nation would push Indigenous peoples off their land and replace them with slaves. A massive forced migration ensued. While some four hundred eighty thousand captive Africans had been brought to mainland North America during all the years of the transatlantic slave trade, one million Black people would be relocated in the half century before the Civil War, undoing fragile friendships, families, and communities.[8]

With an enslaved population of some four million people by 1860, the United States became the largest slave society in world history. Throughout the Southern states, enslaved Black people performed nearly all of the essential labor. Given their numbers in the population, this could not be limited to menial work. Much of the skilled artisanal craft work was performed by slaves as well. Slaveholders tried to exploit their strength, skill, and intelligence while keeping them socially degraded. The challenge for enslaved people was to derive whatever benefit they could from their own work while defending themselves against the enslavers' motives.

The anticolonial thinker Frantz Fanon suggested that slavery was not in fact work at all, in the sense of the effort people put into bettering their own conditions. "Work is not a simple notion," he wrote, "slavery is the opposite of work, and that work presupposes freedom, responsibility, and consciousness."[9] Forced labor could not be individual innovation. When we think about the art of enslaved labor, then, we are trapped between our condemnation of coercion and our celebration of creativity.[10]

The historian Walter Johnson has offered a helpful way to escape this predicament. In his analysis of enslaved humanity, Johnson separates work from labor. While "slave labor was a bloody and hierarchical social relation," the knowledge that enslaved people channeled into their work was something they could be proud of, and could even take satisfaction in. People lived in a world of "embodied experience that was conditioned—even determined—by slavery, yet never fully reducible to their status as slaves." The enslaved could take pride in their skill at knowing and mastering their tasks, even as slavery violently appropriated what they knew and what they made. This was know-how that slaveholders "might command or even claim as their own, but that they could never fully understand."[11]

Degradation was at the heart of forced labor. It wasn't just that slaveholders made slaves do things, but that they wanted to reduce the enslaved to mere extensions of their will. Personal touches, flair, style, and material gestures of communal support that escaped control were suspect, and in many cases explicitly forbidden. In 1800, fearing Black autonomy, the South Carolina General Assembly passed a bill prohibiting slaves from seeking any form of "mental instruction."[12] In the 1830s, as slaveholders absorbed news of Nat Turner's insurrection in Southampton, Virginia, the Baptist War in Jamaica, and the end of slavery in the British Empire, they toughened laws that criminalized literacy in enslaved people and mandated that any who

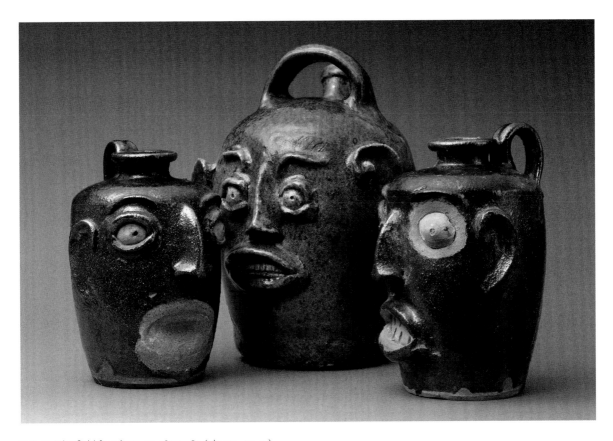

FIG. 6. Edgefield face jugs, ca. 1850–85 (pls. 39, 42, 41)

had this skill be sold out of the state.[13] These efforts resulted from insecurity. Masters could own slaves without quite being able to master them. That is why they needed to continually degrade them.

The Edgefield potters exemplified not only achievement in potting techniques but also how the enslaved separated fulfilling work from degrading labor under the most extreme conditions. They could celebrate the creations co-opted by their owners, and they could also make things for themselves. Among the items included in the exhibition are face vessels, what have been called "grotesques," "voodoo jugs," or "monkey jugs" (fig. 6).[14] The ceramic historian Edwin AtLee Barber remarked that the enslaved often occupied their idle time "in making homely designs in coarse pottery. Among these were some weird-looking water jugs, roughly modelled on the front in the form of a grotesque human face,—evidently intended to portray the African features." These were deemed reminiscent of "aboriginal art as formerly practised by the ancestors of the makers" in the so-called Dark Continent.[15] For many of Africa's descendants, these face vessels have a deep spiritual resonance. Art historians have debated whether or not these forms are derived from West-Central

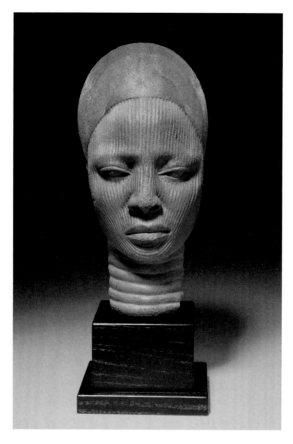

FIG. 7. Shrine head. Ancient Yoruba, 12th – 14th century. Terracotta, H. 7¼ in. (18.4 cm). Minneapolis Institute of Art, The John R. Van Derlip Fund (95.84)

African wood-carving techniques or are a cousin to the Ife terracotta of what is today Nigeria (fig. 7). Some surmise that the vessels' style descended from the migrating English Toby jugs, which were imported into Africa, and then carried from there to America.[16] Perhaps more important than the genealogy of their form, though, is their undeniable whimsy. The heroism required to find the spirit of levity in such grave circumstances reminds us that stigma too is a raw material that can be molded and fashioned into objects of veneration.

THE COMEDY OF SURVIVAL

Harvey Drake's business partner Abner Landrum also published a local newspaper called the *Edgefield Hive*. It is perhaps by working around the *Hive* that Dave learned to read and write, no doubt practicing furtively to avoid persecution. He soon began to inscribe verses on many of the pots he made. Added to his superior

skill as a turner, these inscriptions made him a highly prized artisan. He was so valuable that when Harvey Drake died in 1833, Dave was quickly bought by Lewis Miles. But Dave's talent could not keep slavery from destroying his family. The woman and children he loved were sold by Harvey Drake's brother, who exiled them five hundred miles away to Louisiana.[17]

In 1840 Dave etched a vessel that documented his owner's claim, but on his own terms: "Dave belongs to Mr. Miles/whir the oven bakes & the pot biles." Did the pot boil or contain bile—the bitterness of Dave's separation from his loved ones? If it was the latter, there is plausible deniability in his phrasing. It accords well with the dark humor evident in many of his other verses, a comedy of survival that the literature scholar Glenda Carpio has described as a "mode of minimizing pain and defeat, as well as a medium capable of expressing grievance and grief in the most artful and incisive ways."[18] In some cases, Dave would use a polysyllabic word like "Concatination," perhaps mocking the pomposity of his legally literate masters while pretending infelicity to cover the "mental instruction" he had achieved.[19] If that was one goal, it seemed to have worked. The men who reported their meeting with him to the *Edgefield Advertiser* greeted him by aping his jokes: "Well, uncle DAVE," they said, "how does your corporosity seem to sagatiate?"[20] It is probably pointless to try to say who had the last laugh, but it is clear that Dave was laughing too, in *spite* of them. His humor was wrested from their control, an illicit mirth that distanced him from the injustice and cruelty of his condition, even if only in his mind or in the recognition of his enslaved peers. You could say that his verses satirized the incongruity between his labor and his work, and highlighted the absurdity of the slave-holders' claim on his humanity.[21] However debased his social condition, Dave's "noble jar" held his personal dignity—more than that, his own nobility. Call it what you will, the name cannot possibly contain its value.

One of Dave's most enigmatic verses is one that documents the destruction of his family and the demand that he survive that with a smile. "I wonder where is all my relation/Friendship to all—and every nation" (pl. 29). It seems to be a greeting, a sarcastic joke, and a curse all at once. It is what Carpio calls a "piercing tragicomedy, one in which laughter is disassociated from gaiety and is, instead, a form of mourning."[22] I can hear a message in this work now. It speaks to *me* across time, saying something that more refined works rarely speak to. It's kind of an inside joke: Black people's endurance is our transcendence. That is the basis of our survival and our art. There will always be people who try to separate things with inflated prices from their social settings—and we'll always be there to prick the bubble. I consider that a great honor.

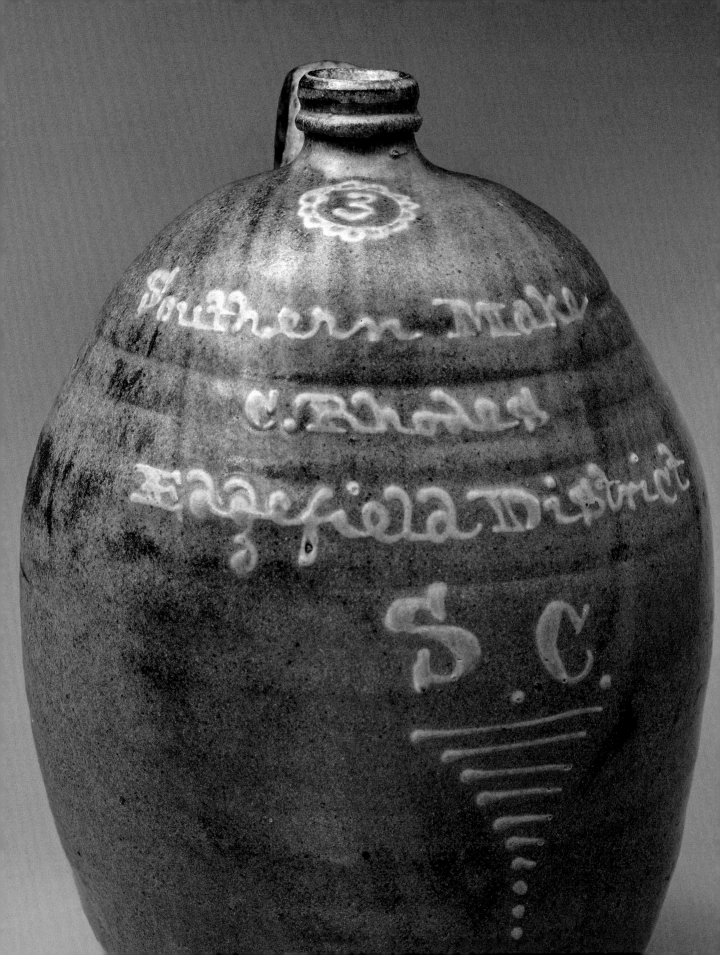

CONFRONTING, COLLECTING, AND CELEBRATING EDGEFIELD STONEWARE

Adrienne Spinozzi

In the spring of 1930, Laura M. Bragg, director of the Charleston Museum, made several trips to western South Carolina in pursuit of information on the alkaline-glazed stoneware entering the museum's collection. Along with her colleagues Emma Richardson and E. Burnham Chamberlain, Bragg conducted the first amateur archaeological surveys of Edgefield's potteries through site visits and field surveys. Her maps depicting the potteries' locations and her notes on the moribund sites are among the earliest to document the region's stoneware industry in detail (fig. 8). Perhaps more importantly, the trio captured early oral histories through interviews, including some with former potters. Motivated by a desire to stimulate local interest in this material, Bragg openly shared her ongoing research, with a Charleston newspaper declaring, "The museum's point in identifying this old ware is to give a story to the stuff which is being more and more appreciated."[1]

The Charleston Museum had eagerly embraced the opportunity to acquire this "old ware" over the previous decade as part of its effort to build a comprehensive collection of South Carolina material culture. This was during the height of the Colonial Revival period, when ethnography and anthropology collections—having long been accumulated, classified, and displayed to present the "natural order" of the world—were diminished as museums made space for collections that presented an idyllic view of the past, often tinged with xenophobia. Under the leadership of its first director, Paul M. Rea, the institution expanded on its unparalleled early anthropological and natural history collections by devoting "equal attention in future to natural history and human culture, with special emphasis in both cases on material relating to South Carolina."[2] The nationalist movement may have been an impetus for the museum's spring 1919 loan exhibition that featured over a thousand objects made and used across the state, as well as the acquisition of Edgefield stoneware.[3]

In early 1919 the museum acquired a rare jar bearing the inscription "made at Stoney bluff;/for making dis old gin enuff/May 13 · 1859 ·/Dave &/Baddler" (fig. 32).[4] Though they had little to no knowledge of its origins, the staff was nonetheless impressed by the vessel's massive size and recognized its rarity: "Until this jar was received we had no idea that such large pieces of pottery were made in South Carolina. Strange to say, no one has been able to give us any accurate information as to what such jars were used for. . . . Since our attention was drawn to this exhibit we have been informed that a good deal of pottery was made in the early days at Abbeville [adjacent to Old Edgefield District], and the Museum hopes to have some of this ware soon."[5]

Visitors to the museum were instrumental in providing contextual information; they also helped locate other important examples. Within months of the 1919 acquisition going on view, another jar was brought to Rea's attention and acquired the

FIG. 8. Detail of a map of South Carolina with Laura M. Bragg's annotations, ca. 1929. Directors' Correspondence, Laura M. Bragg, Charleston Museum Records Collection, Charleston Museum Archives, South Carolina

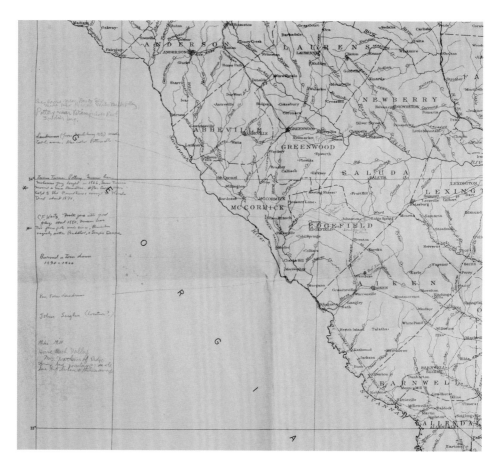

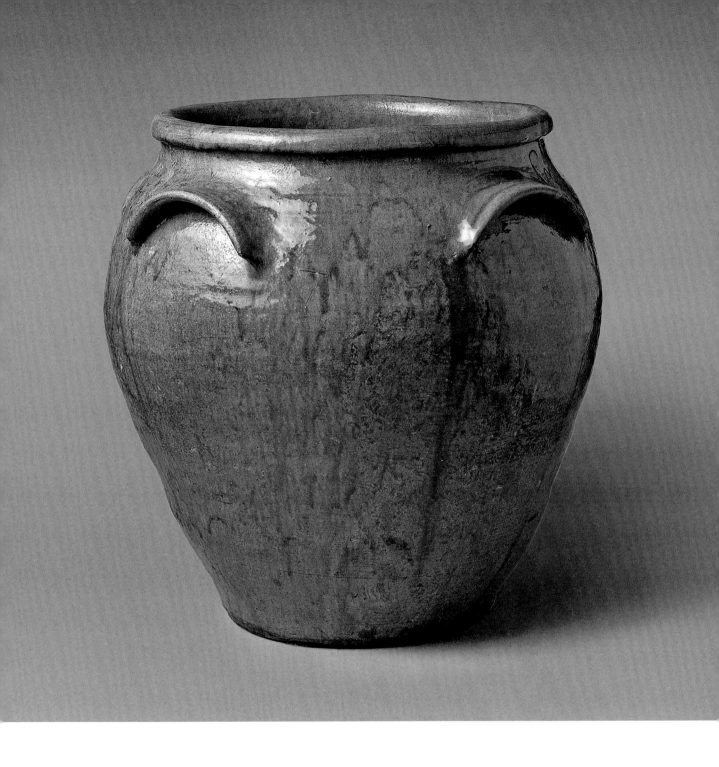

FIG. 9. Dave (later recorded as David Drake; ca. 1801–1870s) and Baddler (active ca. 1859), Stony Bluff Manufactory (ca. 1848–67). Storage jar, 1859. Alkaline-glazed stoneware, H. 25⅞ in. (65.7 cm). Inscription: "Great & Noble Jar / hold Sheep goat or bear / Lm · / May 13 · 1859 / Dave & / Baddler." Charleston Museum, South Carolina (1920.39)

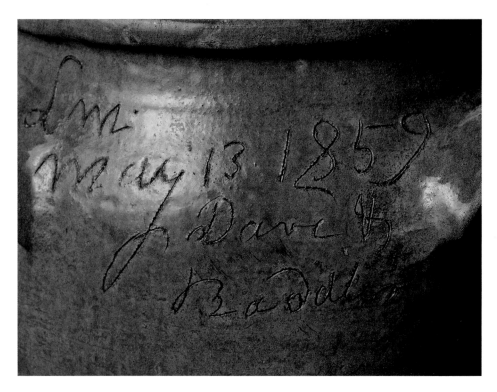

Detail of fig. 9

following year (fig. 9).[6] Incredibly, it bore the same date and names within its inscription: "Great & Noble Jar /hold Sheep goat or bear / Lm · / May 13 · 1859 / Dave & /Baddler" (fig. 10). These two jars, relics of the not-too-distant prewar past, provided an unparalleled window to a little-known aspect of the state's history. At the time of their acquisition, one of the only confirmed pieces of information was the owner of the pottery, Lewis Miles, whose initials "Lm" appear on one of the jars; neither Dave nor Baddler had been identified. Today, these vessels bearing the names of enslaved potters David Drake and Baddler are considered the two most significant made by their hands.

Rea's successor and a former librarian at the institution, Bragg was appointed director in 1920, becoming the first woman to hold this position in a public museum in the United States. She was a self-described suffragist with a fiercely progressive spirit, and within her first year had launched pioneering educational partnerships with schools, cemented the pivotal role of the museum's library, and opened the museum to Black visitors for the first time in its history, all of which made a lasting imprint on the institution.[7] She continued to transform the collection, adding objects that would help tell the history of the state. One resulting installation was the "South Carolina Culture Exhibit," composed of two sections, one "devoted to

that highest of the vertebrates, man" and the other to nonmammals, including reptile, bird, and fish specimens.[8] The museum's *Bulletin* described the focal point as a "comprehensive exhibit of plantation life," adding that it included "exhibits contrasting porcelains and earthenware with the pottery developed in South Carolina."[9]

While her collecting interests and expertise were wide ranging, Bragg acquired more than one hundred examples and two hundred and fifty fragments of pottery.[10] Presenting her work as an endeavor of both state pride and practical safekeeping, she wrote an impassioned appeal to a potential donor in 1927: "The story of South Carolina pottery has not yet been told but we are preserving all the data which comes to us and hope to be able to furnish a really interesting article on the subject later. It is a pity that we could not revive the South Carolina pottery work as North Carolina has done. Meanwhile, since in private hands pieces get broken and records of their origin lost, it would be quite splendid if you could help to secure as many pieces as possible of your local pottery for preservation in the Charleston Museum."[11]

Bragg sought to elevate these wares as important historical records of the region's material culture. The vessels were not easily recognizable to Charlestonians or commonly found in the Lowcountry, implying that by the second quarter of the twentieth century they were obsolete. Those that did survive were primarily found in the western part of the state, and many may have been adapted for other uses or relegated to the barn or porch. Much of the stoneware that entered the museum at the time was brokered through Pearle Felder Danner of Orangeburg, South Carolina, whose family had lived in the area for generations.[12] Danner wrote regularly to Bragg about pots she had found in local collections, and between 1929 and 1930 she helped the institution acquire at least six jars with inscriptions. One letter from Danner describes a "large crock that hold[s] 15 gall, Dated Apr. 2 — 1858 made by Dave. It is beautiful & I can't describe it. Just as soon as I saw it I brought it down for you to see, & if you want for [the] Museum you can have it. If not I have three or four already spoke for it," an indication that as early as 1930 there was strong interest in these intriguing objects.[13] While the museum did not end up acquiring this particular jar, Bragg asked for the details "to see how it compares with the two large ones we already have," and Danner obliged, adding a handwritten sketch and notes with dimensions to Bragg's letter (fig. 11).[14] It seems as if the director's early concerns about preservation bore out, as the whereabouts of this large dated and signed jar are unknown.

The year 1930 proved a critical moment. A number of potters interviewed by Bragg mentioned the "mighty good" enslaved potter named Dave, and so the identity of the potter who made the massive signed and dated jars became known.[15] The interviewees corroborated Danner's letter to Bragg earlier that spring in which she remarked about a barely legible inscription, "Its grey on one side has '22' July 1840 on opposite side has L. Midis Cave [L. Miles Dave] — I believe this last was a slaves

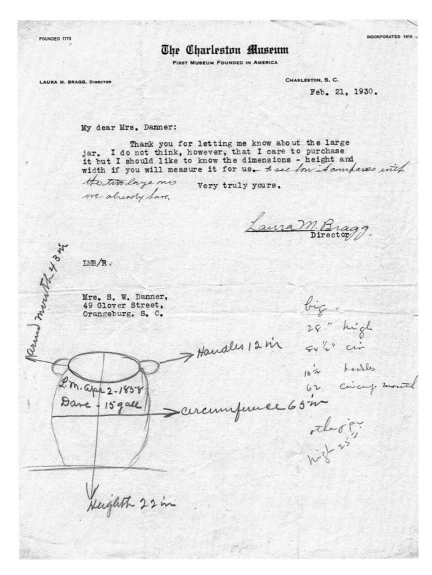

FIG. 11. Notes by Pearle Felder Danner on letter from Laura M. Bragg to Pearle Felder Danner, February 21, 1930. Directors' Correspondence, Laura M. Bragg, Charleston Museum Records Collection, Charleston Museum Archives, South Carolina

name who made the jar."[16] Two generations after emancipation and years before the Works Progress Administration would initiate efforts to document the histories of formerly enslaved people, Bragg pieced together physical artifacts—the tangible evidence of a region's past—with first- and secondhand accounts of the potteries and the individuals who labored there. She was the first to document Edgefield's stoneware industry, the full breadth of which is still being revealed.

AN INDUSTRY DEVELOPS

The area that now makes up the southeastern United States has long been rich in clay deposits. For centuries prior to incursion by Euro-American settlers, this material was integral to the output of Indigenous peoples, from the Woodland and South Appalachian Mississippian cultures, who produced shell-tempered pottery (pl. 1), to the Catawba Indian Nation, who made pottery to sustain their communities (pl. 2), traditions that remain central today.[17] The beginnings of the alkaline-glazed stoneware industry can be traced to the Edgefield region in the early nineteenth century, when Abner Landrum happened upon local deposits of "chalk," or kaolin, along the western border of South Carolina.[18] Within a few years of his find, Landrum requested a sizable loan of two thousand dollars from the state to assist his efforts in building a pottery for the manufacture of Queensware or porcelain.[19] The timing was fortuitous: reliance on domestic production had recently been renewed, a repercussion of the War of 1812, and the dangers of lead glaze, commonly used on local earthenware, were becoming widely known.[20] Despite the capital, Landrum did not succeed in producing the white-bodied ware he intended; however, by 1816 his experiments led to the development of an alkaline-glazed stoneware. What started as an economic venture—largely subsidized by the government—to develop a local, sustainable product for a rapidly expanding population became a massively profitable enterprise built on slave labor.

Landrum's kiln and pottery were the first in the country to produce alkaline-glazed stoneware. They eventually became part of the village of Pottersville (also known as Landrumsville; see map, p. 14, bottom left), located a little over a mile north of the Edgefield Court House, the center of Old Edgefield District and the seat of all community activities in the rural county.[21] Recent archaeological excavations have provided unambiguous details about the sophistication and scale of the pottery.[22] Most significant was the size of the kiln: 105 feet in length, more than three times larger than most groundhog kilns then operating in the South.[23] Landrum's kiln and similar ones built later in Edgefield were most closely related in size and design to the industrial kilns first developed centuries earlier in Asia.

Old Edgefield District (as it was designated from 1785 to 1865) bordered the Savannah River on the west and covered a region that today comprises Aiken, Edgefield, Greenwood, McCormick, and Saluda Counties (see map, p. 14).[24] At least twelve different pottery sites operated across the district between 1815 and the 1890s, the majority of which were formed by familial relationships, kinship networks, and strategic partnerships.[25] Eighty percent of the owners were related by blood or marriage, and notably the vast majority held other professions within the tight-knit community, such as doctor, publisher, clergy, or planter.[26] Many of the potteries were located on plantations and established as business ventures by entrepreneurs and

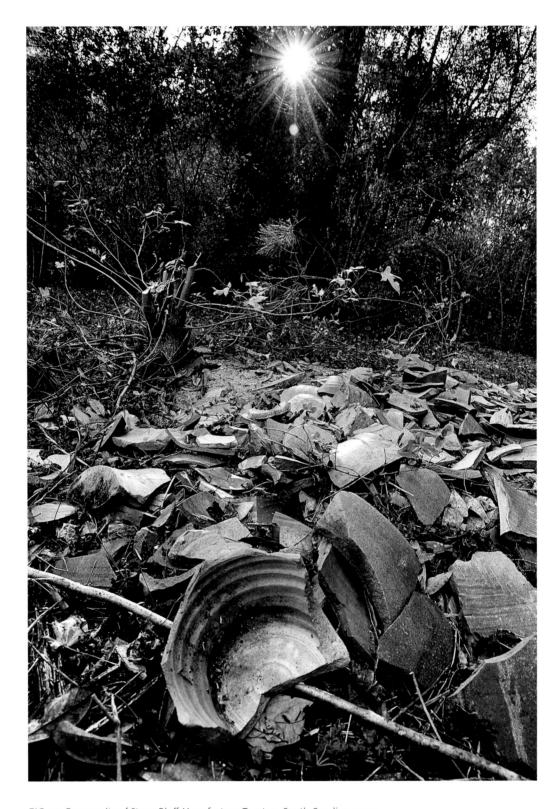

FIG. 12. Former site of Stony Bluff Manufactory, Trenton, South Carolina, 2021

investors, underscoring the economic alliances that reinforced the upwardly mobile professional class.

The stoneware directly supported the needs of the region's plantations, which expanded and proliferated as the population grew. By the mid-nineteenth century, agriculture, and specifically the cultivation of short-staple cotton, was the predominant source of wealth, all controlled by the thriving planter class.[27] For much of the century, the district was second only to Charleston in capital and in property values. As the unequivocal basis for this wealth, the enslaved population ballooned proportionally.[28] During the first quarter of the nineteenth century, the number of enslaved people in Edgefield expanded nearly threefold, while the White population decreased after its earlier growth in the previous decades; by 1830 African Americans constituted the majority in the district.[29] Africans continued to be forcibly brought to the area throughout the first half of the nineteenth century, and even as late as 1858 on the illegal slave ship *Wanderer*.[30]

Pottery production likewise reached an industrial scale, with the corresponding capital and resources required to sustain it. The manufacture of stoneware relied on enslaved labor at every level, and it responded to the needs of the area's expanding population. The utilitarian ware met the specific requirements of preparing and storing large quantities of food, a need unique to the region's homesteads and plantations. While the majority of the wares—bowls, churns, pitchers, cups, crocks, jars, jugs—were common, pedestrian forms ubiquitous in Southern kitchens, some potters were also producing monumental food-storage jars and watercoolers with capacities of up to forty gallons (see figs. 9, 32). Vessels of this size were not made elsewhere, even in the South. The majority of David Drake's most sizable jars, by far the largest objects made in Edgefield, date between 1857 and 1860, the years just preceding the Civil War, tangible proof that enslavement in the region had climbed to its zenith in that period.[31]

Slavery in America has long been understood as agricultural, reinforced by stereotypes of the plantation system, and Southern potteries were assumed to be small, self-sustaining enterprises. Industrialization brings to mind large-scale factories and highly mechanized manufacturing. While the overwhelming majority of this country's enslaved people labored in the cultivation and distribution of cash crops, they were also the backbone of nineteenth-century industrial endeavors, including mining, lumbering, turpentine extraction, transportation, crop processing, metalworking, and stoneware manufacturing.[32] Such was the case in Edgefield, where highly skilled enslaved people were responsible for every aspect of manufacturing large quantities of stoneware for a localized economy. Today, former pottery sites containing hundreds of thousands of fragments—some of which bear partial verses and dates (fig. 29; pls. 22, 24)—attest to the massive scale of production, corroborating the industrial nature of the potteries (fig. 12).

The large-scale production of goods required reliable means of distribution and sale, tasks also performed by those working at the potteries. Edgefield was well positioned for distribution to extended markets by wagon roads, waterways, and railways. An announcement in the *Edgefield Advertiser* from 1840 confirms that stoneware was brought as far east as Charleston and plantations in the Lowcountry, distances of up to a hundred and fifty miles.[33] The proximity of Hamburg, an important commercial center in South Carolina, to Augusta, Georgia, across the river, enabled expansion west and south into the latter state.[34] The Charleston-Hamburg Railroad was one of the first inland railroad systems in the country and the world's longest railroad when it opened in 1833 (see map, p. 14).[35] Created to support the flourishing cotton industry, it also benefited the nascent stoneware industry in Edgefield by enabling greater and more efficient distribution of its wares.

During the Civil War and following emancipation, many of the potteries closed or were significantly scaled back due to the loss of forced labor and the diminishment of the agrarian plantation economy. While the majority of production tapered off, some factories adapted to making other products, such as bricks, conductors, or wares to support the Confederacy. In some cases, formerly enslaved potters entered into agreements with pottery owners, in effect renting space and employing their skills to support their livelihoods.[36] Others left the area and headed west to establish their own potteries. Most notable is John Chandler, a freedman who moved to Guadalupe County, Texas, and worked at the Durham-Chandler-Wilson pottery.[37] The pottery was one of three operated by the Wilsons, founders of H. Wilson & Company outside San Antonio, Texas, widely recognized as the first African American business in the state.[38]

PRESERVING THE PAST

Although the consumption of Edgefield stoneware fell precipitously by the last quarter of the nineteenth century, the vessels remained in use, perhaps out of necessity or practicality. Given their broad application in everyday tasks, it's probable that the majority of the wares have not survived, a common fate for objects that served a useful life. Despite the durability of alkaline-glazed stoneware, utilitarian crockery would have been susceptible to wear and breakage, and there would have been an abundant supply of replacements. Some objects are likely extant because of their rare decoration, including storage vessels with applied figural designs or with incised dates and verses by David Drake. The largest vessels—some of which weigh over eighty pounds—inevitably survived because they were handled and moved far less.[39]

The decrease in consumption and production was soon followed by rising interest in collecting the Edgefield stoneware that did survive. The earliest type to be collected both in South Carolina and elsewhere was the face vessel, the intimate, highly sculptural figural form with hand-modeled facial features often made with

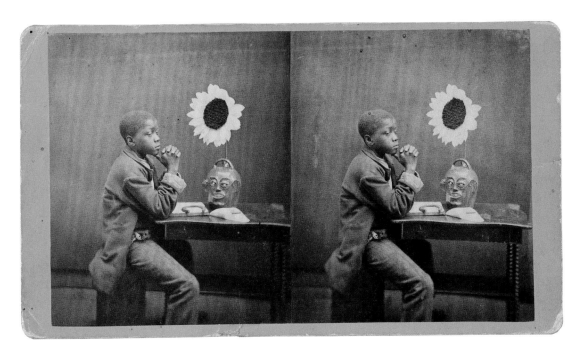

FIG. 13. James A. Palmer (American, born Ireland, 1825–1896). "An Aesthetic Darkey," from the "Aiken and Vicinity" series, 1882. Albumen silver print, 7 × 4 in. (17.8 × 10.2 cm). The Metropolitan Museum of Art, New York, Purchase, Nancy Dunn Revocable Trust Gift, 2017 (2017.311)

kaolin. Created at several Edgefield potteries, the face vessels were part of an artistic practice unique to the region that developed adjacent to the larger stoneware industry and reflected spiritual traditions from Africa adapted to a local context.[40] The vessels were not made for utilitarian purposes or sold, but primarily created by and for enslaved potters for use within the community. Their status as ritualistic objects would have precluded them from entering the local economy, and there is scant contemporaneous documentation about their function and use.

It's possible some face vessels were brought north by enslaved people via the Underground Railroad: a number have early histories that can be traced back to eastern Pennsylvania, a crossroads for many people escaping the South (see fig. 16). Freed African Americans later left the Edgefield area in significant numbers during Reconstruction due to the horrific violence toward newly emancipated Black people and could have also carried these objects north with them (see pp. 177–78, pl. 41). A handful also have direct connections to Union and Confederate soldiers, and some may have been exchanged between soldiers and the potters (see p. 178, pl. 48).

In 1882 a face vessel was featured prominently in Aiken-based photographer James A. Palmer's "Aiken and Vicinity" series, a collection of stereographs created for middle- and upper-class White consumers. These two startling, racist images depict a young Black boy and a Black girl in similar staged settings, seated at a table with a face

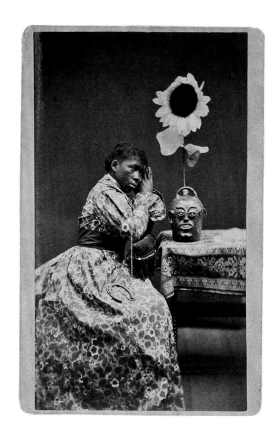 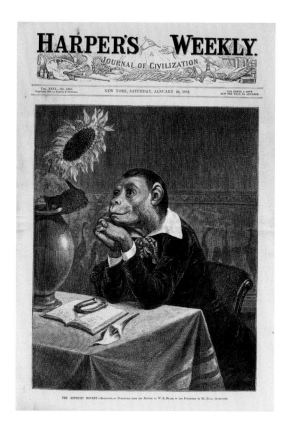

FIG. 14. James A. Palmer (American, born Ireland, 1825–1896). "The Wilde Woman of Aiken," from the "Aiken and Vicinity" series, 1882. Albumen silver print, 6½ × 4⅛ in. (16.5 × 10.5 cm). The Metropolitan Museum of Art, New York, Purchase, Nancy Dunn Revocable Trust Gift, 2018 (2018.629)

FIG. 15. Cover of *Harper's Weekly*, January 28, 1882, featuring William Holbrook Beard's woodcut engraving *The Aesthetic Monkey*

vessel holding a sunflower (figs. 13, 14). The tableau closely mirrors the January 28, 1882, cover of *Harper's Weekly*, which featured an offensive caricature of Irish-born aesthete and playwright Oscar Wilde as a monkey, published to coincide with the start of his North American lecture tour (fig. 15). Wilde's sold-out tour sparked equal parts fascination and ridicule; while some Americans embraced the cultured, flamboyant poet, he was also met with disgust. Palmer's decision to base his composition on the derisive cover was an overt insult to Wilde, and the titles of both reproductions attest to the derogatory association. The photographer appropriated the significant cultural moment of Wilde's tour for a local audience, including a form recognizable as made by local enslaved potters and intimating the association with African Americans as well as the region's stoneware traditions.[41] Palmer's use of the jug as a vase in this

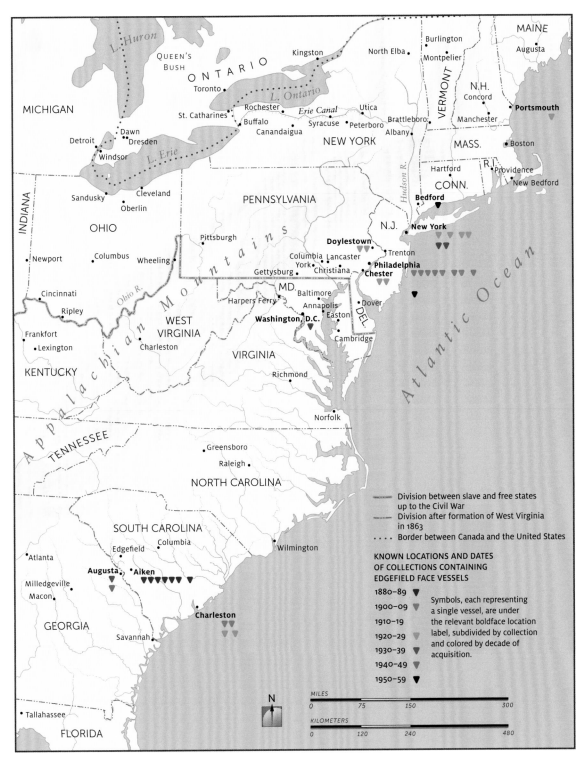

FIG. 16. Map showing locations of Edgefield face vessels, 1880s–1950s. Additional locations noted are significant sites in the history of the Underground Railroad, the abolition movement, pre–Civil War free Black populations, and state and provincial capitals.

demeaning image may have been an attempt to demystify these ritualistic objects and undermine their power while mocking Wilde at the same time.

Palmer's stereographic series was printed in multiples and widely distributed, and these two images—the earliest known reproductions of Edgefield face vessels—would have introduced the form to a larger public. It appears they were also roughly contemporaneous with the use of "monkey" as a racist term associated with the face vessels (see fig. 18).[42] While "monkey jug" can refer to a vessel with a horizontal stirrup handle between two spouts (one for drinking, the other an airhole), a design for keeping the contents cool, the majority of Edgefield face vessels have a small loop handle and only one spout.[43] The term seems to have been applied only to jugs made by Black potters, rather than all vessels of this design with modeled faces, meaning its associations were racial and therefore derogatory.

By the late nineteenth century, many face vessels had already been removed from their original context and entered the holdings of White collectors.[44] They may have been purchased by visitors to Aiken, a county established in 1871 during Reconstruction that was previously part of Old Edgefield District. Many affluent northerners wintered in Aiken, and there was at least one shop in the area that sold "Monkey head jugs."[45] Easily transportable and aesthetically distinctive, the objects may have served as a memento or curio; Palmer's stereograph cards likely served a similar purpose. A number of museums acquired Edgefield face vessels during the first quarter of the twentieth century, most through donations by collectors, a remarkable trajectory for objects made for private use by enslaved people only two generations earlier (fig. 16). The first stoneware objects from Edgefield's potteries to enter a public collection were two face vessels given to the Charleston Museum in 1902 by Benjamin Hammett Teague, a dentist, collector, and Civil War veteran from Aiken; he would donate another to the institution in 1920 (figs. 17, 18).[46] Perhaps one of the earliest collectors of Edgefield face vessels, Teague had in "about 1880 half a dozen 'monkey' jars made by negroes at the Miles' pottery."[47]

The earliest documented acquisitions of face vessels outside South Carolina were in the Northeast, more specifically the greater mid-Atlantic region: 1904 and 1917, Philadelphia Museum of Art; 1922, The Metropolitan Museum of Art, New York; 1922, Smithsonian Institution, Washington, D.C.; and 1937, New-York Historical Society, all objects with earlier histories in private collections.[48] Others have descended—and still remain—in personal collections. The fact that at least a dozen examples had entered prominent collections by the 1930s attests to their magnetism and mobility.[49] Of all the stoneware produced in Edgefield, the face vessels remain the least documented and understood, although there are several efforts underway to catalogue the almost two hundred extant examples, a crucial step toward building a body of knowledge on these objects (fig. 19).[50]

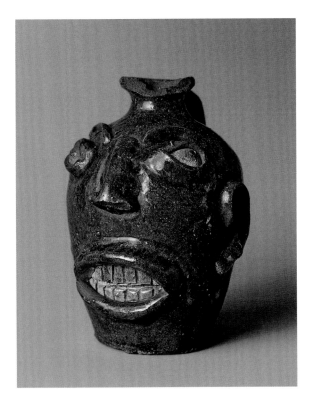 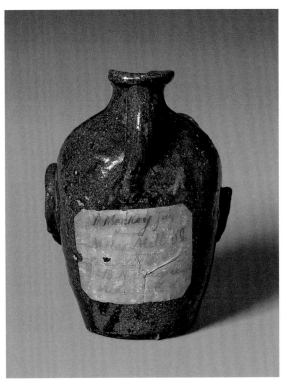

FIG. 17. Unrecorded potter. Face jug, ca. 1850–80. Alkaline-glazed stoneware with kaolin, H. 5¾ in. (14.6 cm). Charleston Museum, South Carolina (1920.25)

FIG. 18. Reverse of fig. 17

SHAPING EARLY SCHOLARSHIP

Beyond the interest of early collectors and the initial documentation and field studies conducted by the Charleston Museum, little attention was paid to Edgefield stoneware until the 1960s and 1970s. Although some examples had entered local museum collections, published documentation was scarce and objects were often miscatalogued.[51] In the 1960s archaeologists and researchers in the South began recording important oral histories and collecting examples of stoneware, in many cases saving objects from both obscurity and irreversible damage from environmental exposure. This generation of researchers includes many who amassed significant private collections as well as information: John A. Burrison, scholar and author; archaeologist Franklin Fenega, perhaps the first to systematically document David Drake's dated and signed vessels; Georgeanna H. Greer, potter, ceramics researcher, and author; Dr. Fred E. Holcombe, optometrist, avocational archaeologist, and researcher; Carlee T. McClendon, educator, Edgefield historian, and founder of the

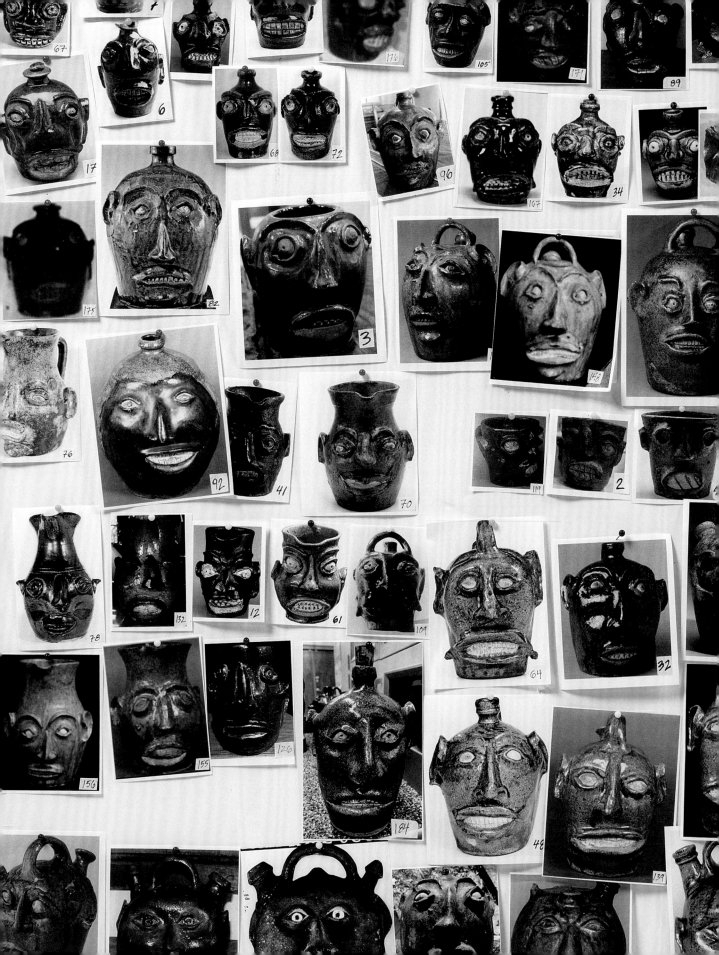

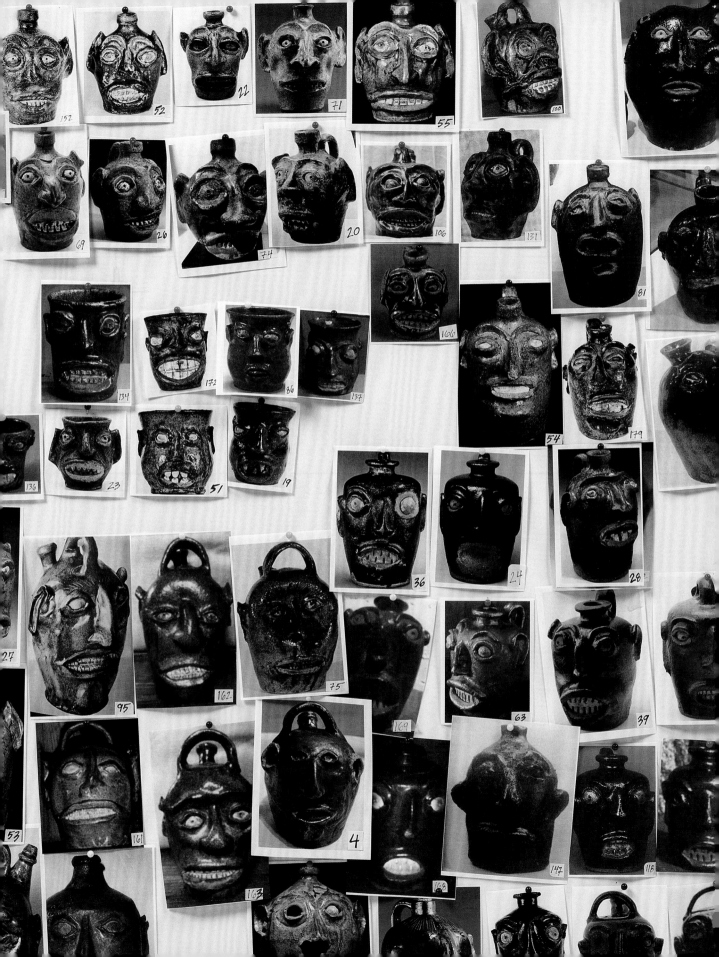

Pottersville Museum; and Tony L. Shank, researcher and antiques collector who assisted museums in acquiring Edgefield stoneware for their collections. Many of their efforts were oriented toward celebrating Edgefield, emphasizing the beauty of the alkaline glazes and exploring its context within the region's larger ceramic traditions. As more people started to recognize the importance of this body of work, local archaeologists followed in Bragg's footsteps, locating and mapping kiln sites, and in some cases unwittingly initiating amateur digs that resulted in sites' being pilfered and ultimately compromised.[52]

The first exhibition to focus on Edgefield stoneware was organized in 1976 by the Greenville County Museum of Art, Greenville, South Carolina, and toured to Columbia and Charleston (fig. 20). Curated by Terry M. and Stephen T. Ferrell—father and son, pastor and potter, respectively, and both astute researchers and collectors—the show presented the history and breadth of the area's stoneware enterprise. To the Ferrells' credit, they readily acknowledged the dependence on enslaved labor: "Another factor which set the potteries apart from most others was the heavy use of Negro slave labor for the manufacturing processes. The majority of time, the dividing line between that made by the pottery owner and that by the slave is indiscernible, if in fact the owner put his hands into the clay at all."[53]

In the same decade, fresh interpretations and recontextualizations of Edgefield stoneware shifted the focus to the enslaved potters, a much-needed intervention. John Michael Vlach, professor and anthropologist of the African diaspora, was instrumental in bringing attention to the contributions of Edgefield's enslaved craftsmen in his groundbreaking 1978 exhibition and publication *The Afro-American Tradition in Decorative Arts*, in which he devoted a chapter to pottery, with an extensive discussion of Edgefield stoneware, notably differentiating between utilitarian ware and face vessels.[54] Other scholars working at the time include Robert Farris Thompson, an art historian and professor of the arts of Africa and the African American world, who published research in 1981 on the relationship between face vessels and the spiritual sculptural figures of northern Kongo. Thompson asserted that the potters' use of kaolin, a substance associated with the spirits of the dead, cemented both a material and visual connection to the African precedents.[55] Significantly, he sought to decouple the vessels from the racist and derogatory terms that had long been associated with them—"grotesque," "monkey," "voodoo," and "ugly"—and introduced the term "Afro-Carolinian," underscoring the hybridity of this tradition and the racial

FIG. 20. Installation view, *Early Decorated Stoneware of the Edgefield District, South Carolina*, Greenville County Museum of Art, Greenville, South Carolina, April 1976

and cultural identity of the makers. Thompson's research informed art historian and curator Regenia A. Perry's pioneering 1985 exhibition and catalogue *Spirits or Satire: African-American Face Vessels of the 19th Century*, notably the first scholarly study of the Edgefield face vessel tradition.[56] These early multidisciplinary studies introduced Edgefield stoneware to people outside the insular group of niche collectors and scholars of Southern art and material culture.

Within the past thirty years, ongoing scholarship and critical attention has further expanded our understanding of this body of work. Scholar and curator Cinda K. Baldwin's important 1993 study, *Great and Noble Jar: Traditional Stoneware of South Carolina*, was the first comprehensive examination of Edgefield stoneware, and it remains the touchstone today. Jill Beute Koverman's research, spurred

FIG. 21. Harry (active ca. 1839–42), probably N. Ramey & Company (1839–40) or J. W. Gibbs & Company (1840). Storage jar, ca. 1840 (detail). Alkaline-glazed stoneware, H. 17⅛ in. (43.5 cm). Inscription: "Harry July 18." Greenville County Museum of Art, Greenville, South Carolina, Museum purchase

by the many unanswered questions about the life and work of David Drake, was instrumental in bringing the enslaved artist and poet to national attention. The 1998 exhibition and publication she organized, *I Made This Jar . . . : The Life and Works of the Enslaved African-American Potter, Dave,* are foundational to the study of his work. Koverman's project was the impetus for another deep dive into the potter's life, Leonard Todd's 2008 book *Carolina Clay: The Life and Legend of the Slave Potter Dave,* which pieced together the history of the author's family, who enslaved David Drake in the nineteenth century, with the biography of his subject. Using records and documents kept by Todd's family, the author carefully reconstructed many details of David Drake's life, the factual and the speculative sometimes overlapping. Todd correctly pointed out that the richest source of information on David Drake is the potter himself, in the form of his pots and the poems and inscriptions forever captured in the clay.[57]

Collectors have also made significant contributions to the study of Edgefield. Arthur F. Goldberg and James P. Witkowski's 2006 listing of all vessels signed by

or attributed to David Drake was invaluable in establishing the artist's oeuvre; since then, the number has doubled.[58] Corbett E. Toussaint's extensive appendix of African American potters and laborers in Edgefield District between 1790 and 1900 marks a major turning point in the scholarship, bringing to light the names of hundreds of people who labored in the stoneware industry. Until recently, the identities of many of the craftspeople were unknown, and this important resource laid the groundwork for research on other enslaved laborers, including the potter Harry, whose body of work is now coming to light (fig. 21).[59] Perhaps the most consequential recent development in Edgefield studies is the genealogical research underway to identify descendants of Edgefield's potters, an ambitious and serious effort with far-ranging personal and ethical implications. Begun about a decade ago by researcher and biographer April L. Hynes, these investigations have uncovered familial connections between generations of descendants and their enslaved ancestors in nineteenth-century Edgefield.[60]

CULTURAL CURRENCY

In recent years Edgefield stoneware has gained significantly more attention and visibility. Its admirers now extend well beyond local collectors, amateur archaeologists, and the landowners in whose possession much of the extant archaeological material resides. A growing body of digitized information once available only in regional repositories is now widely accessible to researchers and scholars. The corpus of objects also continues to expand, with newly discovered Edgefield vessels coming to light, often through the art market. The profitable sale of Edgefield stoneware has undeniably played a central role in the renewed attention to and scrutiny of these wares, and vice versa. Record-breaking prices have surfaced objects that have otherwise gone unnoticed.[61] In some cases, new attributions and discoveries motivated by potential sales are muddying the scholarship. Interest from both museums and private collectors continues to grow, signaling a further shift from an insular, regional focus to a broader, more diverse audience.

There is likewise increased recognition of this area of study within academia. Edgefield stoneware has solidified its place in the disciplines of art history, material culture and craft, literature, and archaeology as well as American history, slavery, and diaspora studies. James A. Miller's essay on David Drake and African American poetry provided important context for the potter's literary contributions.[62] This was followed by Michael A. Chaney's *Where Is All My Relation? The Poetics of Dave the Potter*, the first multidisciplinary compilation of essays investigating the historical record, which presents new contexts for understanding David Drake's work.[63] This visibility has ushered in fresh critiques of and methodologies for the study of Edgefield stoneware, as well as a growing body of new voices.

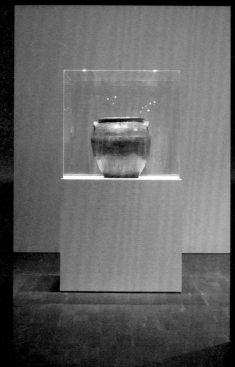

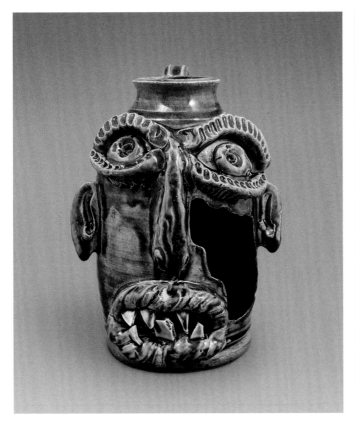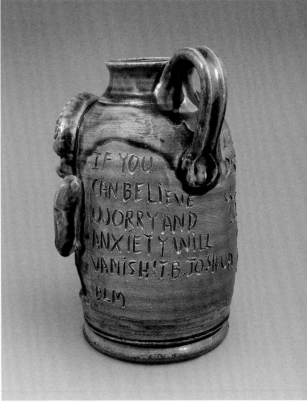

FIG. 23. Jim McDowell (born 1945). *Disappearing Black Man*, 2020. Glazed stoneware with porcelain, H. 9 ½ in. (24.1 cm). Inscription: "If you can believe, worry and anxiety will vanish! / T.B. Joshua / BLM / If I disappear will you look for me?" Krannert Art Museum, University of Illinois, Urbana-Champaign, Museum Purchase through the Theresa E. and Harlan E. Moore Charitable Trust Fund (2021-16-1)

FIG. 24. Reverse of fig. 23

Attesting to the relevance and cultural currency of these objects, contemporary artists are literally reshaping the narrative, building knowledge, and bridging the historical with the present through their practice. From the performance pieces of interdisciplinary artist Theaster Gates (fig. 22) to the powerful explorations of the face vessel form by potter Jim McDowell (figs. 23, 24), the varied artistic responses to Edgefield stoneware both signal and solidify its lasting significance. Like the objects made a century and a half ago that they reference, these works illustrate the power of artists across time to create work that both responds to and transcends the issues of their day.

Opposite:
FIG. 22. Installation view, *To Speculate Darkly: Theaster Gates and Dave the Potter*, Milwaukee Art Museum, Wisconsin, 2010

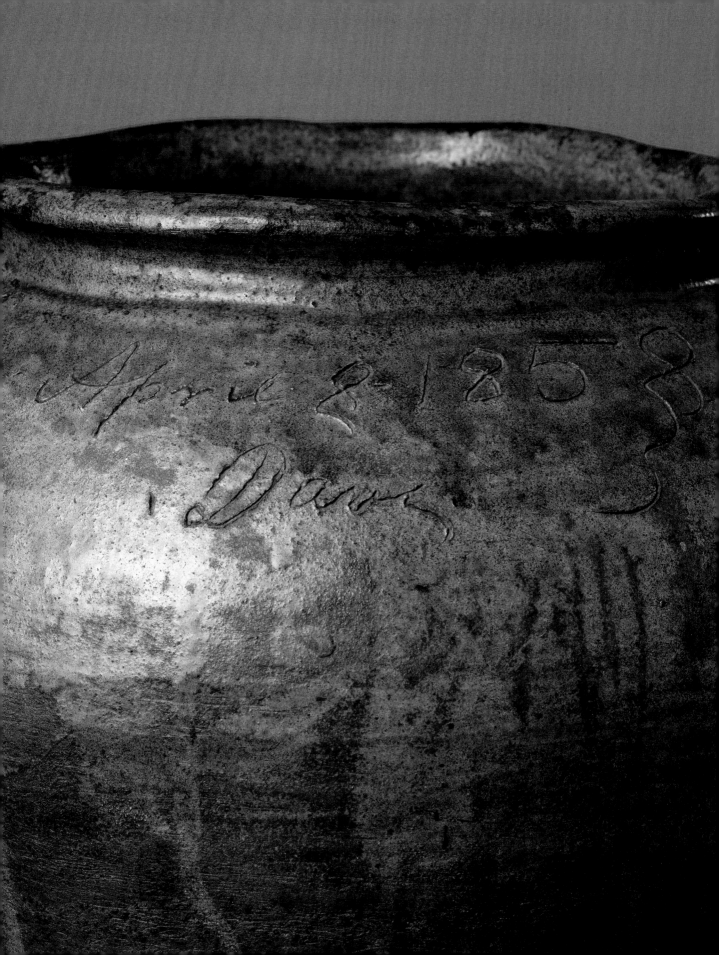

INCIDENTS IN THE LIFE OF AN ENSLAVED ABOLITIONIST POTTER WRITTEN BY OTHERS

Michael J. Bramwell and Ethan W. Lasser

Etched into the side of a stoneware jar in the hot summer sun of 1857 by Edgefield's famed potter, poet, and abolitionist, the disabled artisan known as Dave, these thirteen words are among the most powerful and emotive in the history of American letters: "I wonder where is all my relation / Friendship to all—and every nation" (fig. 25). Dave's expression of longing for his loved ones suggests he experienced the family separations that were all too common in the cruel, evil, and racist system of slavery. Who was Dave wondering about? His parents or his children? His partner? Perhaps some distant ancestor? These poetic words echo abolitionist writings and foreshadow the later prose of oppressed peoples—from the poems of Jewish Holocaust survivors to the pleas of twenty-first-century refugees. In this remarkably short verse, Dave bears witness to tremendous suffering and indicts and calls to account all those who brought it about. Of course, the potter had to be careful not to threaten his enslavers directly, which may have been why he softened his message with an evocation of friendship, a turn characteristic of his verse.

Little is known about Dave's biography beyond the fact that he was a boy of African descent who was enslaved since his birth around 1801.[1] If nothing else is certain, we can say for sure, with Zora Neale Hurston, that somebody "got born."[2] And that birth implies a genealogy of an African mother enslaved in the eighteenth century, following the doctrine of *partus sequitur ventrem*, a law mandating that children inherit the legal status of their mothers. But despite her strength and fortitude, she remains anonymous and unconsidered in craft literature. Dave's mother was not the first Madonna to carry an important child. Perhaps she sensed through maternal instinct or divine inspiration that her baby was important, someone W. E. B. Du Bois would later describe as a "seventh son, born with a veil, and gifted with second-sight in this American world."[3]

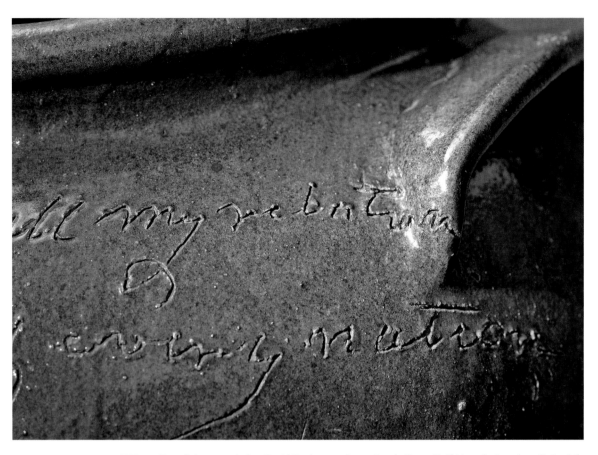

FIG. 25. Dave (later recorded as David Drake; ca. 1801–1870s), Stony Bluff Manufactory (ca. 1848–67). Storage jar, 1857 (detail of pl. 29)

Dave turned hundreds if not thousands of stoneware jugs and jars alongside other enslaved potters in the decades before and during the Civil War.[4] He duplicated a set of standard forms by hand day after day, year after year. Reproducing the same pot under variable conditions, including fluctuating temperature and humidity, required tremendous skill and knowledge.[5] But Dave's contribution to the history of American art runs deeper still: he signed and inscribed some fifty of his largest pots with short verses, dates, or both (see pp. 180–81 for the complete list of known verses). By weaving together poetry and pottery, Dave carved out a space of autonomy within the context of enslavement, bearing witness to its horrors while transforming objects of oppression into sites of abolitionist struggle.

Resistance is one particularly compelling interpretive pathway through Dave's work. By identifying and decoding the hidden transcripts of resistance embedded in his stoneware artifacts, the connection between his work and other forms of resistance active at the time becomes clear. This effort also locates the potter and poet within the lineage of great enslaved narrators—Frederick Douglass,

Harriet Jacobs, David Walker—as well as the many unrecorded artisans who staged their resistance through quieter interventions in the workshop.

Acts of questioning and witnessing were courageous for an enslaved man in rural Edgefield. Past scholars have recognized "covert, yet overt, protest" in Dave's pots, but resistance connotes a deeper and more powerful set of actions.[6] To protest is to express objection, whereas resistance goes beyond to counter, push back, and attempt to change one's circumstances. Dave's practice of freedom stands between two extremes, with the conspiracies and revolts of abolitionists like John Brown, Nat Turner, and Denmark Vesey at one end and the strategic capitulation of people considered to be Sambos and Uncle Toms of the romantic South at the other. While the latter terms were used pejoratively to describe people perceived as too accommodating and happy-go-lucky about their oppressed condition, they also signify an adaptive strategy of survival. Dave's actions fell in the space of what anthropologist James C. Scott calls "everyday resistance," with the potter diverting time and materials away from the standard jars he was forced to make and doing his own thing.[7] While evasion, false compliance, and pilfering were standard responses to oppression at the time, Dave also drew on the master's tool of literacy to leave his own mark on plantation practice in a process of liberation that brought together word and craft. His actions appear to counter what Audre Lorde said years later: "the master's tools will never dismantle the master's house."[8] The essential character of Dave's work was nonviolent while seeming to retain the same oppositional consciousness and emancipatory aims as its more radical counterparts.

Who read Dave's poems? His vessels were destined for spaces across the South where food for enslaved people was stored and consumed: smokehouses, kitchens, storerooms. The pottery owners dispatched his stoneware to local patrons as well as markets far from Edgefield—via railroad to the Charleston seacoast and by wagon to Augusta, Georgia, and from there by boat to plantations farther south and west along the Savannah River and beyond (see map, p. 14). Dave's prose sometimes acknowledged the distance the vessels traveled, and several of the jars appear to be addressed to far-flung consumers, both White and Black.[9] These patterns of circulation and exchange gave the potter access to a large and diverse network of readers, an imagined community throughout local and regional plantations.[10] Dave literally and figuratively self-published his poetry, engaging a broad audience of enslaved and enslavers in his acts of resistance.

IN THE BEGINNING WAS THE WORD

On June 12, 1834, Dave inscribed "Concatenation" in neat, flowing cursive script on the shoulder of a jar—the form of the letters almost replicating penmanship guides of the period—as well as the date in day, month, year format, reminiscent of letters and official documents (fig. 26). "Concatenation" means the linking of

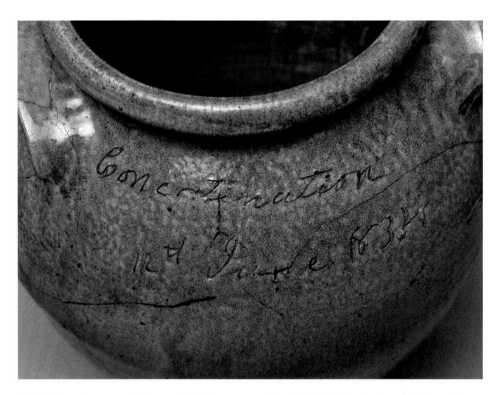

FIG. 26. Dave (later recorded as David Drake; ca. 1801–1870s), Drake & Rhodes Factory (1832–36). Storage jar, 1834 (detail of pl. 26)

parts or events into a series, such as the stanzas of a poem or a chain of events. Conjuring the act of gathering separate things, the word reflects Dave's abiding interest in coming together.

The inscription was straightforward from a maker's point of view, something any literate potter could write without much planning or forethought, so long as they had access to a metal stylus or sharpened stick. But through this act and through the hundreds of pots he would later sign and date, Dave entered the plane of discursive resistance—the battlefield where Douglass, Jacobs, Walker, and other enslaved and formerly enslaved writers fought for liberation. In the aftermath of Nat Turner's 1831 rebellion, which was coordinated by passing notes, an educated enslaved person became especially terrifying to enslavers. The revolt ushered in the "slave security state," which prohibited "educational opportunities for African-descended residents," as the historian Calvin Schermerhorn explains.[11] Dave's inscriptions were therefore acts of defiance, conspicuous violations of a system of oppression and control. The potter displayed his literacy, education, and likely access to books and penmanship guides on his "Concatination" jar just months before South Carolina passed a new set of more punitive antiliteracy codes in December 1834. The

legislation prescribed a brutal fifty lashes for an enslaved person caught teaching another enslaved person to read and write and a prison sentence for a free person convicted of this offense.[12]

Literary historian Michael A. Chaney quotes an unsettling account of punishment from the autobiography *Life of William Grimes, the Runaway Slave* (1825): "At one time my master having caused an oven to be built in the yard, for the purpose of baking bread for the negroes, I went there and finding it not quite dry, made impressions with my fingers, such as letters &c. on it, while the mortar was green on the outside. Gabriel, one of the servants, a son of old Volentine, was ordered to strip my shirt up and whip me."[13] In other cases, the retribution was even more violent. Recalled one enslaved Georgian, "If they caught you trying to write they would cut your finger off and if they caught you again they would cut your head off."[14] In her drawing *Oof*, contemporary artist Kara Walker visualizes the swift and depraved practice of severing the limbs of people who failed to submit to the terms of their oppression (fig. 27).

Accounts such as these raise questions about Dave's allegedly losing his leg, which likely required another person to work the foot pedal of the potter's wheel for

FIG. 27. Kara Walker (born 1969). *Oof*, 2001. Ink and watercolor on paper, 12 × 18 in. (30.5 × 45.7 cm). Courtesy of the artist and Sikkema Jenkins & Co., New York

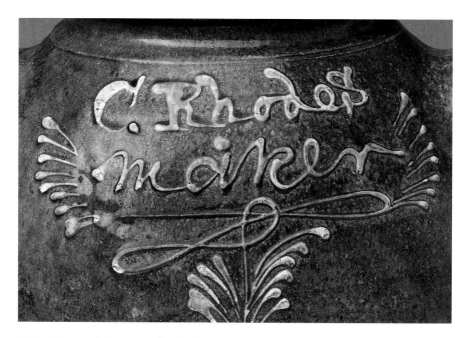

FIG. 28. Unrecorded potter, Collin Rhodes Factory (ca. 1846–53). Storage jar, ca. 1846–53 (detail of pl. 11)

him. Many scholars repeat a thirdhand account of a train supposedly severing Dave's leg when he was passed out drunk on a railroad track.[15] At a time when amputations were standard forms of punishment for offenses like reading, writing, and self-liberating, it seems plausible that Dave's missing limb was not the result of a steam-train accident. The potter's habit of signing and dating his pots not only broke the law but also violated protocols of ceramic production. Custom and tradition predominated in Edgefield, and custom dictated that enslavers and pottery owners mark the wares made in their factories, even if their hands never touched the clay body. Thus, for instance, the prevalence of wares signed "C. Rhodes Maker," even though Collin Rhodes was only an investor in Edgefield's ceramics industry (fig. 28). This convention rendered invisible the identities and individual touch of the Black potters who fabricated the stoneware.[16] Therefore an inscription such as "Mr Miles Dave Turning," found on a fragment at the Stony Bluff Manufactory, was a dual act of resistance: Dave proclaimed his authorship contrary to a local culture and a larger system designed both to keep the enslaved illiterate and to obscure their contributions (fig. 29). In a lithograph created in 2010 as a response to a Dave pot, contemporary artist Theaster Gates offers a powerful act of redress for those whose authorship was erased. A bold inscription placed next to a rendering of a vessel reads, "Bitch, I made this pot" (fig. 30).

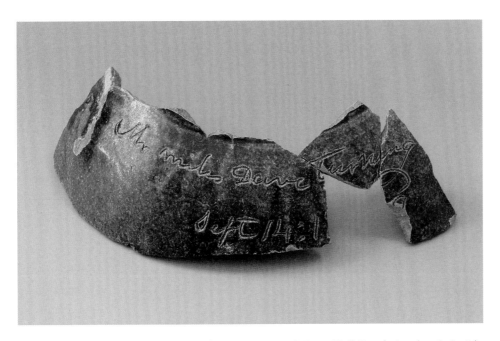

FIG. 29. Dave (later recorded as David Drake; ca. 1801–1870s), Stony Bluff Manufactory (ca. 1848–67). Three fragments, ca. 1848–67. Alkaline-glazed stoneware. Inscription: "Mr Miles Dave Turning / Sept 14: 1." Collection of C. Philip and Corbett Toussaint

Fig. 30. Theaster Gates (born 1973). *Bitch, I Made This Pot*, 2013. Lithograph, screen print, and rubber stamp on paper, 23 ⅝ × 31½ in. (60 × 80 cm). Courtesy of the artist and Whitechapel Gallery, London

A JAR "NOT COUNTED"

On Tuesday, May 16, 1843, Dave turned a strange and wonderful jar inscribed "not counted" (fig. 31). This gigantic vessel represents a materially based form of resistance that is distinct from the potter's defiant practice of inscription. Measuring almost twenty-eight inches tall, with a circumference of more than seventy inches at the widest point and a capacity of twenty-five to thirty gallons, it looks like a standard Edgefield jar that has been elastically stretched or telescoped upward.[17] The work marks the expansion of Dave's output from jars of fifteen gallons or less to those a third or more larger, which dwarfed much of the region's output.[18] While Dave threw his standard vessels on a wheel, manipulating this amount of clay required a change of technique. As scholar Jill Beute Koverman observed, for the 1843 jar Dave used a turn-and-coil process, throwing the base on a wheel and then adding separately made coils of clay. This method required both prodigious hand strength and a delicate touch. Smooth and secure joins were crucial, as even the tiniest air pocket could expand and explode in the kiln's high heat.[19]

The concise inscription seems to reflect the pot's experimental character. Perhaps whoever tracked production that day did not include this jar in the count, or perhaps Dave was uncertain of its capacity, given how much larger it was than his standard wares. "Not counted" can also be read as a broader statement about experimentation within industrial slavery. As Schermerhorn has explained, the "slave security state . . . frustrated creativity, innovation, and entrepreneurship" to maintain order and control and focus attention on the predictable cycles of growing and harvesting cotton.[20] This

FIG. 31. Dave (later recorded as David Drake; ca. 1801–1870s). Storage jar, 1843. Alkaline-glazed stoneware, H. 27¾ in. (70.5 cm). Inscription: "Mr. L Miles Dave / not counted / 16 May 1843." Private collection

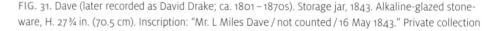

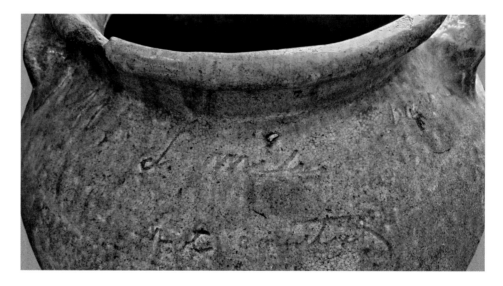

was certainly true in Edgefield. Dave was forced to make hundreds of standardized vessels a year to supply the market with a uniform and trustworthy product, as advertised in local outlets such as the *Edgefield Advertiser*.[21]

It is not immediately clear why Dave deviated from the standard production algorithm that Tuesday in May. The jar's size may have been a response to the food storage and preservation needs of the increasing number of enslaved people on up-country plantations, or maybe a fellow potter challenged him to make a large-scale work.[22] What is clear is that Dave diverted time and materials away from the production line and channeled his craft intelligence in a way that pushed back against both the local authorities and the larger system that stymied innovation and experimentation. His act was similar to those of the contemporary incarcerated artists whom critic Nicole R. Fleetwood discusses in *Marking Time: Art in the Age of Mass Incarceration*. Fleetwood describes how the artists "reconstitute what productivity and labor mean in states of captivity" by creating works that "entail laborious, time-consuming, and immersive practices and planning" in an industrial environment organized against such practices.[23] The French philosopher Michel de Certeau terms such a departure from the norms of production *la perruque* (the wig), a French idiom that refers to the work someone does for themselves under the guise of doing work for their employer. This tactic is a form of everyday resistance in which the worker "diverts time . . . from the factory for work that is free, creative, and precisely not directed toward profit"—"not counted," in other words—in order "to signify his own capabilities."[24]

WRITING FOR THE FUTURE

In the late 1850s Dave employed the turn-and-coil method to create some of his largest and most impressive objects, regularizing and monumentalizing his earlier acts of resistance. More than half of the thirty-five extant storage vessels attributed to Dave from this period were significantly larger than the standard Edgefield pot, and he turned massive four-handled jars between 1858 and 1859 that were even more sizable than the "not counted" jar—the two largest capable of holding an astonishing forty gallons (figs. 9, 32).[25] With this increased size came added space for inscriptions. Between July 1857 and July 1859, Dave engaged in a flurry of writing, seemingly cutting more verses into the clay body than he had in the prior twenty-three years combined (see pp. 180–81). These late verses are physically larger and incised more deeply—and therefore more visibly—than those of the 1830s and 1840s. Dave also added flourishes and adornments to his script that make his prose more conspicuous (fig. 33).

What differentiates these late vessels from the potter's earlier work is not just the confidence with which he defied his enslavers and the expansive scale of his inscriptions but also the objects' temporality. Some of the four-handled pots weigh

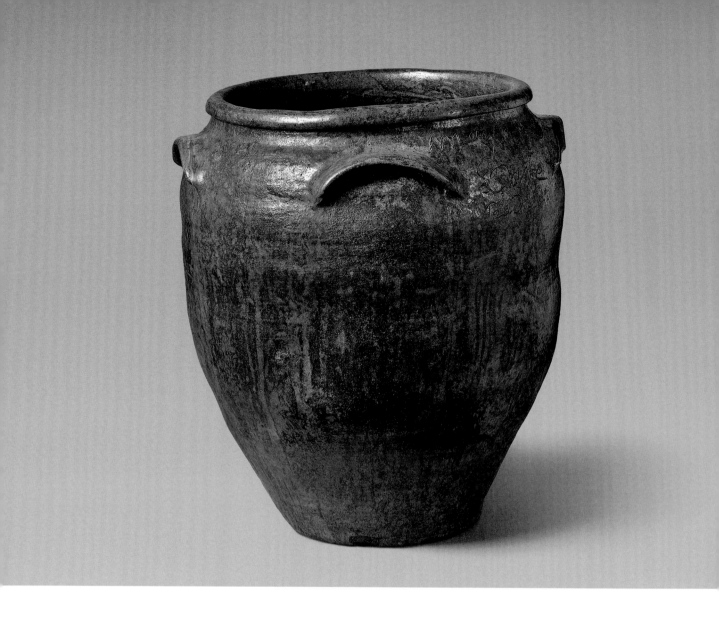

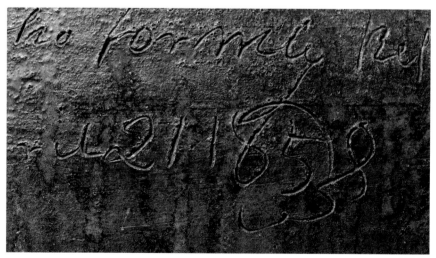

more than eighty pounds and are virtually unmovable, making them as close as ceramics come to permanent, monumental objects. They could (and did) chip and crack through use, but it was highly unlikely they would break if they emerged intact from the kiln. Dave indirectly acknowledged this permanence in an 1858 poem that boasts of the object's—and its contents'—capacity to withstand decay: "I made this for our- sott/It will x never—never, rott."

In the material world of Edgefield, the monumental late pots find their closest cognate in the gravestones of the local churchyard, many of which were prominently inscribed with names and dates, and some of which were stoneware (fig. 34). (Two extant examples, which are convex in shape and designed to lay over a mound, are signed "F. E. Justice/Maker." Scholar Corbett E. Toussaint has confirmed that Fortune Justice was a Black potter born in Aiken, near Edgefield.[26]) Durable, rooted into the ground, and exceedingly heavy, gravestones are difficult to move and even harder to break. The same holds true for Dave's large stoneware pots.[27] Like the monuments in the Old Edgefield District cemetery, they perform an act of immortalization while also pushing against a system that attempted to render the enslaved forgotten and invisible.

Dave engaged with a range of subjects in his late writing, tying together many of the threads he explored in his earliest work while crafting verses that set forth in new directions.[28] Among the latter are two that take a religious tone. Dave undoubtedly heard the gospel, given the religious fervor that swept the "Christ-haunted" South

Opposite, top:
FIG. 32. Dave (later recorded as David Drake; ca. 1801–1870s) and Baddler (active ca. 1859), Stony Bluff Manufactory (ca. 1848–67). Storage jar, 1859. Alkaline-glazed stoneware, H. 28¾ in. (73 cm). Inscription: "made at Stoney bluff; / for making dis old gin enuff / May 13 · 1859 · / Dave & / Baddler." Charleston Museum, South Carolina (1919.5)

Opposite, bottom:
FIG. 33. Dave (later recorded as David Drake; ca. 1801–1870s), Stony Bluff Manufactory (ca. 1848–67). Storage jar, 1858 (detail of pl. 33)

FIG. 34. Left: Tombstone of Henry Daniels, 1873. Alkaline-glazed stoneware with kaolin. South Carolina State Museum, Columbia (SC95.29.1). Right: Tombstone of Harriet Hazzard, 1868. Alkaline-glazed stoneware with kaolin. South Carolina State Museum, Columbia (SC95.101.1)

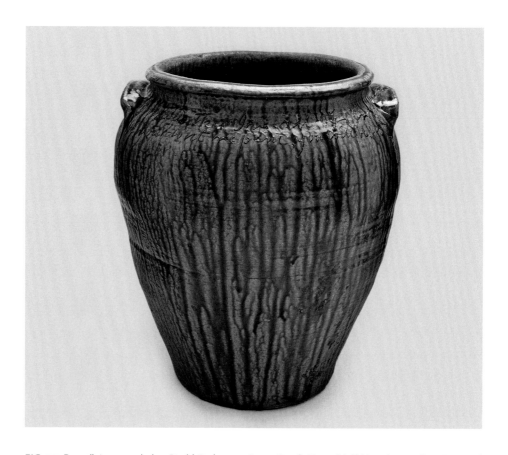

during the Second Great Awakening (1790–1840) and the concurrent antislavery debates.[29] On the eve of the Civil War and in the midst of the conflict, Dave called on his readers—enslaver and enslaved—to repent in two pot poems: "I made this out numer, & cross `'/if you do not listen at the bible you'll be lost—" (March 25, 1859) and "I, made this Jar, all of cross/If, you dont repent, you will be, lost" (May 3, 1862; fig. 35).

These verses bring to mind the writings of David Walker, the Black New England tailor who sewed his abolitionist pamphlets into the clothes of Black sailors heading south. Dave evokes the spiritual call in *Walker's Appeal, in Four Articles; Together with a Preamble, to the Coloured Citizens of the World, but in Particular, and Very Expressly, to Those of the United States of America*, written in 1829: "O Americans! Americans!! I call God—I call angels—I call men, to witness, that your DESTRUCTION *is at hand*, and will be speedily consummated unless you REPENT" (fig. 36).[30]

FIG. 36. Title page of *Walker's Appeal*, 3rd edition (1829; Boston: David Walker, 1830)

It appears that both writers were navigating by the light of a religious consciousness that was changing the South in a way different from that of antislavery movements. Enslaved persons reading Dave's words were freed—not necessarily because their physical condition changed, but rather their spiritual one. It was freedom achieved through an abiding faith that could humanize the enslaver by grace and help them understand the right way of being-in-the-world. This spiritual task was not limited to theologians and prophets, but was accessible to ordinary people. Dave's work did not have a malevolent telos; it did not seek the destruction of his enemies. As with abolitionists such as Douglass, Dave mobilized the ethical imagination that encouraged enslavers to repent from the original sin of slavery, and by doing so, carved out a space for spirituality within American decorative arts. As long as the human capacity for evil still exists, Dave's messages of repentance have as much resonance in the twenty-first century as they did in the nineteenth, always reminding us, "it is appointed unto men once to die, but after this the judgment" (Hebrews 9:27).

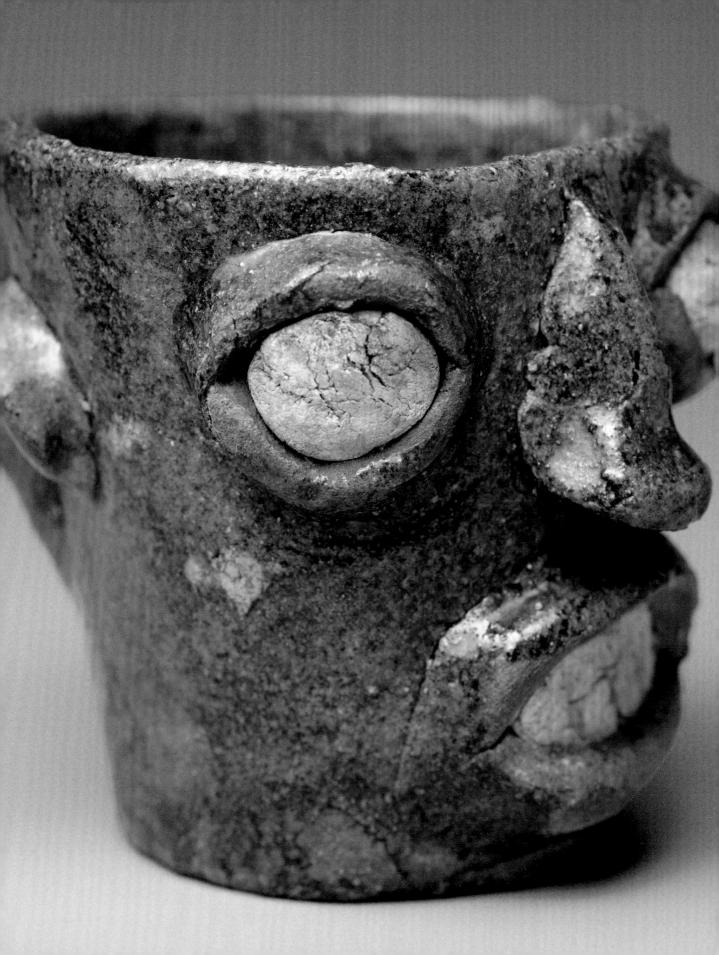

"BUT OH THE CLAY IS VILE": EDGEFIELD POTTERY IN LIFE AND DEATH

Jason R. Young

As they gathered for the funeral, the friends and family of Old John marveled at the beauty of the grave, noting the pieces of fine blue china that had been placed lovingly atop the burial mound. Now broken and scattered, the china had once belonged to the family of South Carolina Governor William Aiken Jr., who presided only briefly over the state, from 1844 to 1846, but who reigned over Jehossee Island, his sprawling rice plantation, for much longer. Jehossee spanned more than fifteen hundred acres, dwarfing most other plantations in the state. To work that land, Aiken enslaved more than seven hundred people, making him one of the wealthiest citizens in South Carolina. Old John had been Aiken's long-serving coachman, driving the prominent planter to various points around the state.

One day at Jehossee, Harriet Lowndes Aiken, mistress of the plantation, sent a young girl to fetch water from a local spring. She was making her way back to the "Big House" when she tripped on a knotty tree root, causing the pitcher to fall to the ground. The mouth of the vessel cracked. Water spilled out in a rush. Undaunted, the girl went back to the spring, filled the pitcher again, placed it atop her head, and set off for home. As she returned, water leaked from the broken mouth and tiny rivulets dribbled down her face. By the time she reached the house, the pitcher was empty, but her face was streaming with what looked to the mistress to be sorrowful tears. Assuming that the girl was crying of despair and regret at having broken the vessel, she took pity on her. Rather than mete out a punishment, the mistress gifted the damaged vessel to the young girl. The pitcher stayed in her possession until she grew up, married Old John, and watched him die. To prepare for the burial, she grabbed a hatchet and finished the job she had started so many years earlier, breaking the pottery into pieces and scattering them on her deceased husband's grave. That blue china held decades of memories, highlighted by a moment when a plantation mistress refrained from an expected brutality, a moment when a river of tears saved a young girl from punishment.[1]

While Old John's widow adorned her late husband's grave with much-coveted blue china, others honored their departed loved ones the best they could with the material they had on hand. Even as one woman complimented the beauty of Old John's grave, she knew full well that she would not be able to decorate her own husband's resting place with any such finery. Instead, she had taken to collecting the bottles of rum that her husband liked to drink, piling them up behind her house "fuh pit 'puntop him grabe w'en 'e dead."[2]

BRIC-A-BRAC

African American funerary tradition has long captured the attention of interested observers, who have often been struck by the similarities between the decoration of African American grave sites throughout the South, especially in South Carolina, and practices common in West-Central Africa. European explorers, traders, and missionaries living and working in West-Central Africa consistently noted what they regarded as the odd methods that people used to honor the dead and decorate graves. To many of these observers, Kongo cemeteries "looked like vast dumping grounds for abandoned glass and stoneware bottles and jars, left in a disorderly manner."[3] In 1891 *Century Magazine* published E. J. Glave's "Fetishism in Congo Land," which described Kongo funerary ritual in detail: "The natives mark the final resting-places of their friends by ornamenting their graves with crockery, empty bottles, old

Fig. 37. "A Congo Chieftain's Grave," E. J. Glave, "Fetishism in Congo Land," *Century Magazine* 41, no. 6 (April 1891)

Fig. 38. Mangaaka power figure (Nkisi N'Kondi). Republic of the Congo or Cabinda, Angola, Chiloango River region; Kongo peoples, Yombe group, 19th century. Wood, iron, resin, ceramic, plant fiber, textile, pigment, H. 46 7/16 in. (118 cm). The Metropolitan Museum of Art, New York, Purchase, Lila Acheson Wallace, Drs. Daniel and Marian Malcolm, Laura G. and James J. Ross, Jeffrey B. Soref, The Robert T. Wall Family, Dr. and Mrs. Sidney G. Clyman, and Steven Kossak Gifts, 2008 (2008.30)

cooking-pots, etc., all of which articles are rendered useless by being cracked or perforated with holes" (fig. 37).[4]

At least some of the materials that Glave saw on Kongolese graves likely reflected changes in the economic relationship between West-Central Africa and Western Europe. In the late nineteenth and early twentieth centuries, a new consumer culture developed in West-Central Africa in which European trade goods emerged as highly coveted commercial items. In exchange for raw materials such as rubber and palm oil, Kongolese consumers received utilitarian as well as luxury goods that were used in a variety of ways. Stoneware pitchers, Toby jugs, and bottles were very much in vogue in Kongo during this time. Prized as status symbols, they were placed atop the graves of prominent chiefs and merchants as a display of earthly wealth. In addition to these commercial items, Kongolese artists were increasingly commissioned by the country's elite to make anthropomorphic figures in stone or wood for the same purpose.[5] This fashion of placing highly prized commercial and commissioned

FIG. 39. African American graveyard on abandoned land in the Santee-Cooper basin near Moncks Corner, South Carolina, March 1941

goods on top of the burial mound reflected a much older tradition in Kongo of ornamenting graves with powerful *minkisi*, wood-carved ritual objects (fig. 38).

Just as pottery, jugs, bottles, and *minkisi* featured prominently in grave decoration in Kongo, so too did the last-worn ornaments of the dead, bowls, pipes, jugs, and bottles appear in African American funerary ritual in South Carolina (fig. 39). The same year Glave published his observations from Kongo, H. Carrington Bolton wrote of his travels in South Carolina, describing an African American grave site: "The numerous graves are decorated with a variety of objects, sometimes arranged with careful symmetry, but more often placed around the margins without regard to order. These objects include oyster-shells, white pebbles, fragments of crockery of every description, glass bottles, and nondescript bric-a-brac of a cheap sort,—all more or less broken and useless"(figs. 40, 41).[6] A Northern visitor to the Edgefield region at the turn of the twentieth century offered an in-depth description of the Aiken Colored Cemetery. Deeply impressed yet thoroughly confused by the grave

FIG. 40. Wooden grave markers at Sunbury, South Carolina, 1939

decoration, the observer sought information from local residents but was stymied in his attempts, noting that "an interview with the dark skinned old grave digger failed to elicit any intelligible explanation of the strange custom."[7]

Contrary to the opinions of many outside observers, the bereaved on both sides of the Atlantic—in Kongo and South Carolina—were not carelessly placing items around the graves of their departed loved ones. For example, the oft-noted presence of the color white on burial mounds both reflected and helped to establish connections between the living and the deceased. A long historical record in Kongo attests to the close association of the color white to *mpemba*, the land of the dead. Much the same is true in the Black communities of South Carolina, in which many embraced the color white as a symbol for death, dying, and the afterlife.[8] Likewise, mourners placed medicine bottles atop burial mounds with the necks facing "upside down with the corks loosened so that the medicine may soak into the grave."[9] That the china, cups, and mirrors placed on graves were invariably broken is a point of no small importance, signifying the certain and necessary break that must be made between the living and the dead. For the living, the cracked dishes and pottery ensured that the chain of death would be broken: "Yuh see, duh one pusson is dead an ef yuh dohn break duh tings, den duh uddahs in duh fambly will die too. Dey will folluh right long."[10] For the deceased, this damage connoted a liberation of movement, a freedom to travel between worlds.

FIG. 41. H. Carrington Bolton, "Decoration of Graves of Negroes in South Carolina," *Journal of American Folk-Lore* 4, no. 14 (July–September 1891)

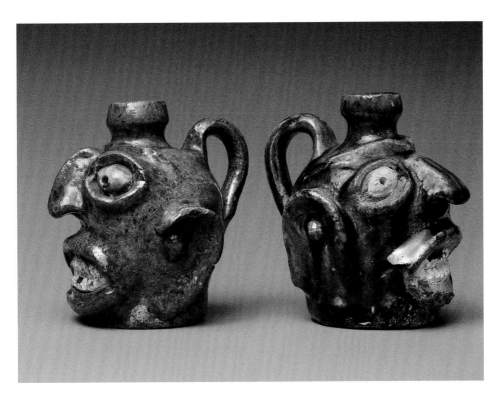

FIG. 42. Edgefield face jugs, ca. 1850–80 (pls. 51, 49)

The graves at Aiken Colored Cemetery, along with many others throughout the Edgefield District, were distinguished from those across the plantation South by their inclusion of "grotesque jugs," a term widely used in South Carolina to describe ceramic face vessels that were produced in the mid-nineteenth century by African American potters from the district (fig. 42). At the turn of the century, ceramic historian Edwin AtLee Barber described the vessels as "weird-looking water jugs, roughly modelled . . . in the form of a grotesque human face,—evidently intended to portray the African features." For Barber, these vessels held particular interest "as representing an art of the Southern negroes, uninfluenced by civilization . . . the modelling reveals a trace of aboriginal art as formerly practised by the ancestors of the makers in the Dark Continent."[11]

　　Barber's "weird-looking water jugs" have subsequently become the subject of sustained scholarly attention, causing controversy across disciplines as successive generations of historians, anthropologists, archaeologists, and others have debated their provenance and ultimate significance. Art historian Robert Farris Thompson was among the first scholars to write about them, arguing that the aesthetic principles underlying their composition and manufacture bear a striking resemblance to *minkisi* from West-Central African religious practices.[12] Though *minkisi* were

constructed in different media, the basic ritual understandings that gave meaning to the wood-carved figures may help us to better understand the face vessels. Edgefield, much like the Kongo kingdom, enjoyed rich natural deposits of kaolin clay that helped fuel its profitable and productive potteries. In Kongo, ritual experts had long used kaolin as a sacred substance that facilitated communication between the living and the dead. The use of kaolin inserts in Edgefield face vessels likely carries resonant spiritual meanings. Largely on the strength of these connections, anthropologist John Michael Vlach views *minkisi* and face vessels as "end points of a stylistic continuum stretching the breadth of the ocean."[13]

Despite this connection to the Kongo, the uses and meanings of face vessels in the African American community may very well have been multiple and varied. Some may have been mere whimsies, while others were used as receptacles for water or alcoholic spirits. Still others may have served deeper spiritual or religious purposes. One of the most compelling lines of inquiry points to the role face vessels played in burial and funerary rituals. Consistent with practices in West-Central Africa and throughout the plantation Americas, these objects served at least in part as key conduits between the land of the living and the realm of the dead. Face vessels may have therefore been one of the principal means by which enslaved and newly freed Black people in South Carolina managed what Vincent Brown calls "mortuary politics," that broad field of social interactions from which people derived meaning from their rituals and beliefs about death, dying, and the hereafter.[14]

While much attention has been paid to the vessels' outward appearance, new lines of inquiry are peering behind the face in an attempt to discover what lies within. A fascinating example is a face vessel once owned by Mamie Deveaux, an herbalist, healer, and ritual expert who built a loyal and successful following in Savannah, Georgia, during the early twentieth century (fig. 43). The interior of the jug reveals a piece of a matchbook affixed to the wall with a warning that is mundane and yet redolent of meaning: "CLOSE COVER BEFORE STRIKING / KEEP AWAY FROM CHILDREN" (fig. 44). In the Kongolese tradition, *minkisi* that were constructed and invested with ritual medicines remained powerless until they were invoked by ritual experts. This invocation often took the form of hitting, banging, or inserting nails into the objects, the act of striking serving as something of a spark to life.[15] The instructions on the matchbook might therefore be a clever play on words. The inherent power and danger of the vessel are implied in the warning to keep it away from children. Moreover, the jug must be closed before striking, sparking it to life.

CLAY BODY

Pottery did not merely adorn African American burial sites as decoration, but was also itself embodied. The corporeality of pottery is reflected in the language we use to describe it. We refer to the mouth of the pot, to its lips, shoulders, and feet. In this

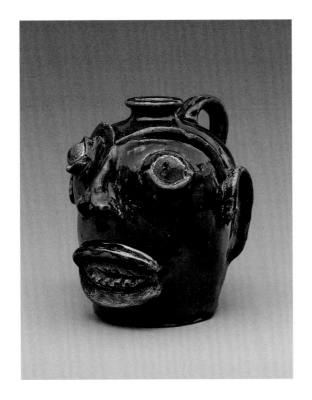

FIG. 43. Unrecorded potter. Face jug, ca. 1850–80 (pl. 43) FIG. 44. Interior of fig. 43

lexical practice, the pot is a (metaphorical) person. The idea of pottery as personified and embodied is elaborated even further when the object is rendered anthropomorphically, as in the face vessels. Here, the metaphorical anatomy of pottery is elevated to the level of a literary double entendre, with the pot bearing both a lip and lips, a mouth and a mouth, etc. With these linguistic and formal connections in mind, longtime scholar and collector John Burrison queries, "Is it any wonder, then, that potters . . . see clay as a sort of mirror, a reflection of their humanity, and exploit its plastic nature to sculpt it into a human likeness?"[16] One might add that neither is it any wonder that potters—who know better than anyone the fickle and capricious nature of their medium—would ascribe to their pots anatomical terms that reflect the fragility of human bodies. Much like the clay body, so too is the human body fleeting and frail. So too is it resilient, hardened by the fiery trials of life. So too can it be broken, cracked, and punctured. In African American funerary ritual, these connections between the human and the clay body are amplified when broken pottery is strewn over the broken bodies of departed loved ones lying just below the burial mound.

In recent years, scholars representing multiple disciplinary traditions have begun to distinguish between *objects* and *things*. One group noted, "to call something a 'thing' rather than an 'object' . . . indicates that it may have inanimate or numinous

qualities."[17] Things arrest our attention, inspiring us to action. Possessing their own qualities of agency, things not only *are* but also *do*. They act in the world, even as they are acted upon. When we bring things into the realm of our holy spaces and high ritual practices—weddings, funerals, and fields of war—they become not only physical repositories but also conduits of our prayers and reverence. Things do not merely symbolize our vows, they effectively consecrate them. The difference between a utilitarian jug and a ritualized face vessel has to do with a question of agency. We act upon the jug, pouring its contents out into our empty mugs, cupped hands, and parched mouths. Conversely, the face vessel acts upon us, pouring its spiritual fullness out into our otherwise mundane world.

On a recent trip to Edgefield, I visited some of the pottery sites that date back to the nineteenth century. Owing to the continuing work of scholars in a range of fields, we are learning more and more about the likely locations of Edgefield's kiln sites as well as their size, scope, and modes of operation.[18] Archaeological surveys, Ground-Penetrating Radar (GPR), and soil analysis promise to enhance our understanding of the vast ceramic production that was the hallmark Edgefield's economy. But in my own walks through the waster piles, I found myself trying to step ever so lightly through the remains of cracked mouths, shoulders, and handles. I felt myself traversing a wasteland, a vast open grave littered with ceramic bones. Just there, the fat, round belly of a jug juts out from underneath. A tiny sherd is all but imperceptible, save for the glimmer of its glaze. Occasionally, I spy a kiln brick, evidence of yet another layer of history sedimented below the surface. I am frustrated that despite my best efforts I am utterly failing to maintain the solemn silence that I deem appropriate when in the presence of the dead. With every step, bits and pieces of ceramic crack, crunching underfoot.

HEAR ME NOW

The title of this essay comes from a lesser-known line of an oft-quoted poem:

> We wear the mask that grins and lies,
> It hides our cheeks and shades our eyes,—
> This debt we pay to human guile;
> With torn and bleeding hearts we smile,
> And mouth with myriad subtleties.
>
> Why should the world be overwise,
> In counting all our tears and sighs?
> Nay, let them only see us, while
> We wear the mask.

We smile, but, O great Christ, our cries
To thee from tortured souls arise.
We sing, but oh the clay is vile
Beneath our feet, and long the mile;
But let the world dream otherwise,
 We wear the mask!
(Paul Laurence Dunbar, "We Wear the Mask," 1895)[19]

Dunbar's melancholy lament has long been taken as a clarion call to *see* Black people behind the mask, to *hear* them through a deafening silence. But the mask is also a protective shield, an outwardly frozen face hiding a wry smirk, a cutting eye, a sharpened set of bared teeth. In the face of overt racism, police brutality, and a multitude of minor humiliations, African Americans have often been made to remain stoic and calm. There are bits and pieces of us that fit nicely there, *behind the mask*. Other parts we carry with us always—like pieces of blue china, like old bottles of rum—before placing them carefully on the burial mound. In these metaphors and rituals of death and dying, I find an opportunity to think through the Black pottery traditions of Old Edgefield. Some of what we find there is meant to be seen. Some of it is hidden from view. I submit this essay as a rumination, a caretaking of so many unmarked graves. *Hear me now.*

As co-curator of *Hear Me Now,* I am somewhat reluctant to admit the complicated feelings that arise in me as I see this material on display for public view. Though Edgefield pottery has become the subject of increased scholarship in recent years, and though some of the material has entered into an increasingly lucrative market of commercial exchange, there is yet so much that we do not know about its production, not to mention the enslaved producers. Edgefield pottery continues to be both alluring and elusive. These objects draw me in even as they push me away. I find myself ever straining to hear what stories they have to tell me, squinting to catch a glint of their hidden meanings. In putting these objects up for view, the genius of enslaved people takes center stage. The pottery-making traditions of Old Edgefield demanded a remarkable degree of strength and dexterity, coupled with the finest attention to deft detail. This work is at turns utilitarian and spiritual. It is visually stunning and poetically captivating. It resonates still in the work of contemporary artists. *But oh the clay is vile.*

A CONVERSATION WITH SIMONE LEIGH

Jason R. Young

Jason R. Young: I've been thinking a lot recently about your professional trajectory. Early in your career, you faced an established art world that largely dismissed sculpture that's made of fired clay. Of course, that has changed dramatically in recent years. What has it meant for you to work through this period of dramatic change?

Simone Leigh: During my first residency as a college student in the 1980s at the Smithsonian, I xeroxed descriptions of how to make various West African pots, knowing full well that they didn't have a place in the craft or art world that existed at the time in the United States. My interest was at odds with the associations of utility, ornamentation, standards of intelligence, and primitivism and modernism that are connected to this material. Clay itself was raced and gendered.

I was studying foundational texts that at the time would have been described as postcolonial—like Edward Said's *Orientalism* (1978), Stephen Jay Gould's *Mismeasure of Man* (1981), and Angela Davis's *Women, Race and Class* (1981)—and starting to reflect on the ways colonial legacies shape perspectives on who and what is valued or disregarded. I wasn't surprised that the art world feared a material, but it did seem odd because it's the only sculptural material that you can manipulate at room temperature. It's incredibly useful for creating a lot of ideas in sculpture.

I took a ceramics class because I wanted to make water pots after reading a book titled *Nigerian Pottery* (1970) by Sylvia Leith-Ross. I just loved the forms and I was really interested in the anonymous labor of women and how all the materials associated with women and femme and Black bodies were valued. In the case of Leith-Ross, her approach was anthropological. My first ceramics professor in college in Indiana, Michael Thiedeman, had apprenticed with Warren MacKenzie, and they were both highly influenced by Japanese ware. They were American studio potters who embraced functional, everyday pottery, but there was a male lineage that hadn't recognized Black women's work with clay as legit.

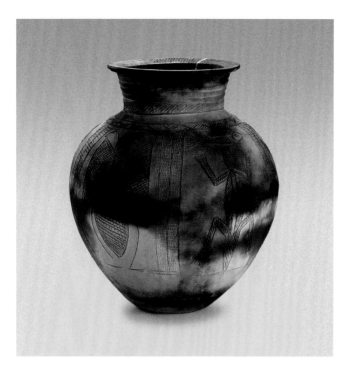

FIG. 45. Ladi Kwali (Nigerian, ca. 1925–1984). Large jar, 1972. Stoneware, H. 15 in. (38 cm). Courtesy of Oxford Ceramics Gallery

JRY: You say you were interested first in making water pots. Were you drawn to the form itself or to the materiality of the clay?

SL: I was drawn to the idea of a handmade readymade and to how these beautiful objects were valued and why. As far as formal concerns, I felt these objects were modernist masterpieces. I was also drawn to the fact that there's clay covering the whole earth that is available to everyone, unlike so many raw materials acquired through violent extraction. The material connects to time from a geological perspective. The process was beautiful to me. I was interested in the feminist implications of a tradition most often restricted to women and that so many who worked in it were anonymous. I think there's no Black woman artist who doesn't have to come to terms with the fact that their foremothers are largely anonymous. The first ceramist that I was aware of was Ladi Kwali from Nigeria (fig. 45). And the first person I saw working in a way I wanted to work was Magdalene Odundo (fig. 46). When I came to New York and was developing skills working with clay, I realized that people did not understand what I was trying to do as a conceptual enterprise. So I abandoned the idea of being an artist who worked in the field of ceramics and just became this kind of weirdo sculptor.

JRY: That was a very brave decision to make. Another artist might have decided to move into a different medium, but you stuck with it.

SL: I was really interested in coming to New York and being in the art world as an intellectual activity. We already had Duchamp, using a ceramic object, make it clear that anything could be art. But when I came to New York, I was told that this material was not something I could use seriously in my conceptual work. So that made me dig in my heels.

JRY: When did you first encounter the Black pottery tradition of Edgefield?

SL: I taught young children for many years, and I developed a curriculum around face jugs. But I didn't become aware of David Drake until much later. The first time I saw a David Drake pot was at the home of collector AC Hudgins, who had several

FIG. 46. Magdalene Odundo (British, born Kenya, 1950). *Untitled*, 1997. Red clay, H. 19 ¾ in. (50.2 cm). The Metropolitan Museum of Art, New York, Purchase, The Katcher Family Foundation Inc. Gift, and Gift of Susan Dwight Bliss, by exchange, 1998 (1998.328)

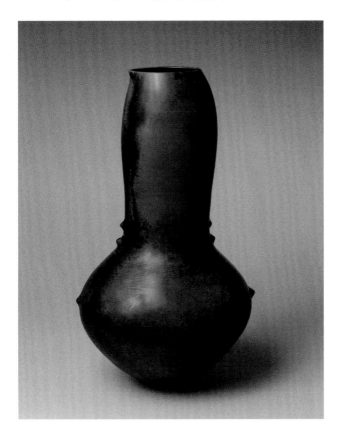

large Dave pots and several smaller face jugs. I immediately felt the walls of the pots with one hand inside and one hand outside to understand how the piece had been made. AC thought I was crazy, but I was just trying to commune with my ancestor [*laughs*]. I think the act of signing his work really launched Dave into history. I'm excited by Black artists who did the work no matter what and claimed space for authorship. Similarly, a wonderful discovery for me was the work of sculptor Nancy Elizabeth Prophet. She kept a diary where you can see that she's working so seriously as if she had a museum show, but she had no opportunities at the time. She was just driven and had a vision. Now museums have collected all her work.

JRY: Many of the people who write about David Drake's work refer to its scale and scope. The size of the pots is often regarded as proof of his technical skills and artistic expertise. But it is also regarded as evidence of his physical strength in very masculinist terms. Scale and scope are also a part of your work. What does it mean for you to work on such grand scales?

SL: Working in a larger scale changed my career. When I got the opportunity to do a piece for the High Line in 2019, I went to a foundry in Philadelphia, and there I was able to make a sixteen-foot model for *Brick House* in clay, the size of the final cast bronze (fig. 47). Often work at that scale is fabricated by blowing up a small sculpture through digital 3-D modeling. But when you blow up a tabletop object to two or three stories, the perspective is all wrong. I realized I was happy at that scale. The physicality of being overwhelmed by the sculpture was fun for me. The larger proportions made my hands into fine tools. And when the work isn't going through the kiln, I don't have to worry about so many things—I can build with armatures and use any kind of material.

JRY: We know that Black women were working in the Edgefield potteries. But standard historical narratives typically regard Edgefield pottery as the product of the intellectual power of White landowners who understood something that other people didn't.

SL: Right [*laughs*].

JRY: Or people emphasize the brute force and physical strength of Black men. David Drake is a prime example. But your work disrupts that standard narrative. As an artist, you work at great scale, which undercuts the idea of strength as something that belongs solely to men. And you celebrate Black womanhood in your work. How have the intellectual traditions of Black feminism affected your work and your creative process?

SL: Black feminist theory informs every aspect of my life. When I was in college, I was studying philosophy and reading a lot of Audre Lorde, whose epistemologies were my bridge to other important Black feminist authors, including Michele Wallace, who had written *Black Macho and the Myth of the Superwoman* (1978), bell hooks, and all the writers in the anthology of radical women of color *This Bridge Called My Back* (1981). Several texts by Black women had already been canonized, such as *A Question of Power* (1973) by Bessie Head and the devastating *Joys of Motherhood* (1979) by Buchi Emecheta. Then there were the earlier works. I knew about Phillis Wheatley. You do not grow up in Chicago without knowing about Ida B. Wells and reciting Gwendolyn Brooks poems. There was never any scarcity of examples of Black women as authors, intellects, and leaders in a variety of political struggles. I experienced profound joy reading Jamaica Kincaid, especially her book *The Autobiography of My Mother* (1996), and Alice Walker's *In Search of Our Mothers' Gardens* (1983). These books felt tailor-made for a young woman trying to forge her own identity. You're following those voices along and then comes a turning point when you say, "I'm going to take these tools and forge my own path."

JRY: I see your work as being very historical and archival. Sometimes your work is explicitly historical, as in *Loophole of Retreat* (2018) or the *Free People's Medical Clinic* (2014). At other times, you collapse different timelines and histories into highly creolized forms where the work operates both as an object and as a text. What is the relationship between art and history in your work?

SL: In college a friend gave me *Tell My Horse* (1938), Zora Neale Hurston's travelogue about her travels throughout the Caribbean, which was very eye-opening. A lot of the rituals that Hurston describes aren't things that I would be privy to because my parents weren't interested in any of those things. When I read *Tell My Horse*, I became aware of another history that is related to me. When I visited Haiti, I saw the presence of voodoo everywhere. Katherine Dunham, the pioneering Black choreographer from Chicago, created an institution of study and practice that incorporated African and Caribbean movement into Western modern dance. I went to see her estate, which had been destroyed during the 2010 earthquake, but they had already rebuilt the two libraries she had established there as well as the medicinal garden. The estate was previously a home of Napoleon's daughter, and Dunham left the entire property available to the Haitian public. Women like Zora Neale Hurston and Katherine Dunham are important not only for their art and intellectual work but also because they showed us a way forward with ethical knowledge production and reciprocity.

FIG. 47. Simone Leigh (born 1967). *Brick House*, 2019. Bronze, H. 16 ft. 4 in. (497.8 cm).
A High Line Plinth commission, on view June 2019 – May 2021, New York

JRY: Can you tell me more about what I have heard you describe as your "classic African American childhood"?

SL: I grew up in a White-flight neighborhood. The abandoned houses supported a growing Black middle class on the South Side of Chicago. I grew up in an entirely Black environment, I mean all the doctors, lawyers, bankers, and teachers. And I wasn't aware of how important that was and how good it was for my self-esteem. It wasn't until I traveled that I saw Black people existing as minorities and marked in this way as if Black skin indicated poverty. I didn't grow up with that at all in Chicago.

JRY: And yet the African diaspora is a big part of your work. For example, you invoke cowrie shells in the work you contributed to this show (pl. 64), calling to mind a global Black aesthetic tradition.

SL: I feel there wasn't a strong postcolonial discourse in art here, even among Black artists. And that moved me to go to Haiti, Namibia, Nigeria, London. I felt affinities with artists I met in South Africa, such as Nicolas Hlobo, a queer artist who has used male initiation traditions in his work, and Dineo Seshee Bopape. I wanted to have what my friend Madeleine Hunt-Ehrlich calls an entirely Black conversation about art. It didn't exist here. At the time we were going through the horrid, dreary, if-you want-to-have-a-career-call-yourself-post-Black moment. This idea that we had to scrub all signs of ethnicity off the work.

JRY: I'd like to have you weigh in on a debate related to this question. There's a running conversation about how best to refer to the Black potters of Edgefield. People will refer to them variously as "artists," "artisans," "makers," or "craftspeople."

SL: I have seen this happen in the context of David Drake. I have seen people struggle with the idea of calling him a poet. I've been experiencing this even in my work recently. People adopt a sense of manifest destiny, of discovering things that were already there. A lot of collectors and even intellectuals want to feel like they discovered Edgefield, and that they're bringing forward certain information and knowledge no one ever had before. This is also market driven. In American culture, there's always a group of people who believe they are the real authors, not the people who make things. When history is written the people who make things are written out of the archive. For example, you mentioned Black women at Edgefield, who rarely appear in historical texts. It's one of the reasons why my practice of critical fabulation, a device used by Saidiya Hartman to engage with memory beyond what is available in the archive or historical documents, becomes important.

JRY: Simone, it's been fantastic talking with you today.

SL: Thank you.

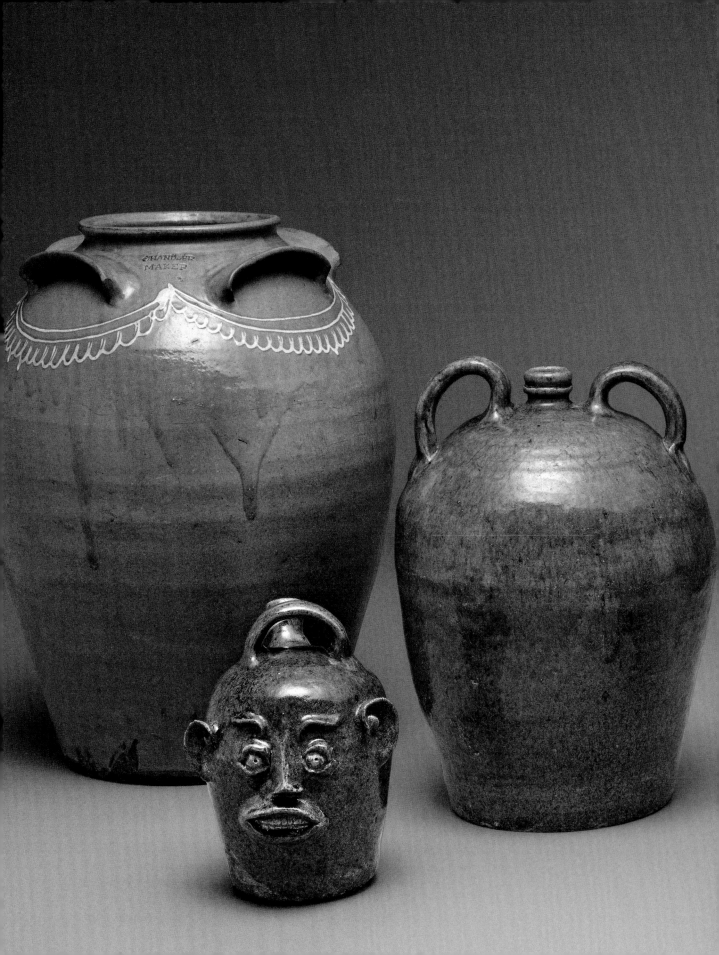

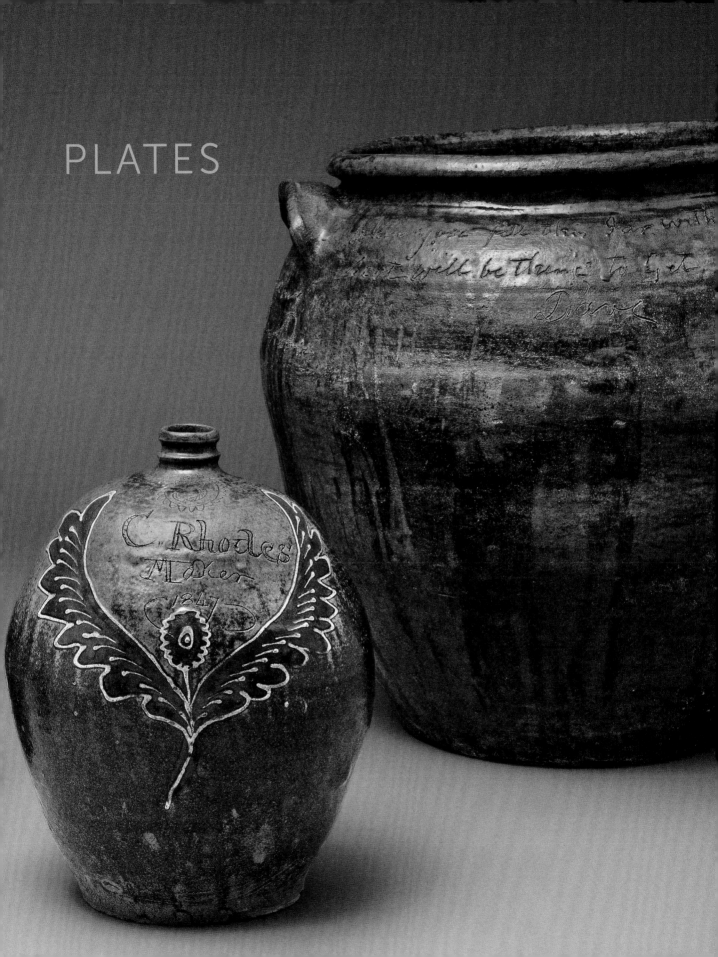

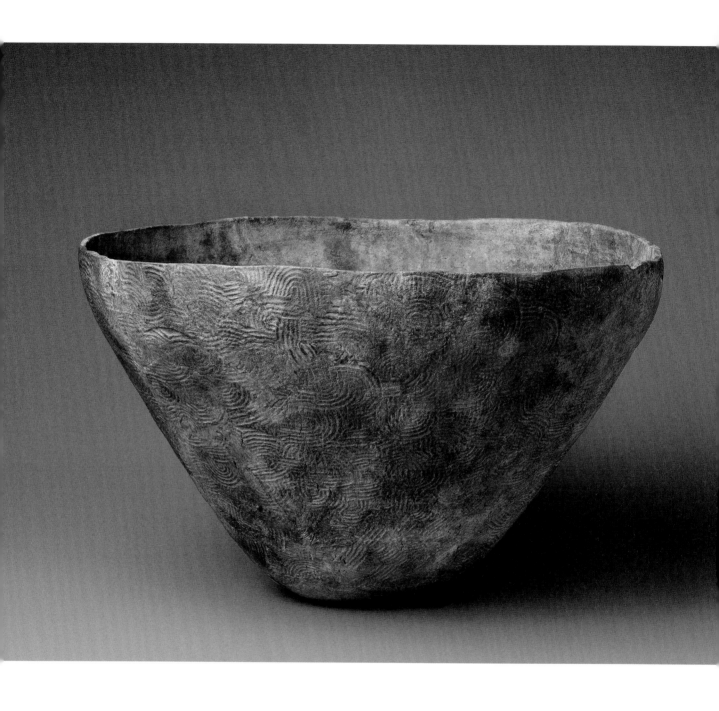

Pl. 1. Unrecorded potter, attributed to Woodland culture. Bowl, ca. 1500.
H. 15¼ in. (38.7 cm). South Carolina State Museum, Columbia

Pl. 2. Earl Robbins (Catawba Indian Nation), York County, South Carolina. Cupid jug, 2000.
H. 11 in. (27.9 cm). South Carolina State Museum, Columbia

Pl. 3. Abner Landrum, Pottersville Stoneware Manufactory. Bottle, 1820. H. 8 in. (20.3 cm). William C. and Susan S. Mariner Collection at the Museum of Early Southern Decorative Arts at Old Salem, Winston-Salem, North Carolina

Pl. 4. Unrecorded potter, Pottersville Stoneware Manufactory. Storage jar, 1821. H. 11 in. (27.9 cm). Collection of Joseph P. Gromacki, Chicago

Pl. 5. Unrecorded potter, possibly Drake & Rhodes Factory; Drake, Rhodes & Company; or Ramey, Rhodes & Company. Jug, 1836. H. 11 in. (27.9 cm). Beamer Collection, Greenville, South Carolina

Pl. 6. Unrecorded potter, probably Thomas M. Chandler Jr., Phoenix Stone Ware Factory.
Watercooler, ca. 1840. H. 31¼ in. (79.4 cm). High Museum of Art, Atlanta

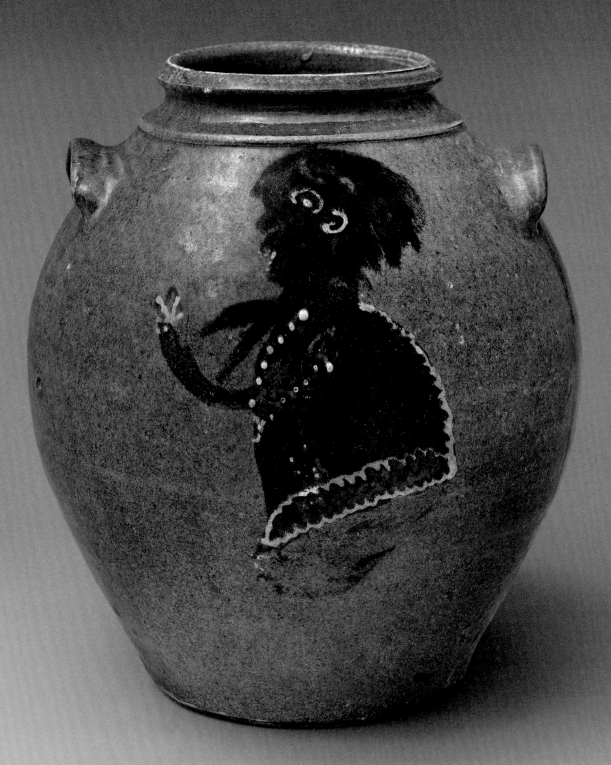

Pl. 7. Unrecorded potter, possibly Phoenix Stone Ware Factory or Collin Rhodes Factory. Storage jar, ca. 1840–53. H. 14 in. (35.6 cm). Mr. and Mrs. John LaFoy, Greenville, South Carolina

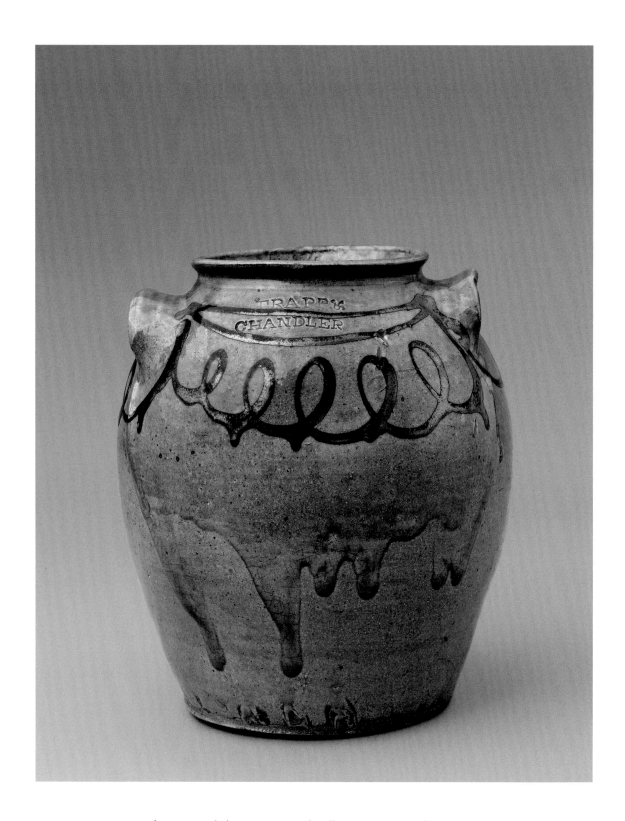

Pl. 8. Unrecorded potter, Trapp & Chandler Pottery. Storage jar, ca. 1845.
H. 11½ in. (29.2 cm). Collection of C. Philip and Corbett Toussaint

Pl. 9. Unrecorded potter, attributed to Trapp & Chandler Pottery. Churn, ca. 1845.
H. 16¾ in. (42.5 cm). Dr. Fred E. Holcombe Family Collection, Cary, North Carolina

Pl. 10. Unrecorded potter, Collin Rhodes Factory. Jug, 1847.
H. 15¾ in. (40 cm). Collection of Carl and Marian Mullis, Atlanta

Pl. 11. Unrecorded potter, Collin Rhodes Factory. Storage jar, ca. 1846 – 53.

H. 13 in. (33 cm). Collection of Larry and Joan Carlson

Pl. 12. Unrecorded potter, Collin Rhodes Factory. Jug, ca. 1846 – 53.
H. 15¼ in. (38.7 cm). Mr. and Mrs. John LaFoy, Greenville, South Carolina

Pl. 13. Unrecorded potter, attributed to Collin Rhodes Factory. Jug, ca. 1850.
H. 7¼ in. (18.4 cm). David and Jon Ward, Greenville, South Carolina

Pl. 14. Unrecorded potter, Collin Rhodes Factory. Jug, ca. 1846–53.
H. 13¼ in. (33.7 cm). Colonial Williamsburg Foundation, Virginia

Pl. 15. Unrecorded potter, Collin Rhodes Factory. Pitcher, ca. 1846 – 53.
H. 10 ½ in. (26.7 cm). Private collection

Pl. 16. Unrecorded potter, probably Thomas M. Chandler Jr. Pitcher, ca. 1838 – 52.
H. 10 in. (25.4 cm). David and Jon Ward, Greenville, South Carolina

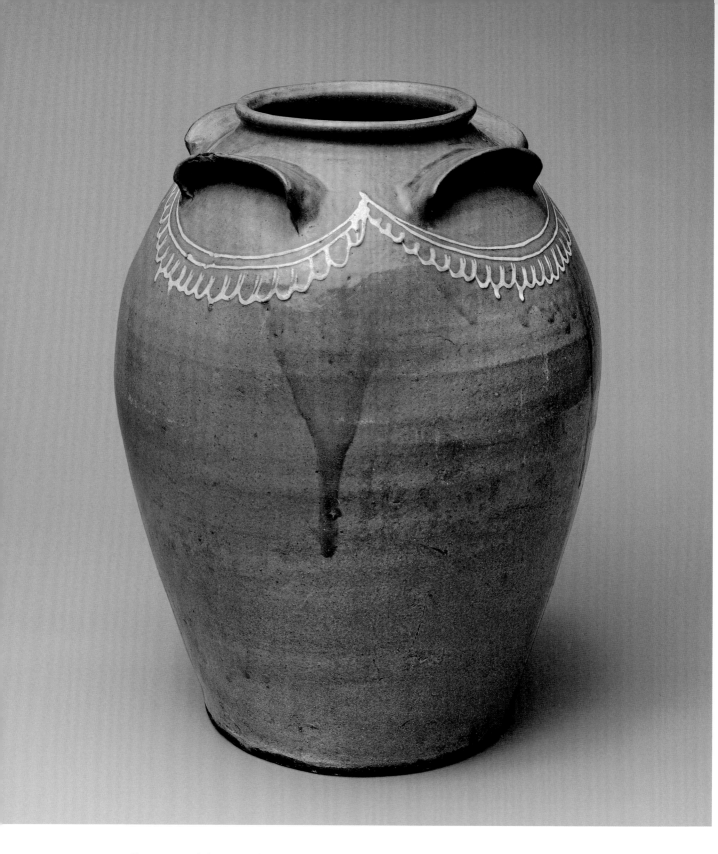

Pl. 17. Unrecorded potter, probably Thomas M. Chandler Jr., Thomas M. Chandler Pottery. Storage jar, ca. 1850.

H. 21½ in. (54.6 cm). The Metropolitan Museum of Art, New York

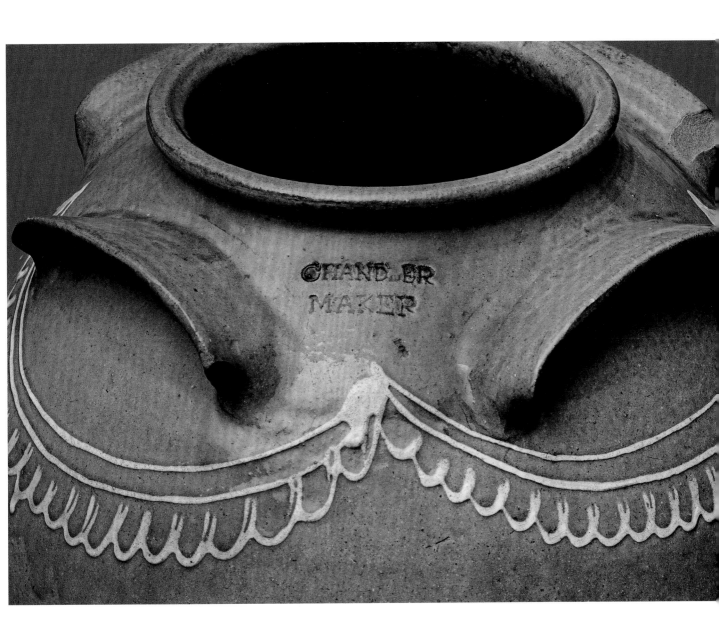

Pl. 18. Unrecorded potter, Stony Bluff Manufactory. Jug, ca. 1850.
H. 14 in. (35.6 cm). Mr. and Mrs. John LaFoy, Greenville, South Carolina

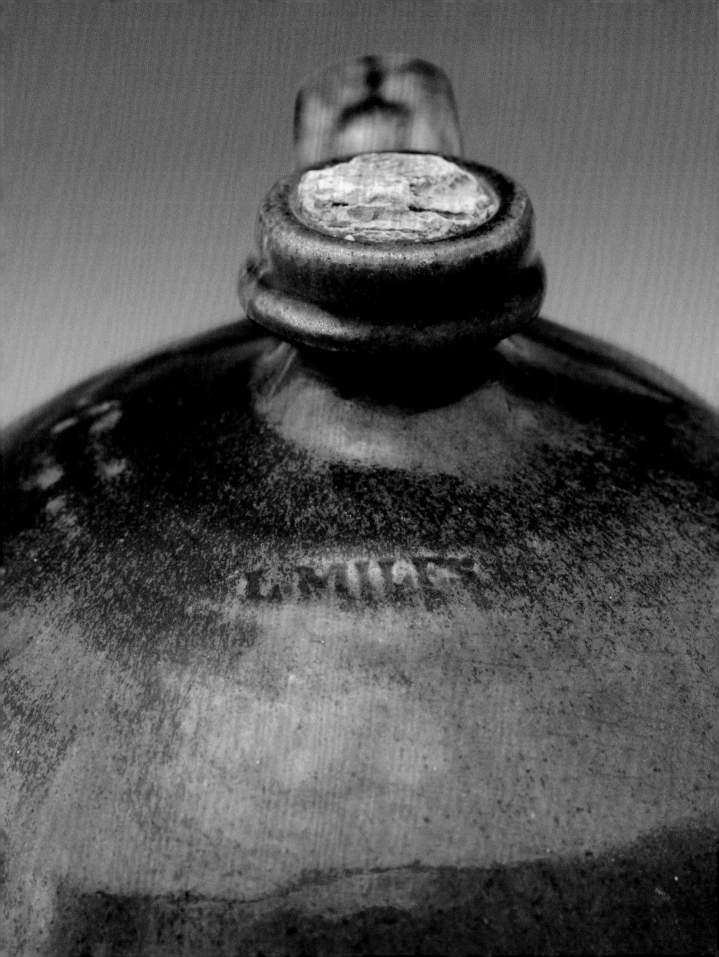

Pl. 19. Benjamin Franklin Landrum, Benjamin Franklin Landrum Pottery. Jug, ca. 1850–70. H. 17 in. (43.2 cm). Collection of James P. and Susan C. Witkowski, Camden, South Carolina

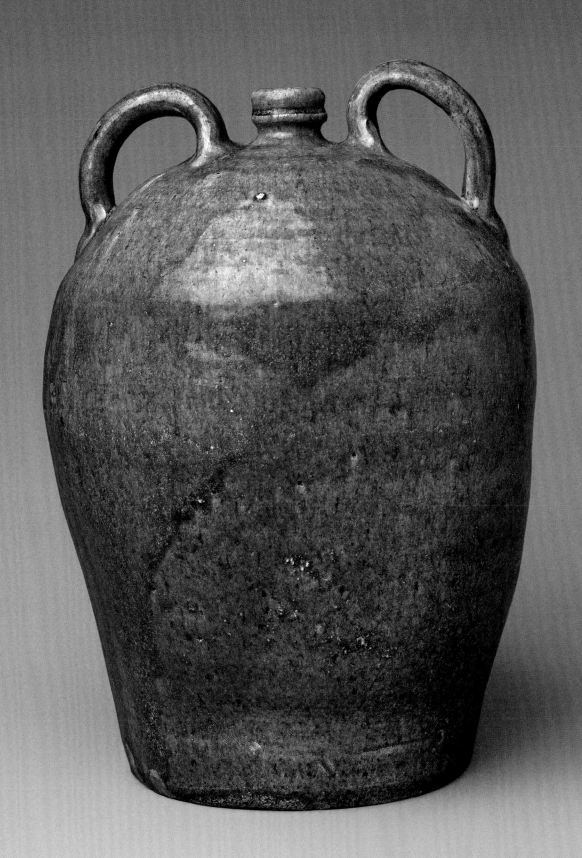

Pl. 20. Unrecorded potter, possibly Rhodes, Ramey & Gibbs; N. Ramey & Company; J. W. Gibbs & Company; or J. Gibbs & Company. Jug, ca. 1840s, reconstructed 2012. H. 13 in. (33 cm).

Department of Anthropology, University of Illinois, Urbana-Champaign

Pl. 21. Possibly Dave (later recorded as David Drake), Stony Bluff Manufactory. Fragment, ca. 1848–67.
Diam. 12 in. (30.5 cm). Collection of C. Philip and Corbett Toussaint

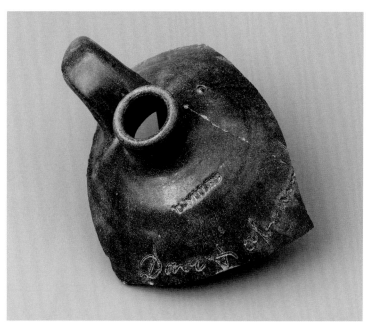

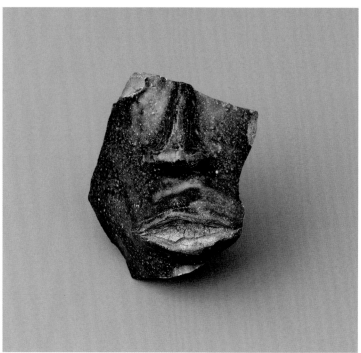

Pl. 22. Dave (later recorded as David Drake) and Abram, Stony Bluff Manufactory. Fragment, ca. 1848–67.
7¼ × 6 in. (18.4 × 15.2 cm). Collection of C. Philip and Corbett Toussaint

Pl. 23. Unrecorded potter, Stony Bluff Manufactory. Fragment, ca. 1848–67.
H. 5 in. (12.7 cm). Collection of C. Philip and Corbett Toussaint

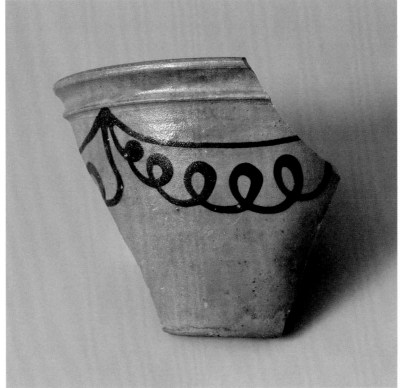

Pl. 24. Dave (later recorded as David Drake), Stony Bluff Manufactory. Fragment, 1866.
3 × 6½ in. (7.6 × 16.5 cm). Collection of C. Philip and Corbett Toussaint

Pl. 25. Trapp & Chandler Pottery or Thomas M. Chandler Pottery. Fragment, ca. 1843–52.
H. 6½ in. (16.5 cm). McKissick Museum, University of South Carolina, Columbia

Pl. 26. Dave (later recorded as David Drake), Drake & Rhodes Factory. Storage jar, 1834.
H. 19 ¼ in. (48.9 cm). Private collection

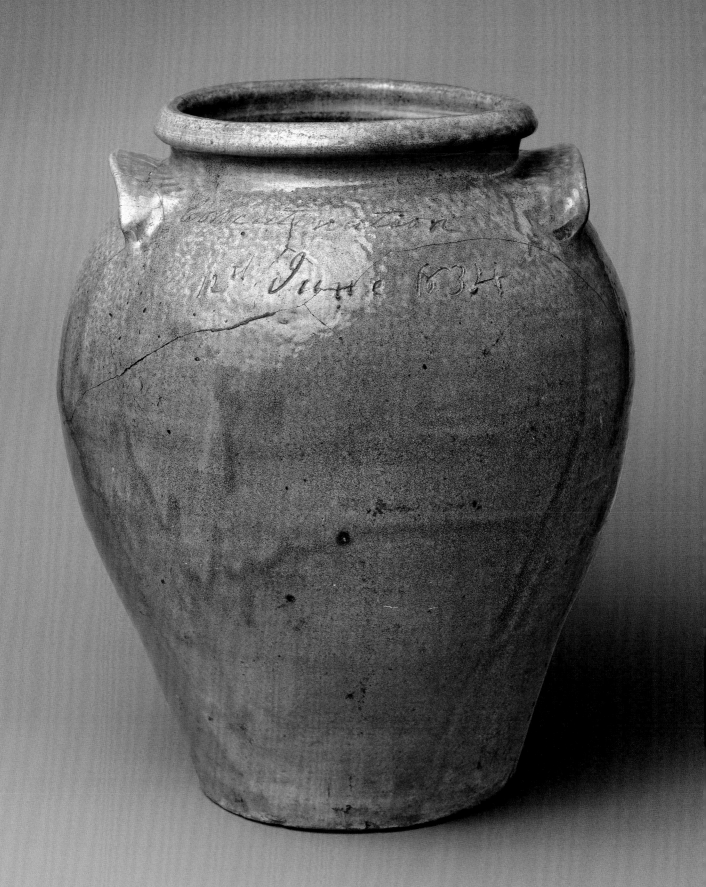

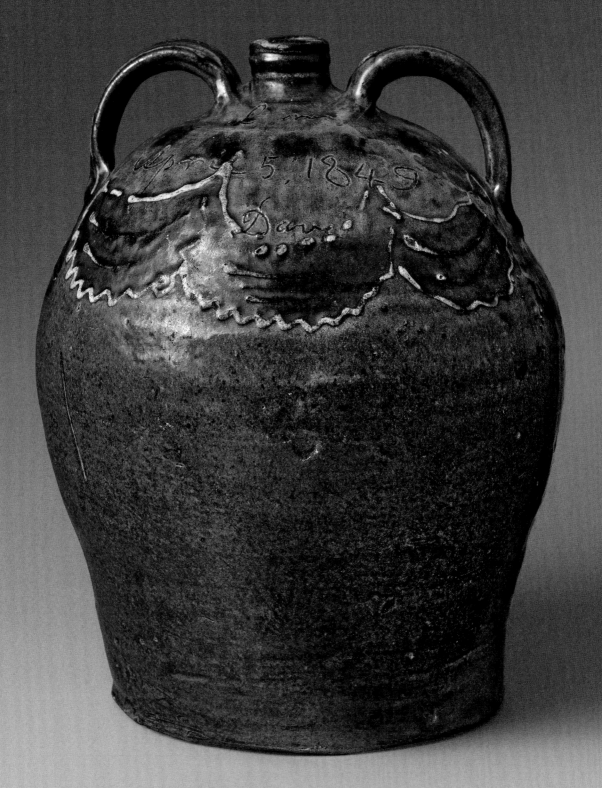

Pl. 27. Dave (later recorded as David Drake), Stony Bluff Manufactory. Jug, 1849.
H. 15 in. (38.1 cm). Beamer Collection, Greenville, South Carolina

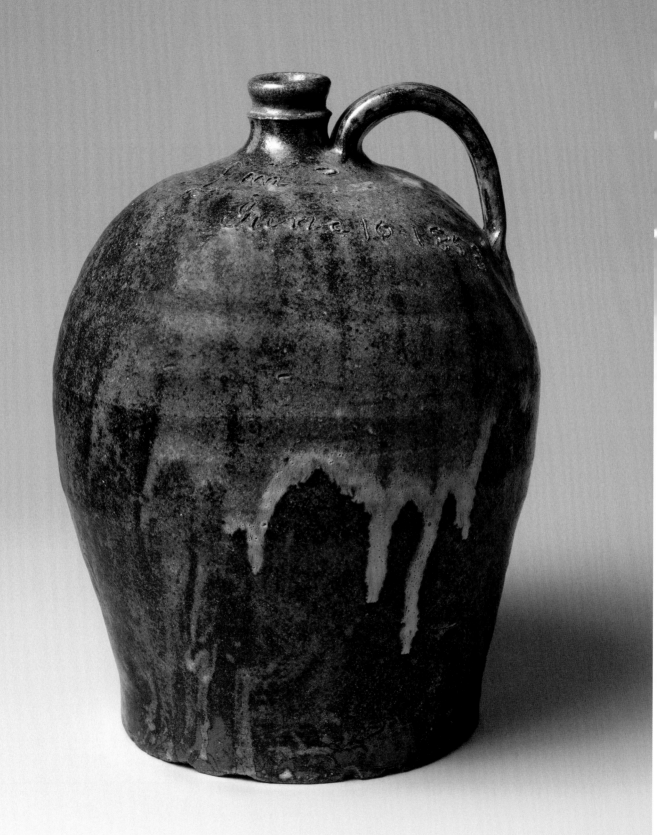

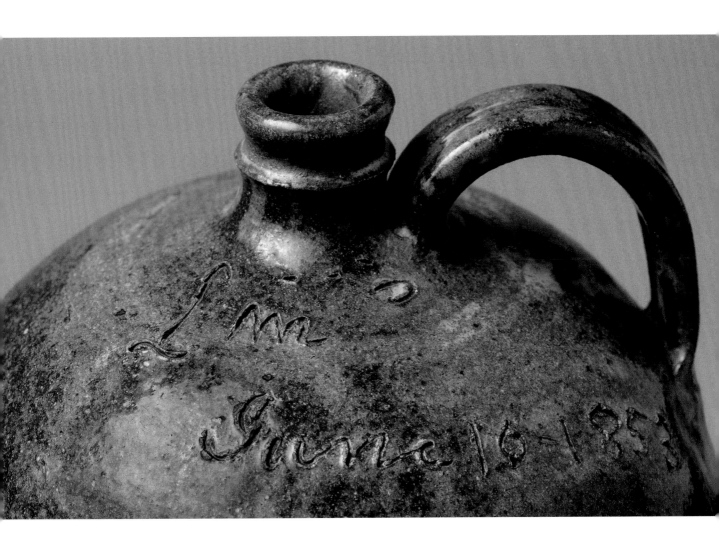

Pl. 28. Dave (later recorded as David Drake), Stony Bluff Manufactory. Jug, 1853.
H. 14 ¾ in. (37.5 cm). Collection of Glenn Ligon

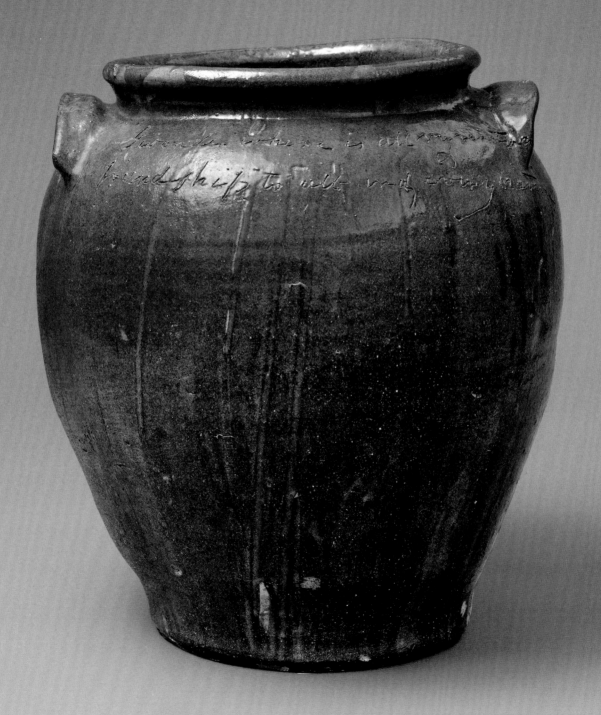

Pl. 29. Dave (later recorded as David Drake), Stony Bluff Manufactory. Storage jar, 1857. H. 19 in. (48.3 cm). Greenville County Museum of Art, Greenville, South Carolina

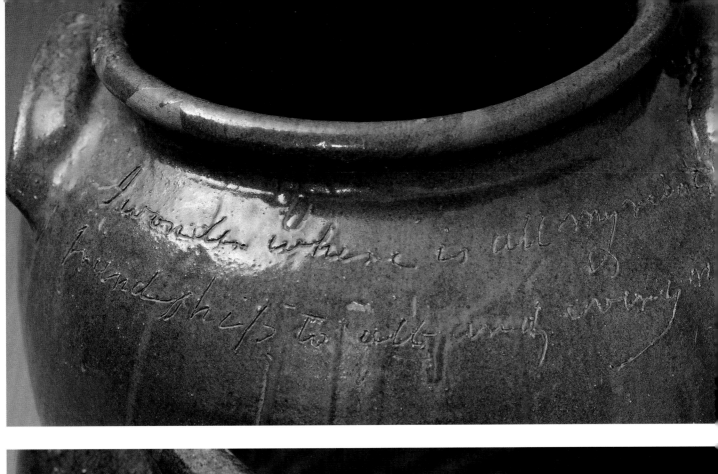

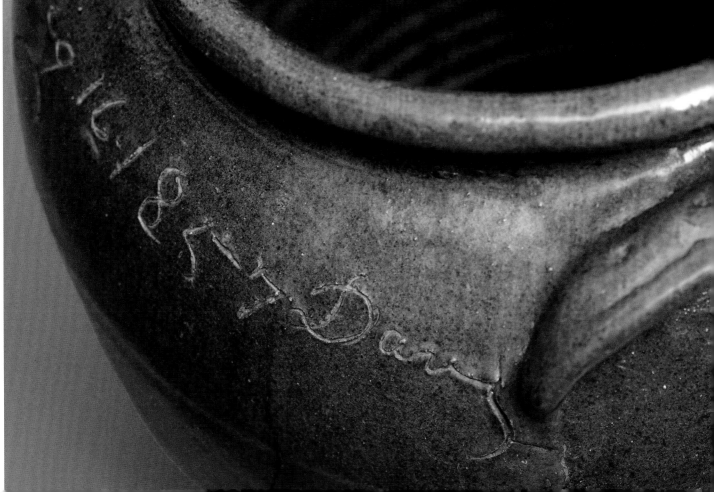

Pl. 30. Dave (later recorded as David Drake), Stony Bluff Manufactory. Storage jar, 1857. H. 19 in. (48.3 cm). Museum of Fine Arts, Boston

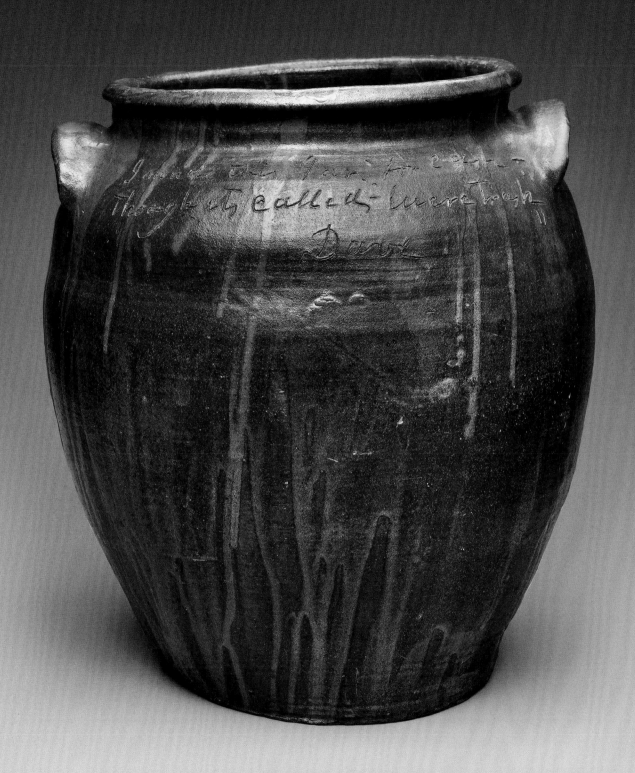

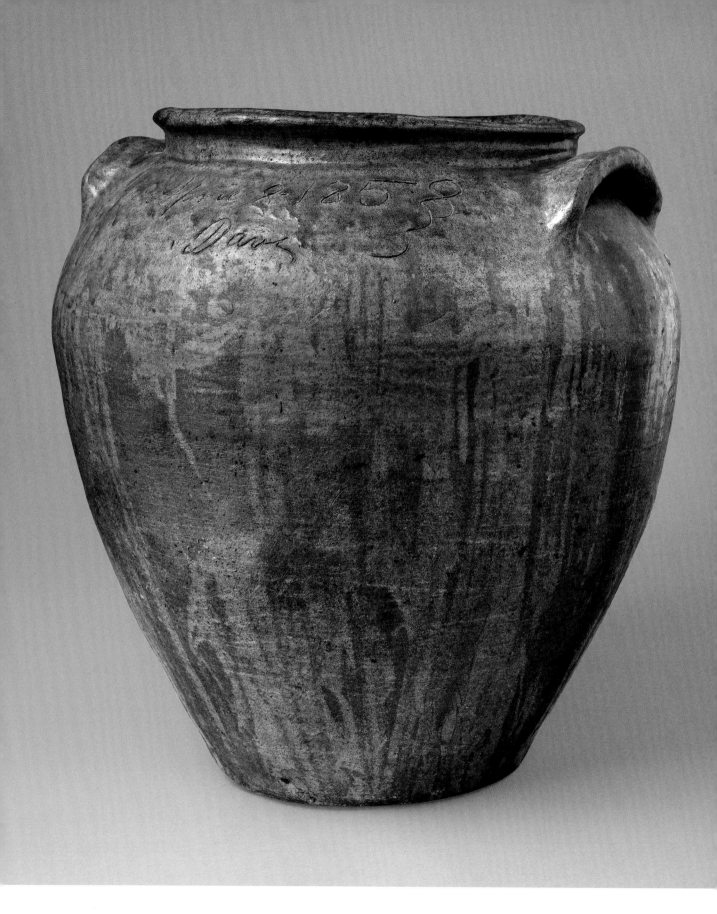

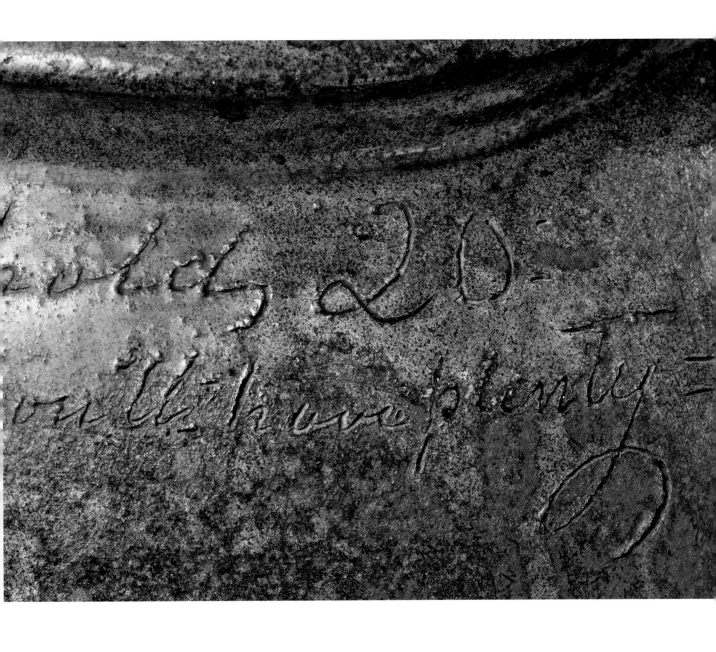

Pl. 31. Dave (later recorded as David Drake), Stony Bluff Manufactory. Storage jar, 1858.

H. 24 in. (61 cm). Hudgins Family Collection, New York

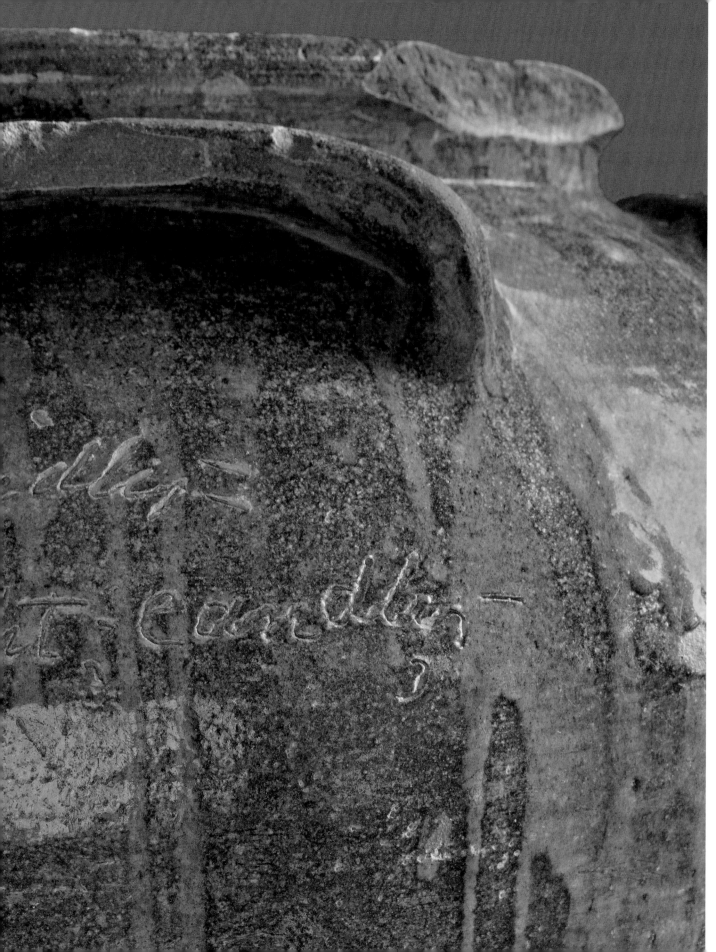

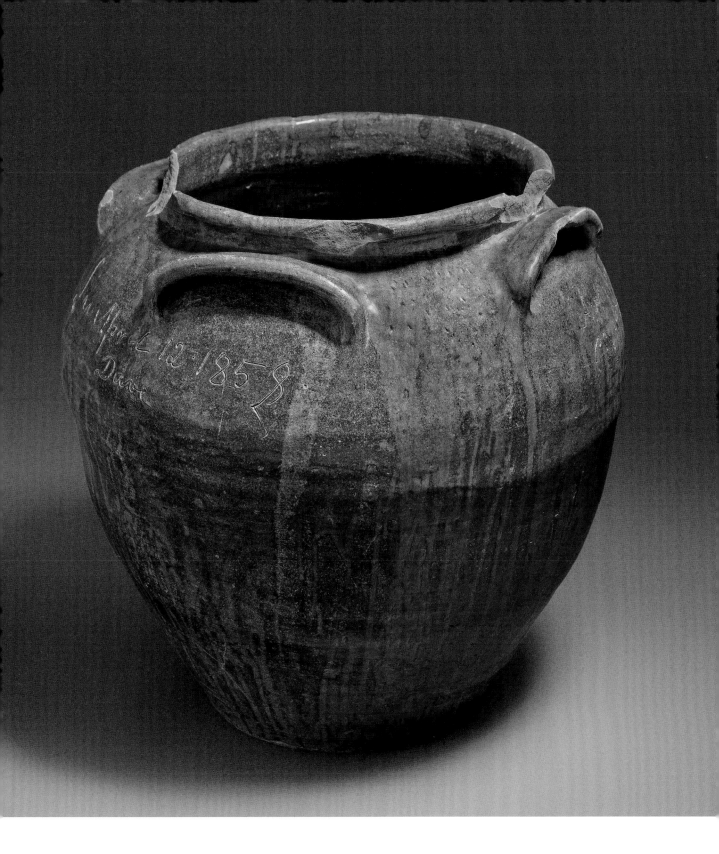

Pl. 32. Dave (later recorded as David Drake), Stony Bluff Manufactory. Storage jar, 1858.
H. 24 ½ in. (62.2 cm). Crystal Bridges Museum of American Art, Bentonville, Arkansas

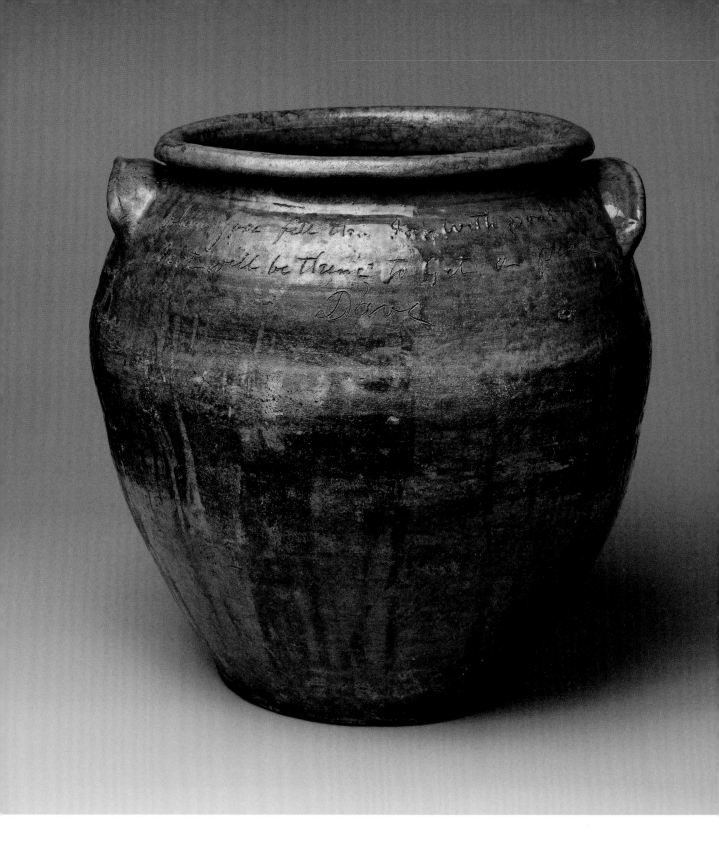

Pl. 33. Dave (later recorded as David Drake), Stony Bluff Manufactory. Storage jar, 1858.
H. 22 ⅝ in. (57.5 cm). The Metropolitan Museum of Art, New York

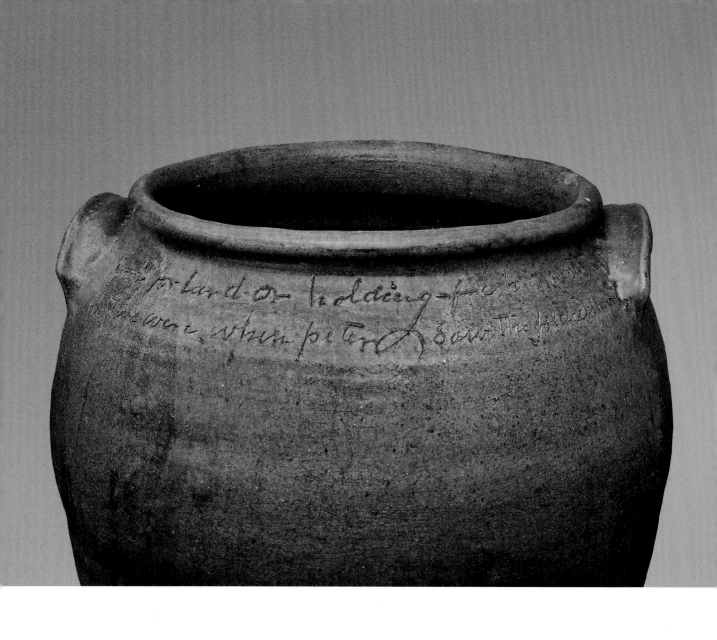

Pl. 34. Dave (later recorded as David Drake), Stony Bluff Manufactory. Storage jar, 1859.
H. 26½ in. (67.3 cm). Philadelphia Museum of Art

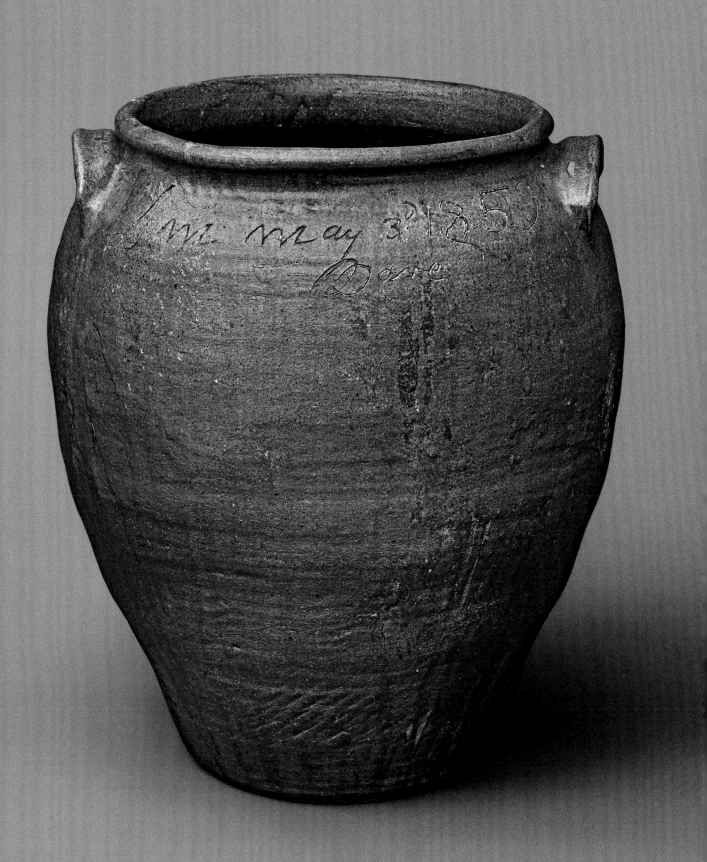

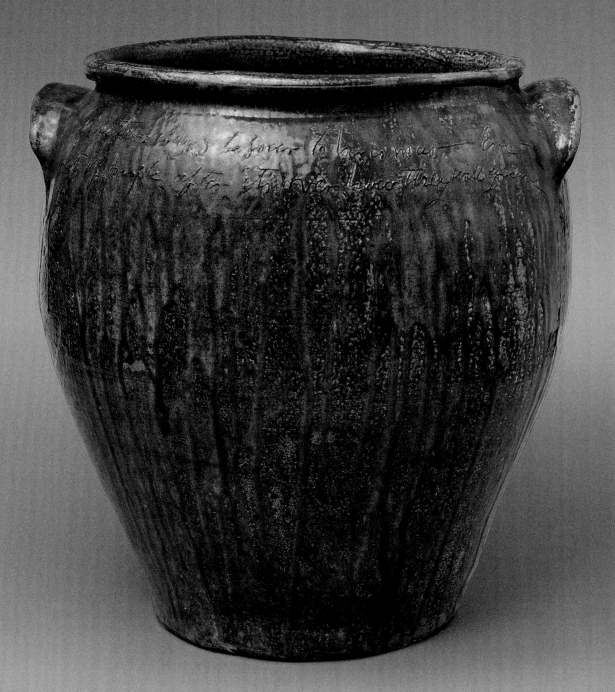

Pl. 35. Dave (later recorded as David Drake), Stony Bluff Manufactory. Storage jar, 1858.
H. 21 in. (53.3 cm). Collection of C. Philip and Corbett Toussaint

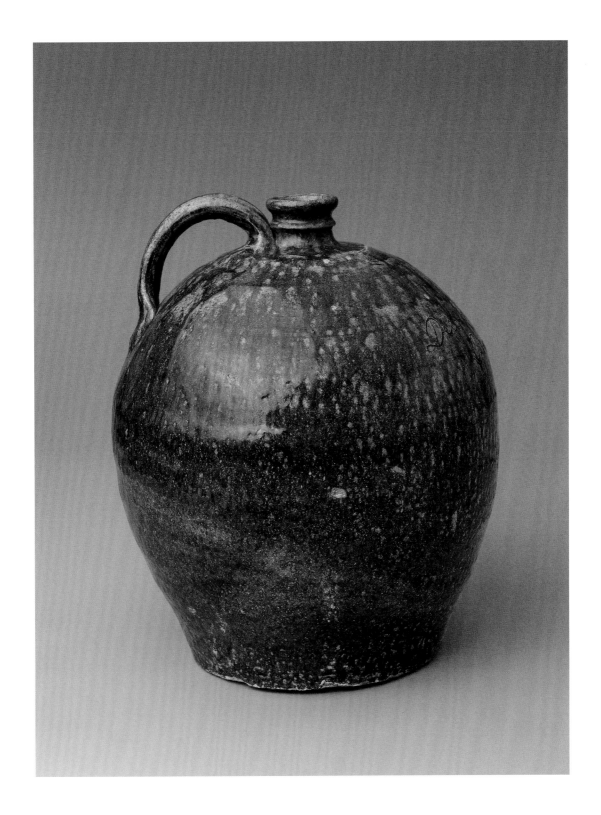

Pl. 36. Dave (later recorded as David Drake), Stony Bluff Manufactory. Jug, 1858.
H. 13 in. (33 cm). Collection of C. Philip and Corbett Toussaint

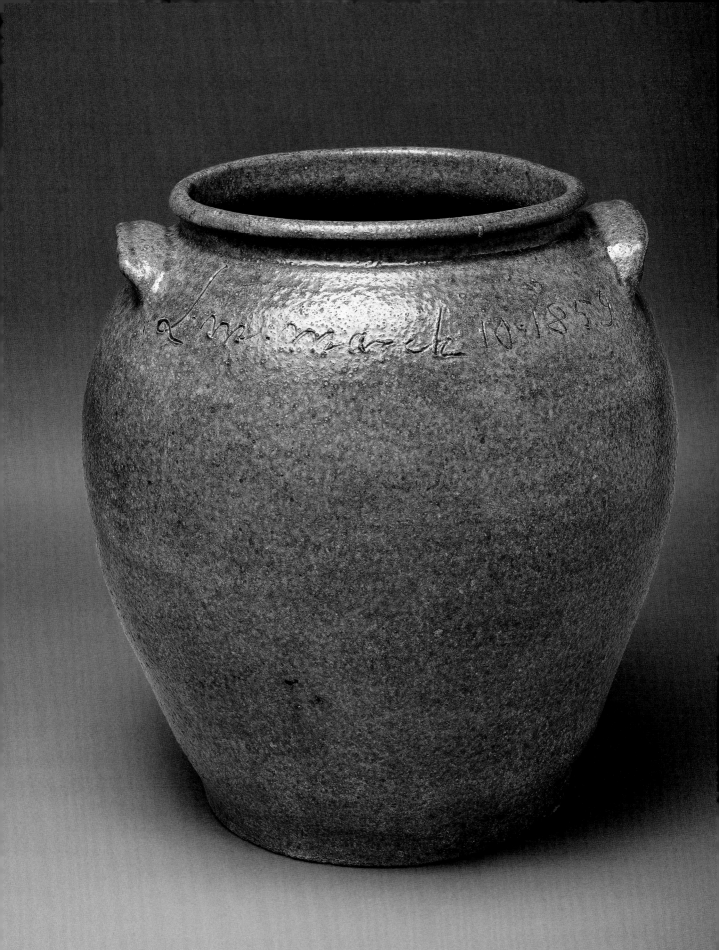

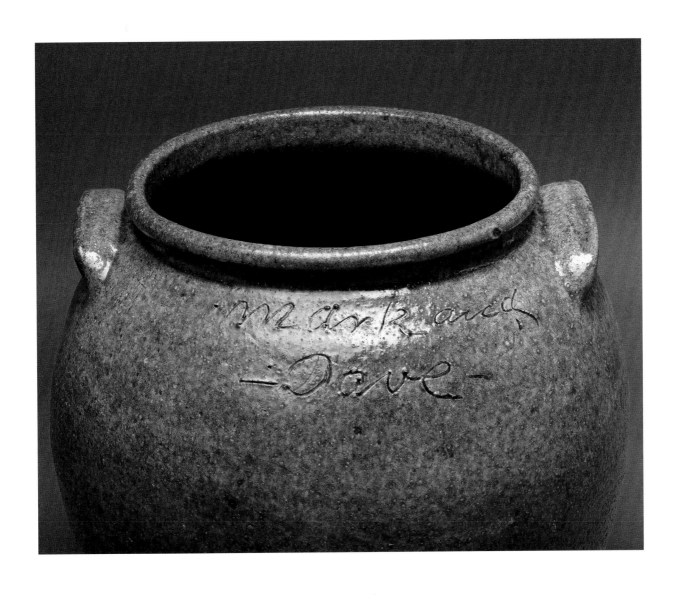

Pl. 37. Dave (later recorded as David Drake) and Mark Jones, Stony Bluff Manufactory. Storage jar, 1859. H. 15 in. (38.1 cm). National Museum of American History, Smithsonian Institution, Washington, D.C.

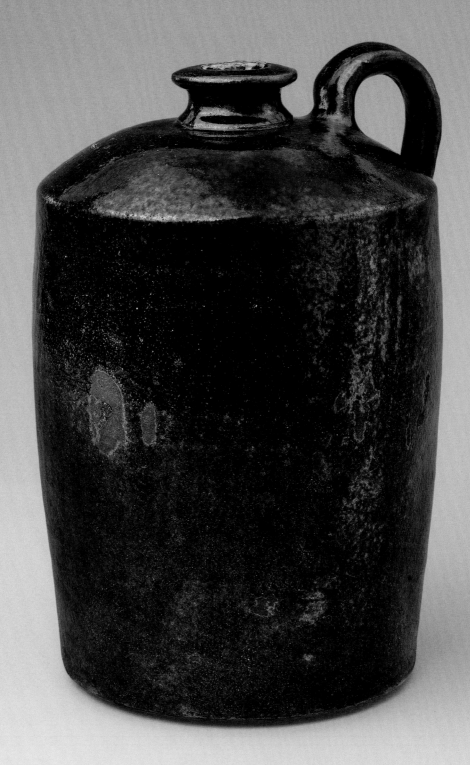

Pl. 38. Unrecorded potter, attributed to Miles Mill Pottery. Jug, ca. 1867–85. H. 10 in. (25.4 cm). Collection of C. Philip and Corbett Toussaint

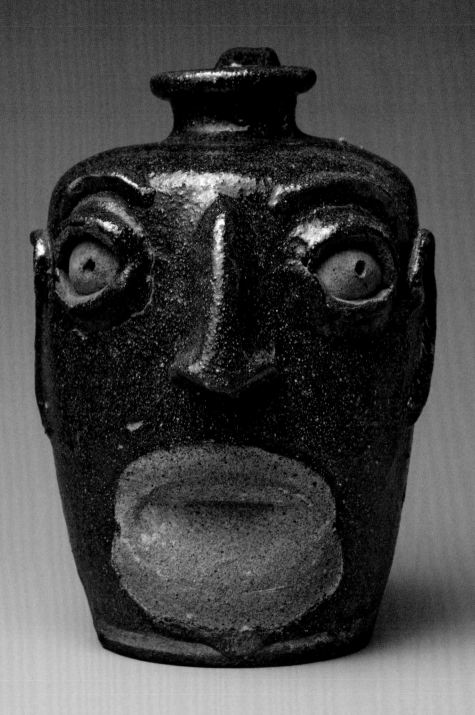

Pl. 39. Unrecorded potter, attributed to Miles Mill Pottery. Face jug, ca. 1867–85.
H. 7 in. (17.8 cm). The Metropolitan Museum of Art, New York

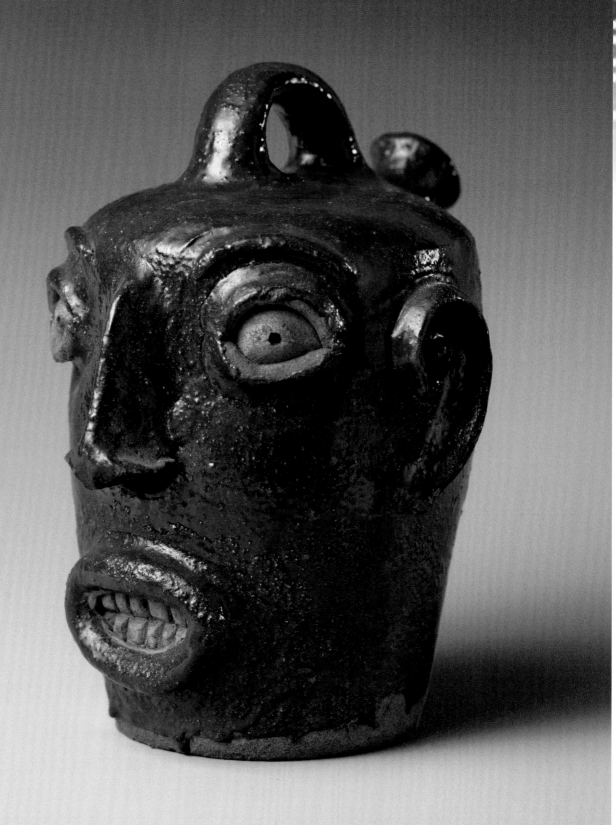

Pl. 40. Unrecorded potter, attributed to Miles Mill Pottery. Face jug, ca. 1867–85.
H. 8 in. (20.3 cm). Hudgins Family Collection, New York

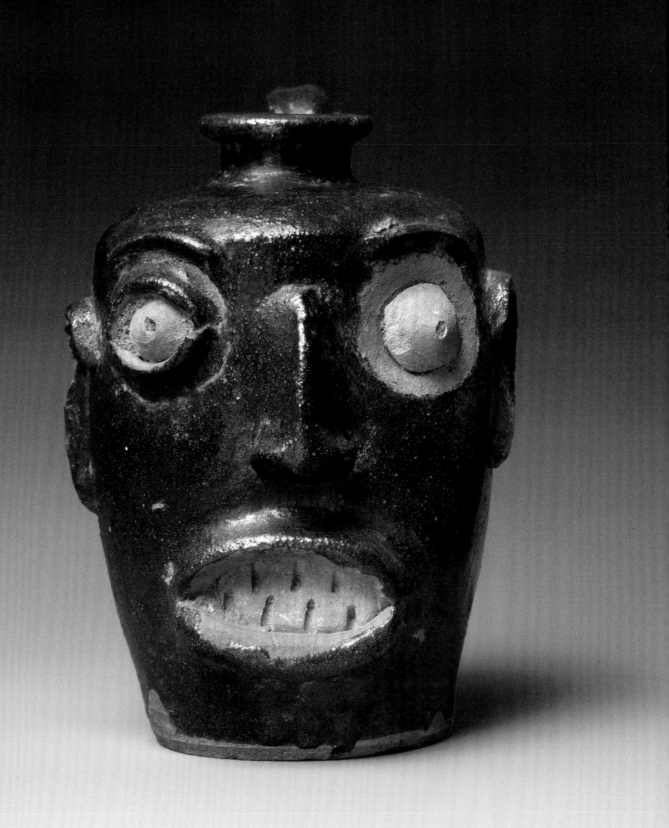

Pl. 41. Unrecorded potter, attributed to Miles Mill Pottery. Face jug, ca. 1867–85.
H. 7 in. (17.8 cm). April L. Hynes, Washington Crossing, Pennsylvania

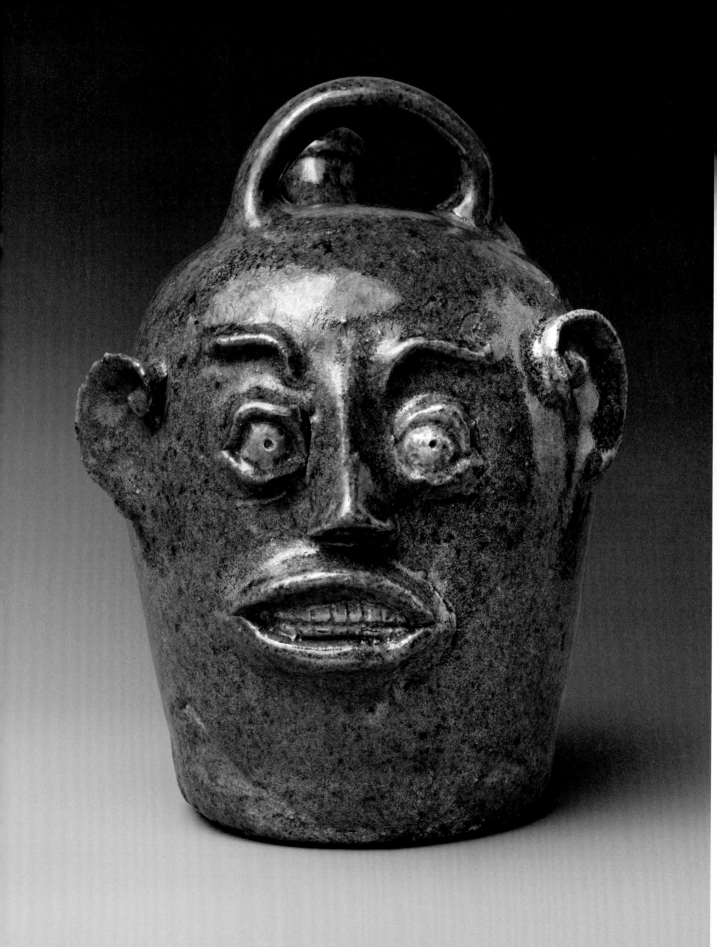

Pl. 42. Unrecorded potter. Face jug, ca. 1850 – 80.
H. 10 ¼ in. (26 cm). The Metropolitan Museum of Art, New York

Pl. 43. Unrecorded potter. Face jug, ca. 1850 – 80.
H. 5⅞ in. (14.9 cm). The Metropolitan Museum of Art, New York

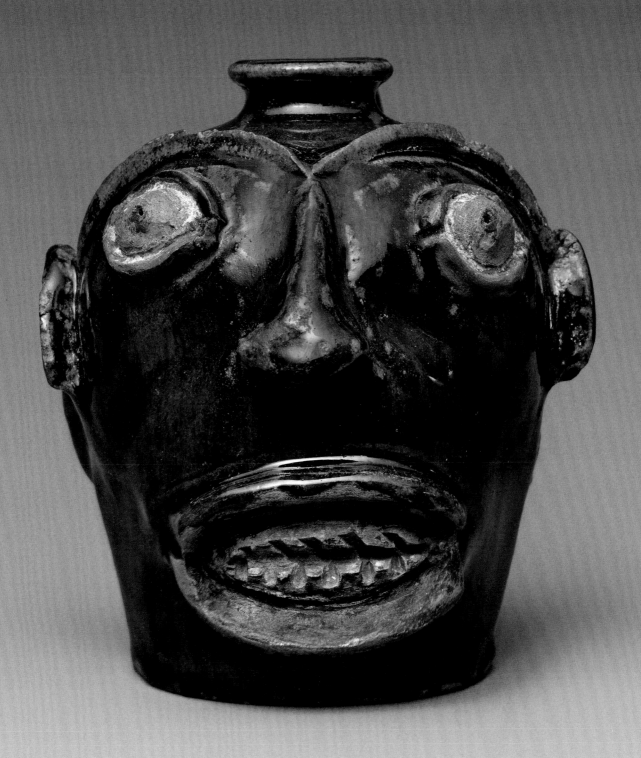

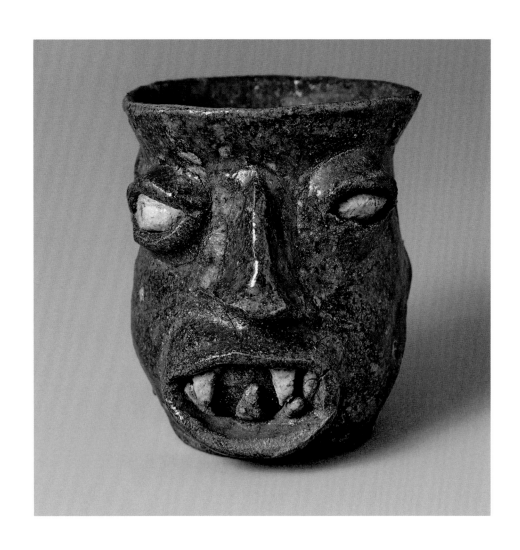

Pl. 44. Unrecorded potter. Face cup, ca. 1850 – 80.
H. 4 ½ in. (11.4 cm). McKissick Museum, University of South Carolina, Columbia

Opposite:
Pl. 45. Unrecorded potter. Face cup, ca. 1850 – 80.
H. 5 in. (12.7 cm). Collection of Joseph P. Gromacki, Chicago

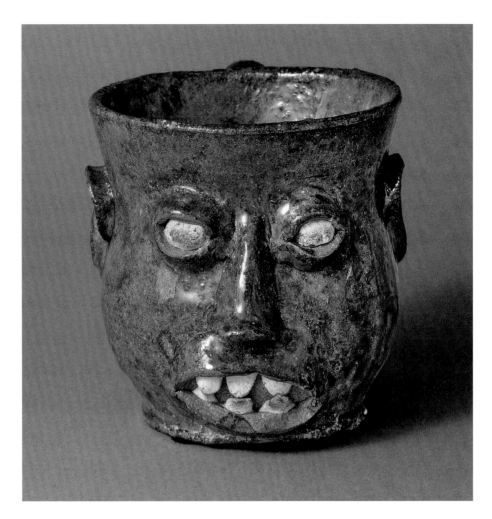

Pl. 46. Kongo artist, Vili group. Power figure, ca. 1850.
H. 40¾ in. (103.5 cm). University of Michigan Museum of Art, Ann Arbor

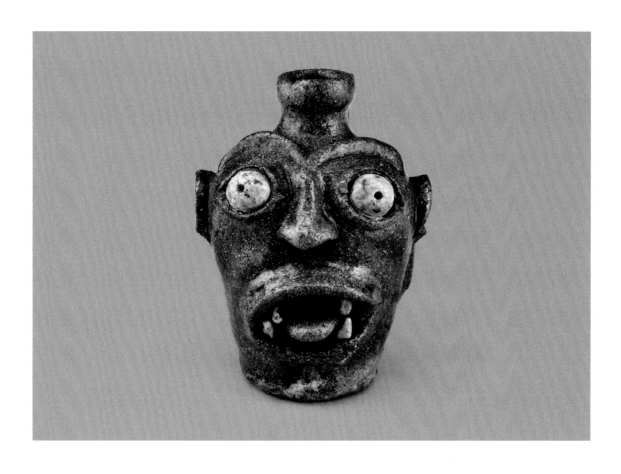

Pl. 47. Unrecorded potter. Face jug, ca. 1850 – 70.
H. 4½ in. (11.4 cm). Collection of the Chipstone Foundation, Milwaukee, Wisconsin

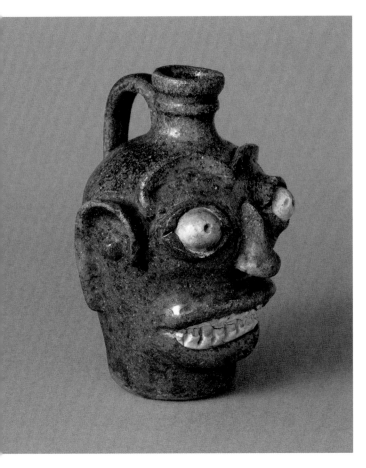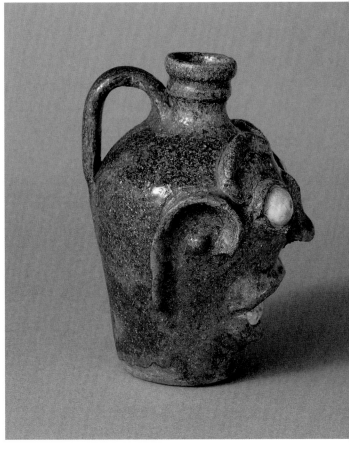

Pl. 48. Unrecorded potter. Face jug, ca. 1850–80.
H. 5½ in. (14 cm). Collection of Joseph P. Gromacki, Chicago

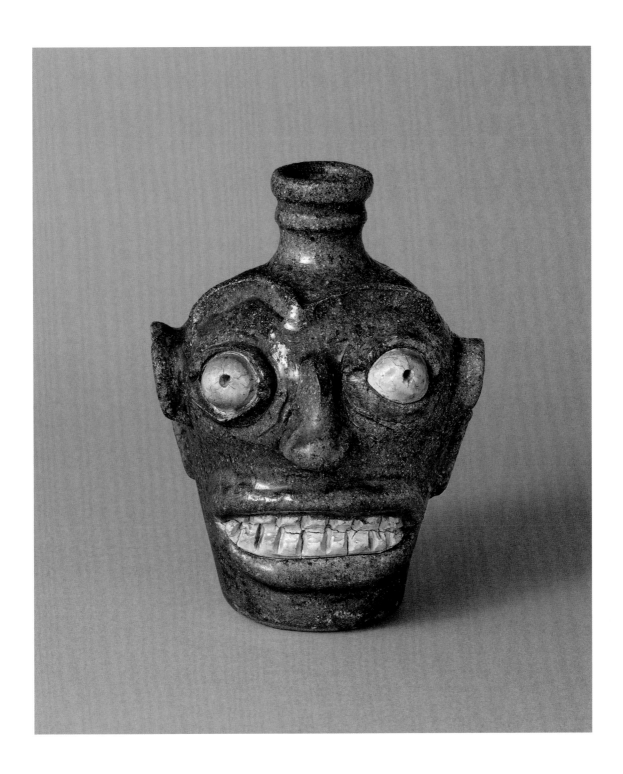

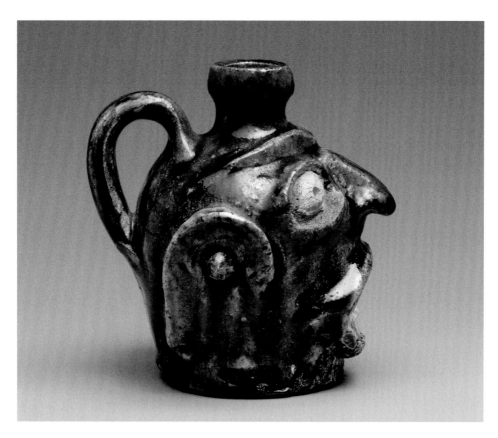

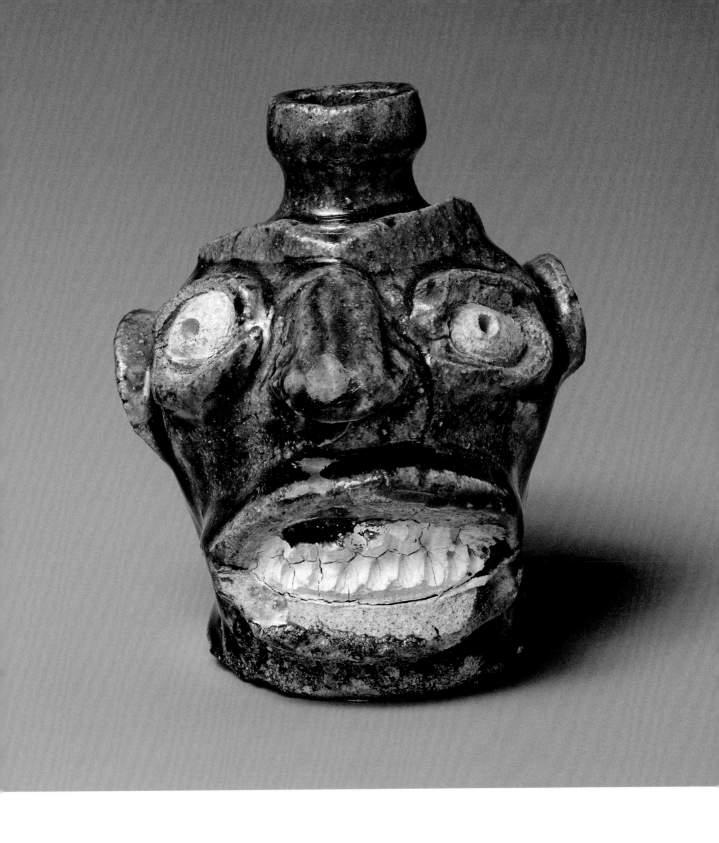

Pl. 49. Unrecorded potter. Face jug, ca. 1850–80.
H. 4¼ in. (10.8 cm). Private collection

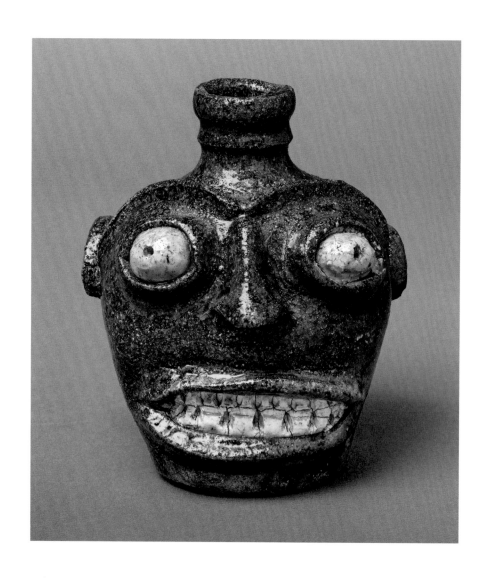

Pl. 50. Unrecorded potter. Face jug, ca. 1850–80.
H. 5 in. (12.7 cm). National Museum of American History,
Smithsonian Institution, Washington, D.C.

Opposite:
Pl. 51. Unrecorded potter. Face jug, ca. 1850–80.
H. 4 in. (10.2 cm). William C. and Susan S. Mariner Private Foundation

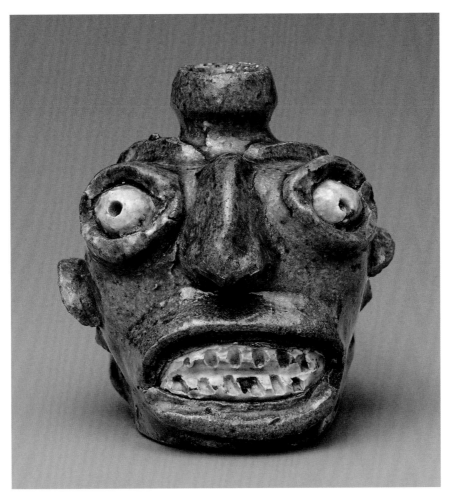

153

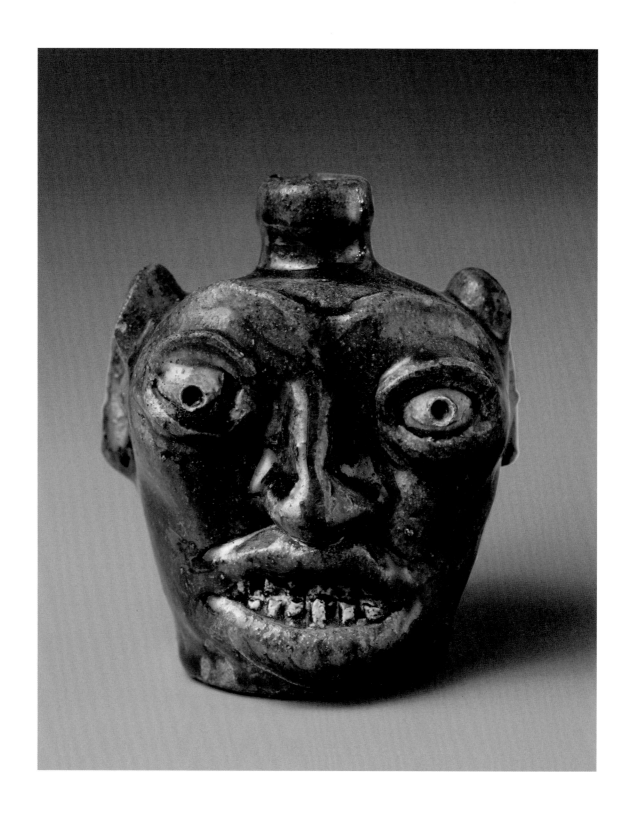

Pl. 52. Unrecorded potter. Face jug, ca. 1850 – 80.
H. 4 in. (10.2 cm). Hudgins Family Collection, New York

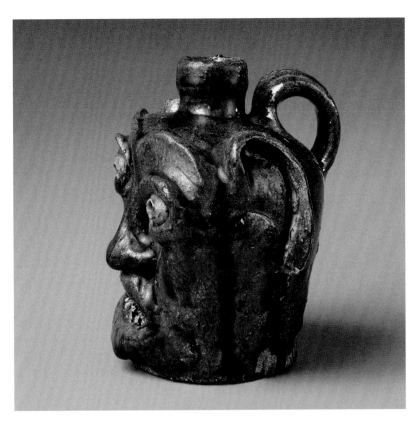

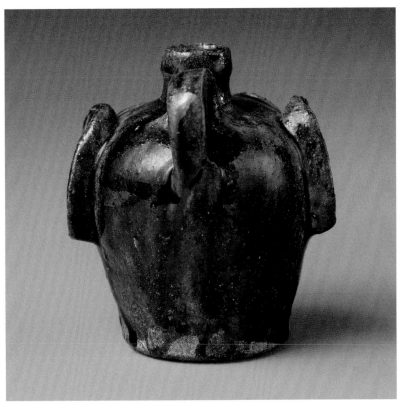

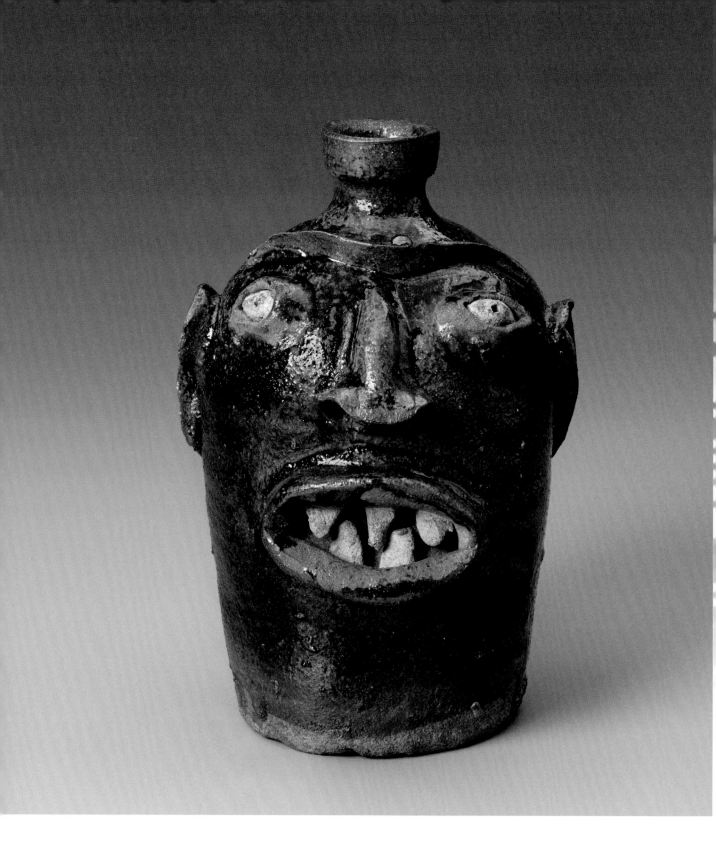

Pl. 53. Unrecorded potter. Face jug, ca. 1850–80.
H. 6¾ in. (17.1 cm). Museum of Fine Arts, Boston

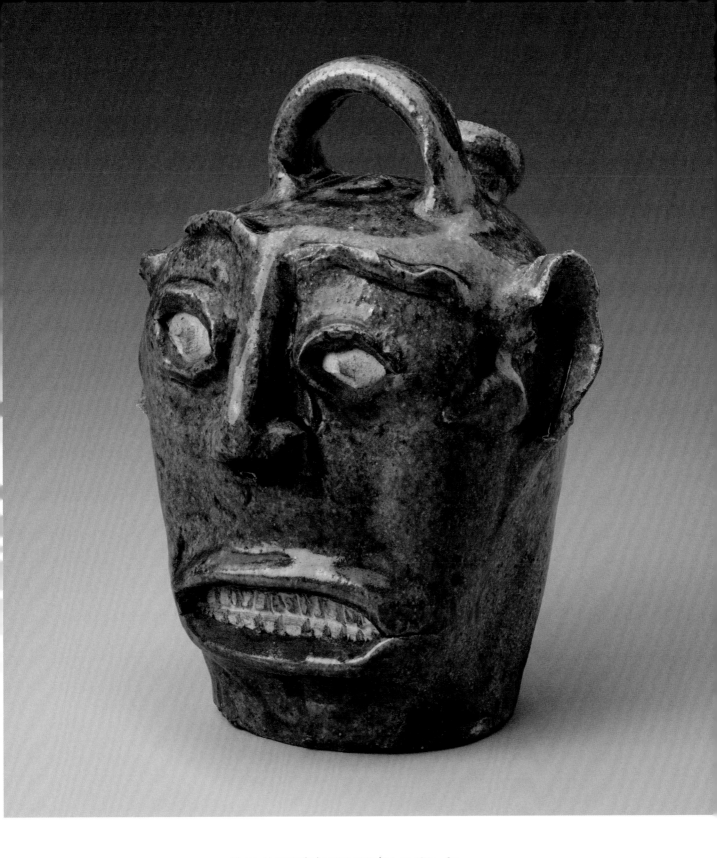

Pl. 54. Unrecorded potter. Face jug, ca. 1850 – 80.
H. 8 ½ in. (21.6 cm). Museum of Fine Arts, Boston

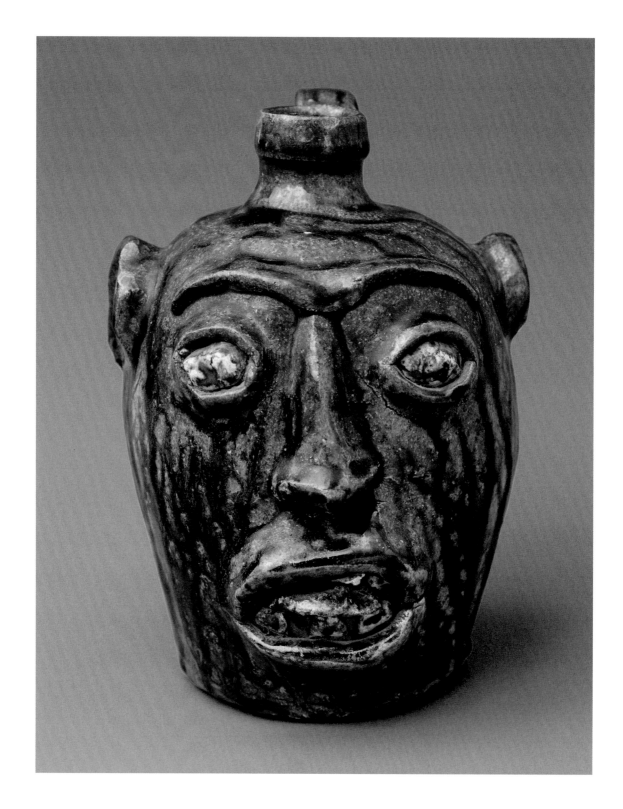

Pl. 55. Unrecorded potter. Face jug, ca. 1850–80.
H. 6¾ in. (17.1 cm). Collection of C. Philip and Corbett Toussaint

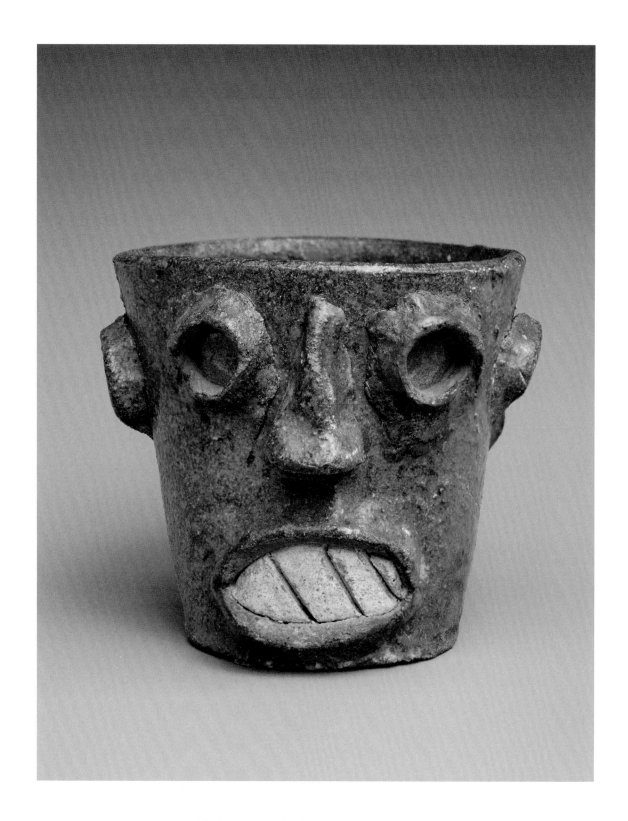

Pl. 56. Unrecorded potter. Face cup, ca. 1850 – 80.
H. 4 ¾ in. (12.1 cm). Hudgins Family Collection, New York

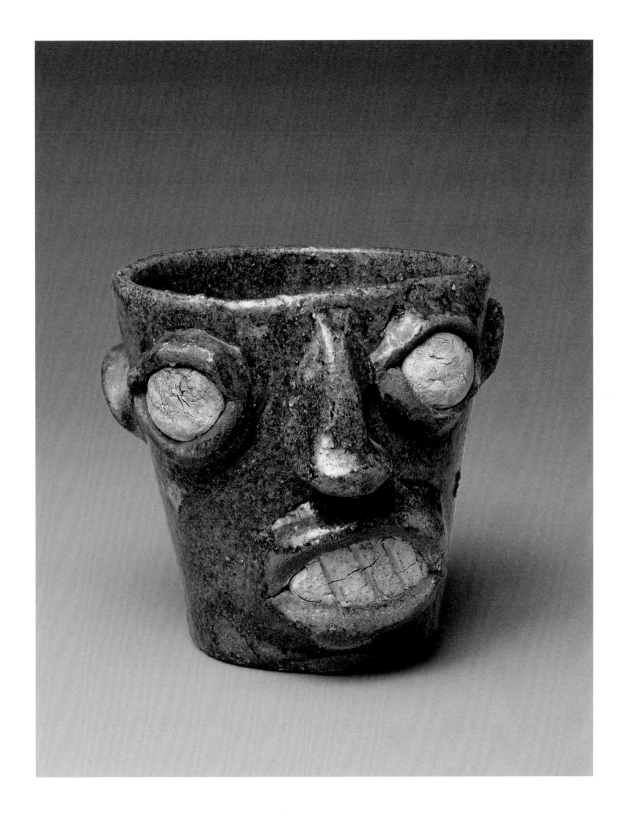

Pl. 57. Unrecorded potter. Face cup, ca. 1850 – 80.
H. 3 ⅞ in. (9.8 cm). Collection of George H. Meyer, Bloomfield Hills, Michigan

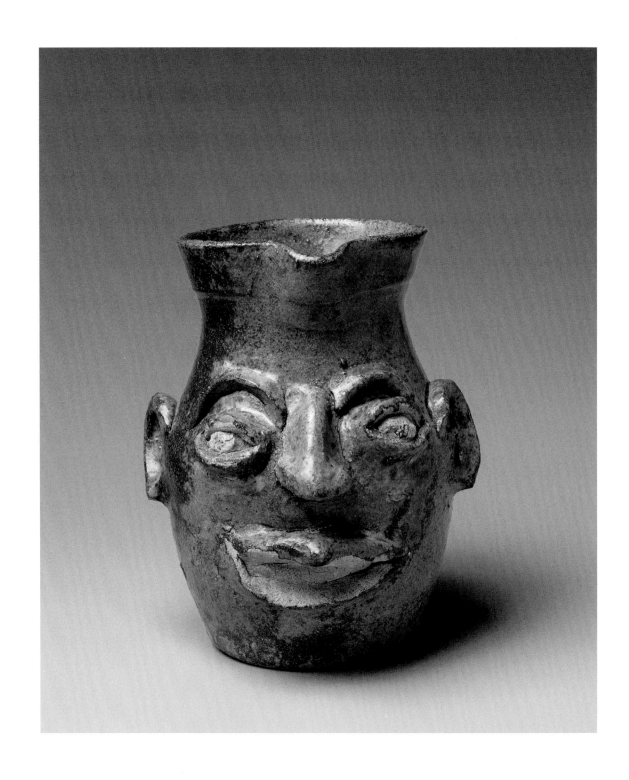

Pl. 58. Unrecorded potter. Face pitcher, ca. 1850 – 80.
H. 6⅞ in. (17.5 cm). Collection of James P. and Susan C. Witkowski, Camden, South Carolina

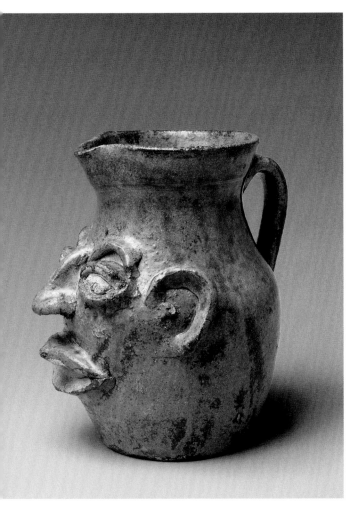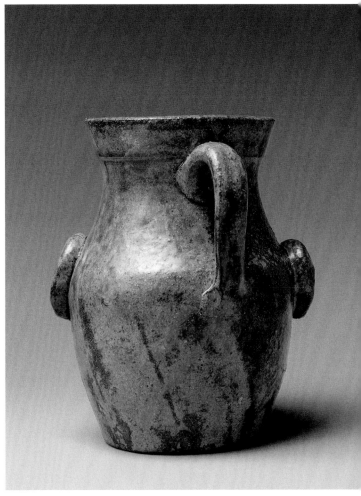

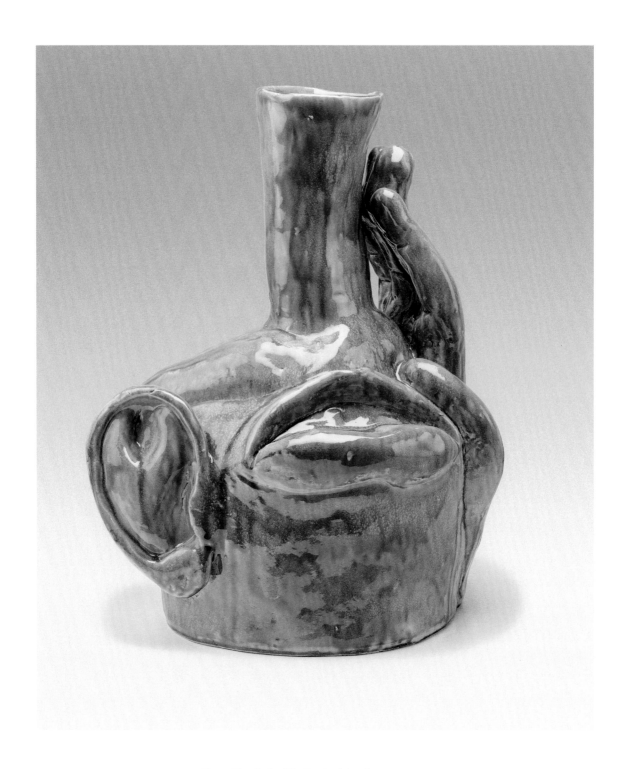

Pl. 59. Woody De Othello. *Applying Pressure*, 2021.
H. 19 in. (48.3 cm). Museum of Fine Arts, Boston

Pl. 60. Theaster Gates. *Signature Study*, 2020.
H. 21⅝ in. (54.9 cm). Courtesy of the artist and White Cube, London

Pl. 61. Robert Pruitt. *Birth and Rebirth and Rebirth*, 2019.
84 × 60 in. (213.4 × 152.4 cm) each. Museum of Fine Arts, Boston

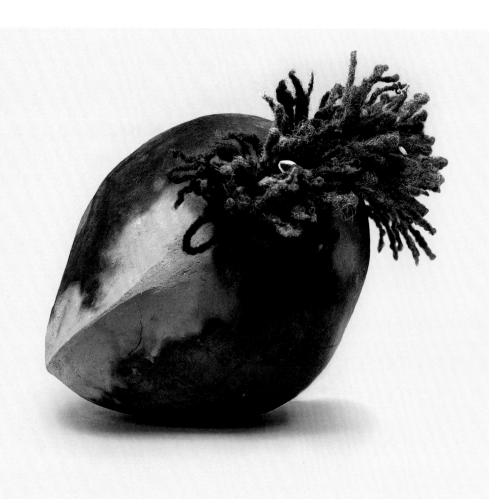

Pl. 62. Adebunmi Gbadebo. *K. S.*, 2021.
L. 22 in. (55.9 cm). Museum of Fine Arts, Boston

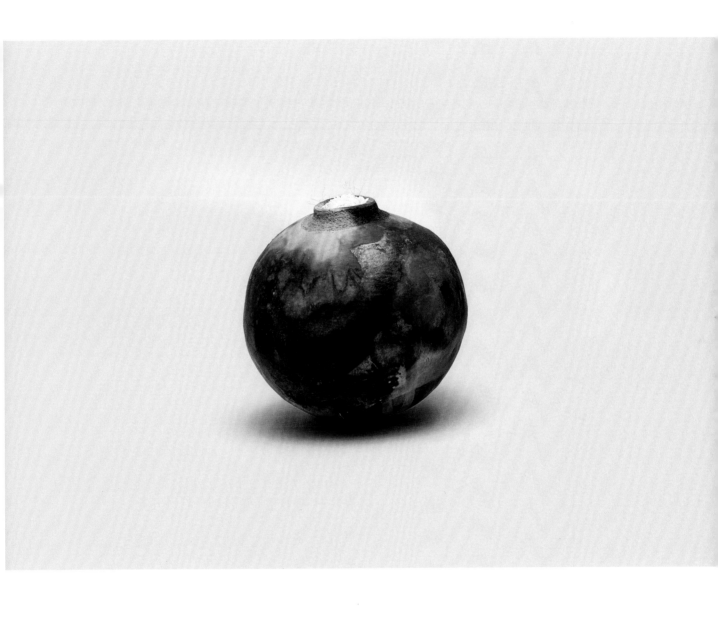

Pl. 63. Adebunmi Gbadebo. *In Memory of Pirecie McCory, Born 1843, Died June 10 1933, In Thy Place to Stand, HFS,* 2021. H. 12 in. (30.5 cm). Museum of Fine Arts, Boston

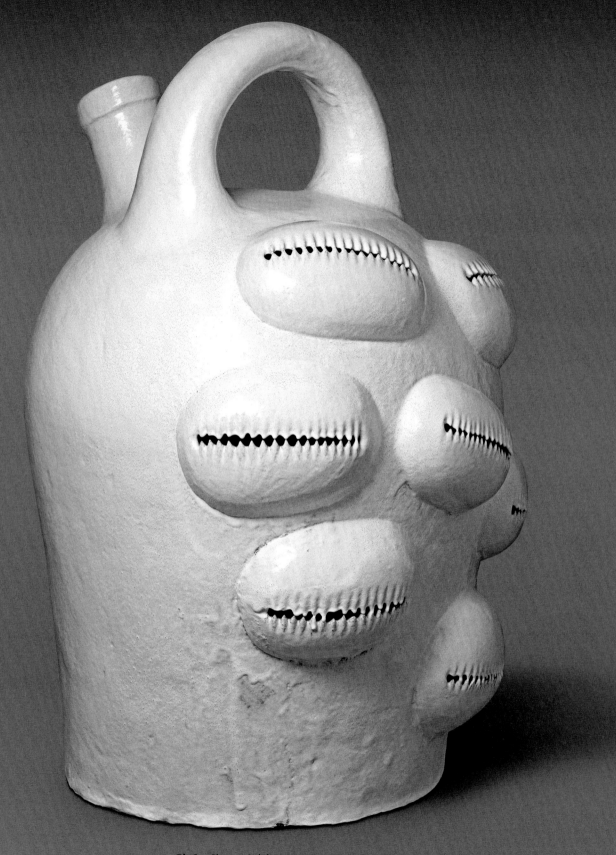

Pl. 64. Simone Leigh. *Jug*, 2022.
H. 61 in. (154.9 cm). Courtesy of the artist and Matthew Marks Gallery, New York

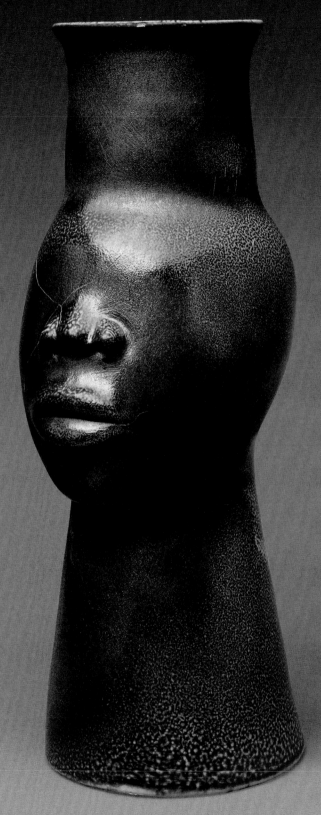

Pl. 65. Simone Leigh. *108 (Face Jug Series)*, 2019.
H. 17½ in. (44.5 cm). Courtesy of the artist and Matthew Marks Gallery, New York

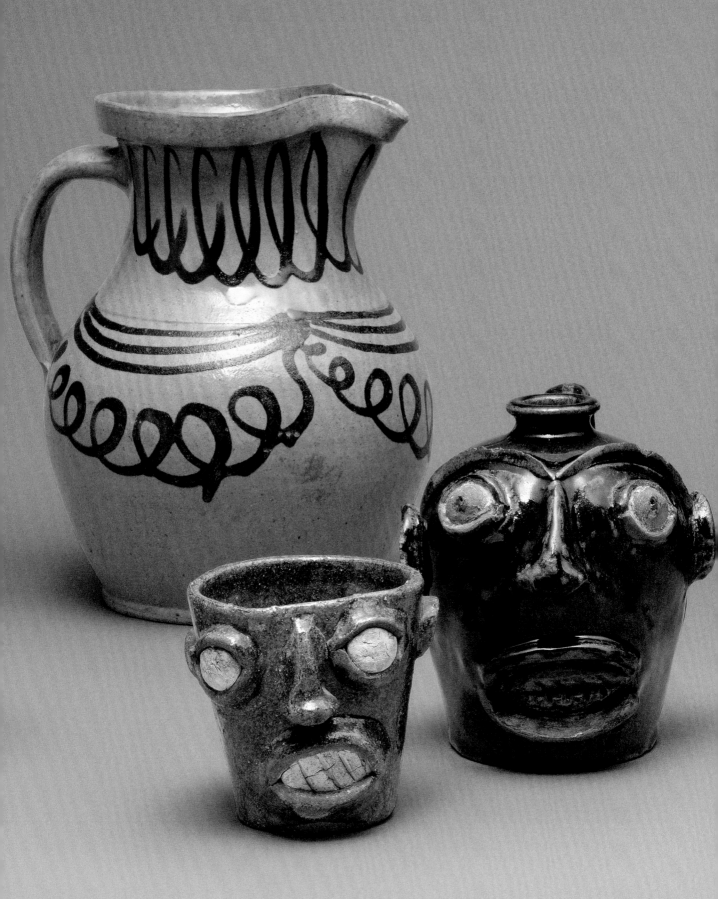

WORKS IN THE EXHIBITION

Katherine C. Hughes (**KCH**)
Ethan W. Lasser (**EWL**)
Adrienne Spinozzi (**AS**)
Jason R. Young (**JRY**)

The dates of the Edgefield-area potteries and individuals were sourced primarily from Carl Steen and Corbett E. Toussaint, "Who Were the Potters in the Old Edgefield District?," *Journal of African Diaspora Archaeology and Heritage* 6, no. 2 (2017), p. 81, table 1, and Corbett E. Toussaint, "Edgefield District Stoneware: The Potter's Legacy," *Journal of Early Southern Decorative Arts* 41 (2020), appendix A, pp. 318–55, and appendix B, pp. 356–57.

Pl. 1

Unrecorded potter, attributed to Woodland culture
Bowl, ca. 1500
Earthenware, H. 15 ¼ in. (38.7 cm)
South Carolina State Museum, Columbia, Bequest of Roy Lyons
(SC80.15.368)

Pl. 2

Earl Robbins (Catawba Indian Nation, 1923–2010), York County,
South Carolina
Cupid jug, 2000
Earthenware, H. 11 in. (27.9 cm)
South Carolina State Museum, Columbia, Gift of Kathe and Tom Stanley
(SC2016.9.15)

Few areas of the United States are as naturally rich in clay as western North and South Carolina, including the land extending from the banks of the Catawba River. Catawba Indian Nation potters have relied on the clay deposits in the region for over four thousand years and continue to mine the same beds for their pottery work to this day. The hand-built forms are dried and burnished to create a smooth, shiny surface for incisions—like the faint feather design on this double-spouted jug by Master Potter Earl Robbins—before being burned in an open pit fire. In addition to the Catawba, the region is currently home to many potters working in the alkaline-glaze traditions. **AS**

Pl. 3

Abner Landrum (active ca. 1812–28), Pottersville Stoneware Manufactory
(ca. 1815–28)
Bottle, 1820
Alkaline-glazed stoneware, H. 8 in. (20.3 cm)
Inscription: "July 20, 1820 A. Landrum"
William C. and Susan S. Mariner Collection at the Museum of Early Southern Decorative Arts at Old Salem, Winston-Salem, North Carolina
(5813.1)

This bottle, with its long-form date and signature in cursive script prominently placed on the wall, is the only known work bearing pottery owner Abner Landrum's name and a rare early example of an inscribed vessel, foreshadowing those produced by the enslaved potter who signed his work "Dave" starting in the following decade. **AS**

Pl. 4

Unrecorded potter, Pottersville Stoneware Manufactory (ca. 1815–28)
Storage jar, 1821
Alkaline-glazed stoneware, H. 11 in. (27.9 cm)
Inscription: "1821"
Collection of Joseph P. Gromacki, Chicago

Made at Abner Landrum's Pottersville Stoneware Manufactory, the earliest known site for the production of alkaline-glazed stoneware in this country, this wheel-thrown vessel as well as the preceding and following (pls. 3, 5) are reminiscent of Asian ceramics; however, the distinctive markings, incised writing, and beige-green glazes are characteristic of Edgefield stoneware. The functional forms intended to store preserves or other foodstuffs were made strong and durable by the addition of the alkaline glaze, ranging in finish from a smooth, uniform surface, as seen on the bottle and jar, to the high-gloss drips that cascade down the jug, an effect created by adding wood ash to the kiln during firing.

The bottle and jar are dated 1820 and 1821, respectively, and are therefore two of the earliest dated industrial stoneware objects attributed to an Edgefield pottery. The jar also bears impressed circular marks on its shoulder and on and below its handles as well as "YY" near the base. These markings may be decorative; provide information about where, when, and why the jar was made; or have been a form of communication between Black potters. The jar is similar in shape—the bulbous thrown form and thick rolled lip—to later examples signed "Dave." **KCH** and **AS**

Pl. 5

Unrecorded potter, possibly Drake & Rhodes Factory (1832–36); Drake, Rhodes & Company (1836); or Ramey, Rhodes & Company (1836–38)
Jug, 1836
Alkaline-glazed stoneware, H. 11 in. (27.9 cm)
Inscription: "February 10, 1836"
Beamer Collection, Greenville, South Carolina

Pl. 6

Unrecorded potter, probably Thomas M. Chandler Jr. (1810–1854),
Phoenix Stone Ware Factory (ca. 1840)
Watercooler, ca. 1840
Alkaline-glazed stoneware with iron and kaolin slip, H. 31 ¼ in. (79.4 cm)
Stamp: "PHOENIX/FACTORY/ED:SC"
High Museum of Art, Atlanta, Purchase in honor of Audrey Shilt, President of the Members Guild, 1996–1997, with funds from the Decorative Arts Acquisition Endowment and Decorative Arts Acquisition Trust (1996.132)

This object stands apart for its striking decoration: on one side, a detailed scene of a Black man and woman toasting, with a nursing hog and vessel below, and on the other side, a painted foliate wreath encircling the pottery's stamp. The Phoenix Stone Ware Factory was owned by two White entrepreneurs and led by the itinerant potter Thomas Chandler. His earlier work included another figural scene that could be read as a story, with an incised illustration of the vessel itself, much like the two-handled cooler depicted on this watercooler.

The sensitive rendering of the couple, in fancy dress and engaged in a celebratory gesture, is unlike the many caricatures of African Americans from this period. The scene is often interpreted as a slave wedding, a rare figural depiction of Black life and regional traditions in Edgefield stoneware. The markedly different subject matter invites speculation about whom this decorative cooler was made for and how it was interpreted at the time. **KCH** and **AS**

Pl. 7

Unrecorded potter, possibly Phoenix Stone Ware Factory (ca. 1840) or Collin Rhodes Factory (ca. 1846–53)
Storage jar, ca. 1840–53
Alkaline-glazed stoneware with kaolin and iron slip, H. 14 in. (35.6 cm)
Mr. and Mrs. John LaFoy, Greenville, South Carolina

The figure in profile on one side of this jar—a Black man in military uniform wearing a cravat and white gloves—is an anomalous depiction of an African American within the Edgefield oeuvre. With an incongruous pedestrian floral design on the reverse, the vessel was perhaps intended to rotate, offering the option to hide the figure. **AS**

Pls. 8, 9

Unrecorded potter, Trapp & Chandler Pottery (1843–ca. 1850)
Storage jar, ca. 1845
Alkaline-glazed stoneware with iron slip, H. 11 ½ in. (29.2 cm)
Stamp: "Trapp & Chandler"
Collection of C. Philip and Corbett Toussaint

Unrecorded potter, attributed to Trapp & Chandler Pottery
(1843–ca. 1850)
Churn, ca. 1845
Alkaline-glazed stoneware with iron slip, H. 16 ¼ in. (42.5 cm)
Inscription: "3"
Dr. Fred E. Holcombe Family Collection, Cary, North Carolina

A confident trailed decoration of interlocking loops and concentric swags in iron oxide under a celadon-like glaze are telltale features of the stoneware produced by itinerant White potter Thomas Chandler. Though many objects bear his stamp, Chandler had at least four enslaved potters working with him at various times and different potteries. The florid "3" within the decorative cartouche of the churn indicates three gallons, cleverly and attractively integrating the container's capacity into its aesthetic treatment. Stoneware vessels were usually sold by volume, and often featured decoration fusing embellishment and function. **KCH** and **AS**

Pl. 10

Unrecorded potter, Collin Rhodes Factory (ca. 1846–53)
Jug, 1847
Alkaline-glazed stoneware with kaolin and iron slip, H. 15 ¾ in. (40 cm)
Inscription: "3/C. Rhodes/Maker/1847"
Collection of Carl and Marian Mullis, Atlanta

"C. Rhodes" refers to Collin Rhodes, a White entrepreneur, planter, enslaver, and descendant of the Landrums, who owned several potteries in the Edgefield area. Despite the conspicuous name on many of the vessels from the Collin Rhodes Factory, these wares were made by enslaved African American and itinerant White potters whose names were not recorded. Applied embellishment is a defining feature of the pottery's products, many of which incorporate floral motifs and decorative flourishes in a contrasting white kaolin slip (a watered-down clay mixture) and iron oxide wash. Rarer are those with incised writing, like the dated jug here, and those with

figural decoration. The elaborate designs contrast with the less decorative, utilitarian products of other potteries, perhaps reflecting the wealth and status of the investor—and his larger, skilled workforce—as well as those who purchased his wares. **KCH** and **AS**

Pl. 11

Unrecorded potter, Collin Rhodes Factory (ca. 1846–53)
Storage jar, ca. 1846–53
Alkaline-glazed stoneware with kaolin slip, H. 13 in. (33 cm)
Inscription: "C. Rhodes/Maker"
Collection of Larry and Joan Carlson

Pl. 12

Unrecorded potter, Collin Rhodes Factory (ca. 1846–53)
Jug, ca. 1846–53
Alkaline-glazed stoneware with kaolin slip, H. 15 ¼ in. (38.7 cm)
Inscription: "3/Southern Make/C. Rhodes/Edgefield District/S.C."
Mr. and Mrs. John LaFoy, Greenville, South Carolina

As early as 1826, South Carolina–born architect Robert Mills wrote highly of Edgefield stoneware, boasting that it was "much stronger, better, and cheaper than any European or American ware of the same kind."* The phrase "Southern Make" surely conveyed a sense of pride as the stoneware traveled from Edgefield to destinations farther south and west. **KCH**

* Robert Mills, *Statistics of South Carolina, including a View of Its Natural, Civil, and Military History, General and Particular* (Charleston, S.C.: Hurlbut and Lloyd, 1826), pp. 523–24 (quotation on p. 524).

Pl. 13

Unrecorded potter, attributed to Collin Rhodes Factory (ca. 1846–53)
Jug, ca. 1850
Alkaline-glazed stoneware with kaolin slip, H. 7 ¼ in. (18.4 cm)
David and Jon Ward, Greenville, South Carolina

Pl. 14

Unrecorded potter, Collin Rhodes Factory (ca. 1846–53)
Jug, ca. 1846–53
Alkaline-glazed stoneware with kaolin and iron slip, H. 13 ¼ in. (33.7 cm)
Inscription: "C Rhodes/Maker/Joel/Ridgel"
Colonial Williamsburg Foundation, Virginia, Museum Purchase
(1997.900.1)

Bearing the name of a prominent planter and enslaver, Joel Ridgell of Batesburg, South Carolina, this jug is highly unusual in its depiction of two women wearing elaborate hoop skirts. The allover decorative ambition is rare for utilitarian wares, and it's likely the object was a special commission, perhaps made to commemorate Ridgell's two wives. **AS**

Pl. 15

Unrecorded potter, Collin Rhodes Factory (ca. 1846–53)
Pitcher, ca. 1846–53
Alkaline-glazed stoneware with kaolin and iron slip, H. 10 ½ in. (26.7 cm)
Private collection

Pl. 16

Unrecorded potter, probably Thomas M. Chandler Jr. (1810–1854)
Pitcher, ca. 1838–52
Alkaline-glazed stoneware with iron slip, H. 10 in. (25.4 cm)
David and Jon Ward, Greenville, South Carolina

Pl. 17

Unrecorded potter, probably Thomas M. Chandler Jr. (1810–1854), Thomas M. Chandler Pottery (1850–52)
Storage jar, ca. 1850
Alkaline-glazed stoneware with kaolin slip, H. 21 ½ in. (54.6 cm)
Stamp: "CHANDLER / MAKER"
The Metropolitan Museum of Art, New York, Purchase, Edisto Island Historic Preservation Society Gift and Friends of the American Wing Fund, 2022 (2022.124)

Pl. 18

Unrecorded potter, Stony Bluff Manufactory (ca. 1848–67)
Jug, ca. 1850
Alkaline-glazed stoneware, H. 14 in. (35.6 cm)
Stamp: "L.MILES"
Mr. and Mrs. John LaFoy, Greenville, South Carolina

The surface of this jug looks like glass, one of the occasional attributes of alkaline glaze, whose final appearance is largely influenced by the components of the glaze recipe and the placement of the object in the kiln, including its proximity to the heat source. The greater the silica component, the glossier the surface. **KCH**

Pl. 19

Benjamin Franklin Landrum (ca. 1812–1900), Benjamin Franklin Landrum Pottery (ca. 1848–1900)
Jug, ca. 1850–70
Alkaline-glazed stoneware, H. 17 in. (43.2 cm)
Inscription: "B F Landrum"
Collection of James P. and Susan C. Witkowski, Camden, South Carolina

A coroner's inquest from 1848 offers direct evidence that both men and women labored in Edgefield potteries. The case involved the harrowing experiences of Ann, an enslaved woman who worked at the Benjamin Franklin Landrum Pottery. Landrum admitted that he whipped Ann because she had a "turbulent disposition" and refused to do her work.* He testified further that when he returned a short time later, he found her unresponsive, purportedly dead by suicide. Ann's life—and her death—reflects the brutal work regime under which enslaved men and women toiled in the potteries. **JRY**

* Coroner's Book of Inquisitions, 1844–50, Edgefield County Judge of Probate, Edgefield, South Carolina, WPA typescript, 1937, no. 165-33-7172, South Caroliniana Library, University of South Carolina, Columbia, as quoted in Cinda K. Baldwin, *Great and Noble Jar: Traditional Stoneware of South Carolina* (Columbia: McKissick Museum, University of South Carolina; Athens: University of Georgia Press, 1993), p. 75.

Pl. 20

Unrecorded potter, possibly Rhodes, Ramey & Gibbs (1838–39); N. Ramey & Company (1839–40); J. W. Gibbs & Company (1840); or J. Gibbs & Company (1840–43)
Jug, ca. 1840s, reconstructed 2012
Alkaline-glazed stoneware, H. 13 in. (33 cm)
Department of Anthropology, University of Illinois, Urbana-Champaign

This jug was excavated from the Pottersville site by a team from the University of Illinois at Urbana-Champaign in 2011. The discovery of the large size of the Pottersville kiln provided unambiguous evidence of the industrial nature of the stoneware operation. Analysis of the pottery sites, along with a nuanced understanding of the manufacturing process and an accounting of the large output, indicates that enslaved labor was the most critical resource for Edgefield's stoneware industry. **AS**

Pl. 21

Possibly Dave (later recorded as David Drake; ca. 1801–1870s), Stony Bluff Manufactory (ca. 1848–67)
Fragment, ca. 1848–67
Alkaline-glazed stoneware, Diam. 12 in. (30.5 cm)
Collection of C. Philip and Corbett Toussaint

Pl. 22

Dave (later recorded as David Drake; ca. 1801–1870s) and Abram (active ca. 1839–60s), Stony Bluff Manufactory (ca. 1848–67)
Fragment, ca. 1848–67
Alkaline-glazed stoneware, 7 ¼ × 6 in. (18.4 × 15.2 cm)
Stamp: "L.MILES"; inscription: "Dave & Abram"
Collection of C. Philip and Corbett Toussaint

The marks on this jug fragment provide invaluable clues about the division of labor at Stony Bluff Manufactory. Visible are the names "Dave" and "Abram," the two enslaved potters responsible for the original vessel's creation. Also present is the name stamp of the White owner of the pottery, Lewis J. Miles, nephew-in-law of Abner Landrum and Dave's enslaver at various points of the Black potter's life. **KCH** and **AS**

Pl. 23

Unrecorded potter, Stony Bluff Manufactory (ca. 1848–67)
Fragment, ca. 1848–67
Alkaline-glazed stoneware, H. 5 in. (12.7 cm)
Collection of C. Philip and Corbett Toussaint

Pl. 24

Dave (later recorded as David Drake; ca. 1801–1870s), Stony Bluff Manufactory (ca. 1848–67)
Fragment, 1866
Alkaline-glazed stoneware, 3 × 6 ½ in. (7.6 × 16.5 cm)
Inscription: "ay 31- 1866-"
Collection of C. Philip and Corbett Toussaint

Pl. 25

Trapp & Chandler Pottery (1843–ca. 1850) or Thomas M. Chandler Pottery (1850–52)
Fragment, ca. 1843–52
Alkaline-glazed stoneware with iron oxide, H. 6 ½ in. (16.5 cm)
McKissick Museum, University of South Carolina, Columbia, Field collection by Dr. George Terry (5.1795)

Pl. 26

Dave (later recorded as David Drake; ca. 1801–1870s), Drake & Rhodes Factory (1832–36)
Storage jar, 1834
Alkaline-glazed stoneware, H. 19 ¼ in. (48.9 cm)
Inscription: "Concatination / 12th June 1834"
Private collection

This poignant verse is the earliest known by Dave. Though unsigned ("Dave" first appears on a jar almost six years later), the vessel is unquestionably the work of his hands. The potter's incised words became more pronounced over the following three decades, but the command of both language and clay seen in this extraordinary object points to years of writing and turning prior to its creation. **AS**

175

Pl. 27
Dave (later recorded as David Drake; ca. 1801–1870s), Stony Bluff
Manufactory (ca. 1848–67)
Jug, 1849
Alkaline-glazed stoneware with kaolin and iron slip, H. 15 in. (38.1 cm)
Inscription: "Lm/April 5, 1849/Dave"
Beamer Collection, Greenville, South Carolina

The embellishment on this signed and dated two-handled jug with applied
slip swags is exceptionally rare within the potter's oeuvre, yet it attests to
his keen awareness of the region's distinctive decorative vocabulary. **AS**

Pl. 28
Dave (later recorded as David Drake; ca. 1801–1870s), Stony Bluff
Manufactory (ca. 1848–67)
Jug, 1853
Alkaline-glazed stoneware, H. 14 ¼ in. (37.5 cm)
Inscription: "Lm/June 10 1853"
Collection of Glenn Ligon

Though Dave is best known for his unparalleled monumental two- and
four-handled storage jars, his large body of work consists of wares of all
types and sizes. This jug, a beautifully proportioned vessel awash in a
contrasting alkaline glaze, illustrates the potter's unmatched material
knowledge, dexterity, and craftsmanship. **AS**

Pl. 29
Dave (later recorded as David Drake; ca. 1801–1870s), Stony Bluff
Manufactory (ca. 1848–67)
Storage jar, 1857
Alkaline-glazed stoneware, H. 19 in. (48.3 cm)
Inscription: "I wonder where is all my relation/Friendship to all—and
every nation/Lm Aug 16, 1857 Dave"
Greenville County Museum of Art, Greenville, South Carolina, Museum
purchase with funds donated by: 2020 Visionaries: AVX/Kyocera
Foundation; The Daniel-Mickel Foundation; Gay and Frank Fowler;
Deborah Gibson and Tom Styron; The Reverend William M. Gilfillin;
Gordon and Sarah Herring; Lucy and Jack Kuhne; Arthur and Holly
Magill Foundation; Rachelle and Charlie Mickel; United Community
Bank; Anne Woods; Wyeth Dynasty Lead Donors: Dan Adams; Laura E.
duPont; Priscilla and John Hagins; Libby and Bill Kehl; Susan and
Thomas O'Hanlan; Sydney and Ed Taylor; The Wallace Foundation

The poem on this jar—Dave's most significant literary contribution—
illuminates the potter's own experience but also transcends it. The poignant
couplet speaks directly to the unimaginable and lasting trauma of forced
family separation, a reality of the institution of slavery. The two short
lines convey the existential and psychological reverberations of slavery's
long and enduring shadow. **AS**

Pl. 30
Dave (later recorded as David Drake; ca. 1801–1870s), Stony Bluff
Manufactory (ca. 1848–67)
Storage jar, 1857
Alkaline-glazed stoneware, H. 19 in. (48.3 cm)
Inscription: "I made this Jar = for cash—/though its called = lucre
Trash/Dave/Lm Aug. 22, 1857/Dave"
Museum of Fine Arts, Boston, Harriet Otis Cruft Fund and Otis Norcross
Fund (1997.10)

Dave signs his name not once but twice on this storage jar and declares,
"I made this Jar = for cash." With these lines, Dave announces his role as
creator, maker, potter, and poet. Though rare, it was not unheard-of for
enslaved men and women with craft skills to sell their services for money,
in many cases using their earnings to buy either themselves or their loved
ones out of slavery. "Lucre" refers to money or profit, often gained through
sordid or dishonorable means. In this sense, the inscription "lucre Trash"
might be read as "filthy money," perhaps referring to the buying and selling
of people as a dirty business. This pot was created just months after the
infamous U.S. Supreme Court case *Dred Scott v. John F. A. Sandford* (1857),
in which Chief Justice Roger Taney, writing the majority decision, found
that African Americans "had no rights which the white man was bound
to respect."* **KCH** and **JRY**
* Benjamin C. Howard, *Report of the Decision of the Supreme Court of the United
States . . . in the Case of Dred Scott versus John F. A. Sandford, December Term,
1856* (Washington, D.C.: Cornelius Wendell, 1857), p. 13.

Pl. 31
Dave (later recorded as David Drake; ca. 1801–1870s), Stony Bluff
Manufactory (ca. 1848–67)
Storage jar, 1858
Alkaline-glazed stoneware, H. 24 in. (61 cm)
Inscription: "This noble Jar = will hold, 20/fill it with silver = then you'll
have plenty/Lm April 8 1858/Dave"
Hudgins Family Collection, New York

This is one of at least four known large storage jars with poems made by
Dave between March and April 1858, part of the most prodigious period
of his known and extant pottery and poetry. The couplet is representative
of the ways in which Dave played with punctuation and symbols in his
writing, similar to contemporaneous poet Emily Dickinson. The potter sug-
gests that the reader "fill [the jar] with silver" because "then you'll have
plenty." But plenty in what sense? The jar was intended to store foodstuffs,
and twenty gallons of salted or pickled meat would go a long way in
feeding the enslaved population on a plantation. Silver could be a reference
to the desire to purchase his own freedom, and that of those he loved.
This vessel was sold for money, but the majority of the income would have
gone to "Lm" (Lewis Miles), who owned the pottery where it was made.
The finish showcases the ever-surprising aesthetic properties of alkaline
glaze, which can produce a range of colors, drips, and surface textures. **KCH**

Pls. 32–34
Dave (later recorded as David Drake; ca. 1801–1870s), Stony Bluff
Manufactory (ca. 1848–67)
Storage jar, 1858
Alkaline-glazed stoneware, H. 24 ½ in. (62.2 cm)
Inscription: "A very Large Jar which has 4 handles = /pack it full of fresh
meats—then light candles—/Lm April 12 1858/Dave"
Crystal Bridges Museum of American Art, Bentonville, Arkansas
(2021.29)

Dave (later recorded as David Drake; ca. 1801–1870s), Stony Bluff
Manufactory (ca. 1848–67)
Storage jar, 1858
Alkaline-glazed stoneware, H. 22 ⅝ in. (57.5 cm)
Inscription: "this Jar is to Mr Segler who keeps the bar in orangeburg/
For Mr Edwards a Gentle man—who formly kept/Mr thos bacons
horses/April 21 1858/when you fill this Jar with pork or beef/Scot will
be there; to Get a peace,—/Dave"
The Metropolitan Museum of Art, New York, Purchase, Ronald S. Kane
Bequest, in memory of Berry B. Tracy, 2020 (2020.7)

Dave (later recorded as David Drake; ca. 1801–1870s), Stony Bluff Manufactory (ca. 1848–67)
Storage jar, 1859
Alkaline-glazed stoneware, H. 26 ½ in. (67.3 cm)
Inscription: "Good for lard—or holding—fresh meats = /blest we were—when peter saw the folded sheets/Lm may 3d 1859/Dave"
Philadelphia Museum of Art, 125th Anniversary Acquisition. Purchased with funds contributed by Keith and Lauren Morgan and with the gifts (by exchange) of John T. Morris, Mrs. John D. Wintersteen, and the bequest of Maurice J. Crean, and with the Baugh-Barber Fund, the Haas Community Fund, and other Museum funds (by exchange), 1997 (1997-35-1)

In an era before refrigeration, covered stoneware jars kept cured and pickled meat cool and free of pests. The verses on these monumental vessels refer to their contents. With capacities approaching twenty-five gallons, they could hold the large amount of food necessary to sustain the enslaved labor force that operated South Carolina plantations. The jars stood at the center of the weekly social ritual known as "allowance day," when enslaved families from across the plantation gathered to receive their rations, which were distributed from a central communal site, such as a smoke-house or storeroom.* The formerly enslaved writer Harriet Jacobs recalled this "busy time" in her 1861 book *Incidents in the Life of a Slave Girl*: "Monday evening came. . . . On that night the slaves received their weekly allowance of food. Three pounds of meat, a peck of corn, and perhaps a dozen herring were allowed to each man."† **EWL**

* Allowance day is also discussed in Drew Gilpin Faust, "Culture, Conflict, and Community: The Meaning of Power on an Ante-bellum Plantation," *Journal of Social History* 14, no. 1 (Autumn 1980), p. 88.
† Harriet Jacobs, *Incidents in the Life of a Slave Girl*, ed. Lydia Maria Child (1861; New York: Washington Square Press, 2003), p. 117.

Pls. 35, 36
Dave (later recorded as David Drake; ca. 1801–1870s), Stony Bluff Manufactory (ca. 1848–67)
Storage jar, 1858
Alkaline-glazed stoneware, H. 21 in. (53.3 cm)
Inscription: "nineteen days before Christmas—Eve—/Lots of people after its over, how they will greave, /Lm December 6. 1858/Dave"
Collection of C. Philip and Corbett Toussaint

Dave (later recorded as David Drake; ca. 1801–1870s), Stony Bluff Manufactory (ca. 1848–67)
Jug, 1858
Alkaline-glazed stoneware, H. 13 in. (33 cm)
Inscription: "Lm/Decr 6 1858/Dave"
Collection of C. Philip and Corbett Toussaint

Dave was at the height of his talents when he made this storage jar, as both a master potter—the size and proportion of the vessel, its symmetry and stability—and a master wordsmith—the rhythm and rhyme of the lines, the sensitivity, the unexpected juxtaposition of the joyous Christmas cele-bration with the knowledge of grief and loss. The moving verse is likely a reference to the common practice of hiring out, and outright selling, enslaved people on New Year's Day in the South, which caused African American family members to be separated from one another, sometimes by thousands of miles and with no way to communicate or find each other in the future. The smaller jug was dated and signed on the same day, and a close comparison between the two vessels reveals a similarity in the color and texture of the glaze that attests to the objects' kinship in the kiln. **KCH**

Pl. 37
Dave (later recorded as David Drake; ca. 1801–1870s) and Mark Jones (1839–after 1910), Stony Bluff Manufactory (ca. 1848–67)
Storage jar, 1859
Alkaline-glazed stoneware, H. 15 in. (38.1 cm)
Inscription: "· Mark and/ · —Dave—/L · m · March 10 · 1859"
National Museum of American History, Smithsonian Institution, Washington, D.C. (1996.0344.02)

The name "Mark" above "Dave" on this vessel affirms not only that there were other literate enslaved potters working in the region but also that Dave was likely a mentor and teacher, both for turning clay and for reading and writing. A pair of jars made two months after this one bear the name Baddler alongside Dave's, suggesting that this period may have been one of collaboration and apprenticeship (figs. 9, 32). Although there is material evidence that Dave was making pots well into the 1860s, the physicality of such demanding, skilled work over several decades likely meant that he relied on others for assistance.

The relationship between Mark Jones and David Drake extends beyond this collaboration and may well be familial. In the 1870 census they are listed at the same residence, along with Mark's wife, Caroline, and their children. This document is also one of the first to list the potter's name as David Drake. **AS**

Pl. 38
Unrecorded potter, attributed to Miles Mill Pottery (1867–85)
Jug, ca. 1867–85
Alkaline-glazed stoneware, H. 10 in. (25.4 cm)
Collection of C. Philip and Corbett Toussaint

With its straight sides, flattened spout, and uniform dark brown surface, this jug is remarkably similar in form and glaze to some face vessels. It is a reminder that all face vessels started as simple thrown jugs, their animating hand-modeled facial features in high relief a conscious deviation by the potter, resulting in something wholly different in function and meaning. **AS**

Pls. 39, 40
Unrecorded potter, attributed to Miles Mill Pottery (1867–85)
Face jug, ca. 1867–85
Alkaline-glazed stoneware with kaolin, H. 7 in. (17.8 cm)
The Metropolitan Museum of Art, New York, Rogers Fund, 1922 (22.26.4)

Unrecorded potter, attributed to Miles Mill Pottery (1867–85)
Face jug, ca. 1867–85
Alkaline-glazed stoneware with kaolin, H. 8 in. (20.3 cm)
Hudgins Family Collection, New York

These face vessels and the following (pl. 41) all share a close visual likeness, suggesting that they were made by the same person or small group of pot-ters. Along with the unadorned jug (pl. 38), archaeological evidence strongly points to their creation at Miles Mill Pottery, opened by Lewis J. Miles after emancipation and following the closing of his nearby Stony Bluff Manufactory. The evidence indicates that face vessels were made first by enslaved and later by freed Black potters in the Edgefield area. **AS**

Pl. 41
Unrecorded potter, attributed to Miles Mill Pottery (1867–85)
Face jug, ca. 1867–85
Alkaline-glazed stoneware with kaolin, H. 7 in. (17.8 cm)
April L. Hynes, Washington Crossing, Pennsylvania

Unearthed in the Germantown section of Philadelphia during a period of urban development in the 1950s, this face vessel was likely brought north by African Americans from the Edgefield area. How and when remains unknown, but census documentation from the 1930s indicates that a couple from Edgefield—with ancestors who were enslaved at the plantation of pottery owner Colonel Thomas J. Davies—lived and worked on the property where the jug was found.* **AS**

* Claudia A. Mooney, April L. Hynes, and Mark M. Newell, "African-American Face Vessels: History and Ritual in 19th-Century Edgefield," *Ceramics in America* (Chipstone Foundation, Milwaukee, Wisc.), 2013, p. 4.

Pl. 42
Unrecorded potter
Face jug, ca. 1850–80
Alkaline-glazed stoneware with kaolin, H. 10 ¼ in. (26 cm)
The Metropolitan Museum of Art, New York, Purchase, Nancy Dunn Revocable Trust Gift, 2017 (2017.310)

This harvest face vessel—so called for the horizontal handle—is one of the most recognizable examples, and bears an uncanny resemblance to the object at the center of James A. Palmer's derogatory "Aiken and Vicinity" stereographs from the early 1880s, the earliest known representations of an Edgefield face vessel (figs. 13, 14). **AS**

Pl. 43
Unrecorded potter
Face jug, ca. 1850–80
Alkaline-glazed stoneware with kaolin, H. 5 ⅞ in. (14.9 cm)
The Metropolitan Museum of Art, New York, Purchase, Friends of the American Wing Fund and Aliva Baker Gift, in honor of Derrick Beard, 2019 (2019.192)

This is one of two face vessels once owned by Mamie Deveaux, an African American fortune-teller who practiced in Savannah, Georgia, throughout the twentieth century, making them the only Edgefield face jugs with a known connection to a voodoo practitioner. A torn matchbook is affixed to the interior shoulder, evidence that the vessel may have been used in ritual or healing practices (fig. 44). Similarly, there are at least two face vessels that bear a small hole on their undersides (pl. 51 and another in the Augusta Museum of History, Georgia [1965.011]). Both holes appear to have been added after the objects were made, and may have been created to help facilitate spells. **AS**

Pl. 44
Unrecorded potter
Face cup, ca. 1850–80
Alkaline-glazed stoneware with kaolin, H. 4 ½ in. (11.4 cm)
McKissick Museum, University of South Carolina, Columbia, Gift of Mr. and Mrs. James P. Barrow (1998.37.120.02)

Pl. 45
Unrecorded potter
Face cup, ca. 1850–80
Alkaline-glazed stoneware with kaolin, H. 5 in. (12.7 cm)
Collection of Joseph P. Gromacki, Chicago

Pl. 46
Kongo artist, Vili group
Power figure, ca. 1850
Wood, iron, nails, blades, fragments, and fiber cord, H. 40 ¼ in. (103.5 cm)
University of Michigan Museum of Art, Ann Arbor, Gift of Candis and Helmut Stern (2005/1.192)

Growing evidence suggests that the late arrival of captive Africans from the Kongo region may have served as a catalyst for the reemergence of African-inspired art, religion, and culture in South Carolina. The aesthetic principles underlying the composition and manufacture of Edgefield face vessels recall the power figures of the Kongo *nkisi* tradition. A *nkisi* is a spiritual force with the power to harm, heal, or protect. Summoned by a ritual expert, or *nganga*, *nkisi* spirits were housed within the body of these fascinating objects. Africans in Kongo used kaolin for its medicinal and spiritual properties, and the articulation of the features of face vessels with kaolin likely continues a tradition first developed there. **JRY**

Pl. 47
Unrecorded potter
Face jug, ca. 1850–70
Alkaline-glazed stoneware with kaolin, H. 4 ½ in. (11.4 cm)
Collection of the Chipstone Foundation, Milwaukee, Wisconsin (2012.3)

Pl. 48
Unrecorded potter
Face jug, ca. 1850–80
Alkaline-glazed stoneware with kaolin, H. 5 ½ in. (14 cm)
Collection of Joseph P. Gromacki, Chicago

This face vessel is noteworthy for its early provenance, having descended in the family of Colonel Alfred Wagstaff Jr., who served as chief of staff of the Army of the Potomac at the end of the Civil War. How Wagstaff came to be in possession of the jug remains a mystery; however, it attests to an early interest in the enigmatic forms. Early documented histories of face vessels are extremely rare, although several were in prominent mid-Atlantic collections in the early twentieth century. **AS**

Pls. 49–51
Unrecorded potter
Face jug, ca. 1850–80
Alkaline-glazed stoneware with kaolin, H. 4 ¼ in. (10.8 cm)
Private collection

Unrecorded potter
Face jug, ca. 1850–80
Alkaline-glazed stoneware with kaolin, H. 5 in. (12.7 cm)
National Museum of American History, Smithsonian Institution, Washington, D.C., The Estate of Mary Elizabeth Sinnott (324313)

Unrecorded potter
Face jug, ca. 1850–80
Alkaline-glazed stoneware with kaolin, H. 4 in. (10.2 cm)
William C. and Susan S. Mariner Private Foundation

Even more than the industrially produced utilitarian wares, the face vessels show the hands of their makers. Smaller examples such as these, which measure about four or five inches high and the width and circumference of a closed fist, demonstrate their craftsmanship particularly well, with obvious thumb and finger indentations from when the vessel was being held and shaped as wet clay. **KCH**

Pl. 52
Unrecorded potter
Face jug, ca. 1850–80
Alkaline-glazed stoneware with kaolin, H. 4 in. (10.2 cm)
Hudgins Family Collection, New York

These three face vessels vary in the placement and modeling of their features
and in their glazes. Their larger scale provides more space for protruding
ears, eyebrows, noses, eyes, mouths, and teeth. The different approaches
distinguish the hands of the potters, such as in the eyebrows and teeth.
Two examples have individually sculpted teeth, and one boasts an extended
tongue, altering their temperaments. **KCH**

The overwhelming majority of the approximately one hundred and eighty
known nineteenth-century face vessels attributed to the Edgefield area
are jugs—a thrown vessel with a narrow neck and a small handle attached
to the shoulder. Fewer than a dozen are cups, including the two here that
appear to be made by the same person, characterized by the distinctive diag-
onal teeth. Pitchers are just as rare. The elongated form presented an
opportunity to experiment with different proportions and placement of
the features. **AS**

Chicago-based artist Theaster Gates introduced Dave to the contemporary
art world in his 2010 exhibition *To Speculate Darkly: Theaster Gates and
Dave the Potter* (fig. 22). Using a poem jar (pl. 33) as his anchor point, Gates
explored his connection to Dave and the ongoing struggles of Black artists
through film, installation, music, and performance. In *Signature Study,* Gates
revisited Dave's work by inscribing his signature into a clay brick.

 Other artists have focused on the form of Edgefield pottery, with scale
a defining characteristic of their work. Simone Leigh monumentalizes
Edgefield vessels. Woody De Othello's *Applying Pressure,* a work with ties
to Edgefield and African *nkisi*, is a cartoonishly large face jug with distorted
features. Robert Pruitt's large-scale drawings depict staff members from
the Museum of Fine Arts, Boston, manipulating face jugs in the collection,
bringing life to the vessels while questioning museum practices.

 For two years, Adebunmi Gbadebo has traveled to the former True
Blue Plantation in Fort Motte, South Carolina, where her ancestors were
enslaved. There, at the burial ground for the enslaved, she collects clay
for her sculptures, turning the earth that ran through the hands of her
ancestors into vessels that commemorate the history of her family. *In
Memory of Pirecie McCory* holds rice like that once grown at True Blue,
while *K. S.* sprouts locs of human hair. **EWL**

VERSES BY DAVE

1834

Jar (two handles), H. 19 ¼ in. (48.9 cm), Private collection
Concatination / 12th June 1834

Jar (two handles), H. 19 ¼ in. (48.9 cm), South Carolina State Museum, Columbia
put every bit all between / surely this Jar will hold 14 / 12 July 1834

Jar (two handles), H. 19 in. (48.3 cm), Private collection, on loan to the South Carolina State Museum, Columbia
oh the moon & the stars / hard work to make big Jars / 22d aug 1834 / Aug 22d 1834

1836

Jar (two handles), H. 16 ⅛ in. (41 cm), Private collection
horses mules and hogs— / all our cows is in the bogs— / there they shall ever stay / till the buzzards take them away = / 29th March 1836

Jar (two handles), H. 14 ½ in. (36.8 cm), Fine Arts Museums of San Francisco
Catination / 12 April 1836

Jug (two handles), H. 17 ¼ in. (43.8 cm), High Museum of Art, Atlanta
better thing, I never saw / when I shot off, the lions Jaw / 9 November 1836

1840

Jug (two handles), H. 17 ⅜ in. (44.1 cm), Virginia Museum of Fine Arts, Richmond
Ladys & gentlemens Shoes = / sell all you can: & nothing you'll loose! X / January 29th 1840 / L Miles Dave

Jar (two handles), H. 14 ½ in. (36.8 cm), Private collection
Give me silver or; either Gold = / though they are dangerous; to our · Soul = / 27th June 1840 / Mr. L Miles Dave

Jar (two handles), H. 15 in. (38.1 cm), Greenville County Museum of Art, Greenville, South Carolina
whats better than Kissing— / while we both are at fishing / July 10th, 1840 / Mr L Miles Dave

Jar (two handles), H. 15 ¼ in. (38.7 cm), Charleston Museum, South Carolina
Dave belongs to Mr. Miles / whir the oven bakes & the pot biles / 31st July 1840

Jar (two handles), H. 15 ¾ in. (40 cm), Greenville County Museum of Art, Greenville, South Carolina
Edgefield District / 25th August 1840 / Mr. L Miles Dave

Jar (two handles), H. 15 ⅜ in. (39.1 cm), Greenville County Museum of Art, Greenville, South Carolina
another trick is worst than this / Dearest miss; spare me a Kiss / 26th August 1840 / L. miles Dave

1843

Jar (two handles), H. 29 in. (73.7 cm), Private collection
Mr. L Miles Dave / not counted / 16 May 1843

1850

Jar (two handles), H. 24 in. (61 cm), Private collection
just a mammouth Jar [illegible] / for I not [illegible] / 17 October 1850

1852

Jar (two handles), H. 17 in. (43.2 cm), Greenville County Museum of Art, Greenville, South Carolina
cash wanted / May 17 — 1852 / Lm

1854

Jug (one handle), H. 13 ¼ in. (33.7 cm), Private collection
Lm says this handle / will crack / June 28 1854 / Dave

1857

Jar (two handles), H. 21 ¾ in. (55.2 cm), McKissick Museum, University of South Carolina, Columbia
for Mr. John monday / Lm July 6 – 1857

Jar (two handles), H. 19 in. (48.3 cm), Greenville Museum of Art, South Carolina
I wonder where is all my relation / Friendship to all—and every nation / Lm Aug 16, 1857 Dave

Jar (two handles), H. 19 in. (48.3 cm), Museum of Fine Arts, Boston
I made this Jar = for cash— / though its called = lucre Trash / Dave / Lm Aug. 22, 1857 / Dave

Jar (two handles), H. 19 in. (48.3 cm), McKissick Museum, University of South Carolina, Columbia
a pretty little Girl, on a virge / Volcaic mountain, how they burge / Dave / Lm·Aug 24 1857 / Dave

1858

Jar (two handles), H. 20 ½ in. (52.1 cm), Private collection
Making this Jar = I had all thougts / Lads & gentlemen = never out walks / 30 January 1858 / Lm Dave

Jar (four handles), H. 26 in. (66 cm), Private collection
A noble jar / For lard or tar / 20 February 1858 / Lm Dave

Churn (two handles), H. 27 in. (68.6 cm), Greenville County Museum of Art, Greenville, South Carolina
this is a noble churn / fill it up, it will never turn, / Dave / Lm March 19 1858

Jar (two handles), H. 22 in. (55.9 cm), High Museum of Art, Atlanta
I made this for our- sott / It will x never—never, rott / L.m. march 31. 1858 / Dave

180

Jar (two handles), H. 24 in. (61 cm), Private collection
This noble Jar = will hold, 20/fill it with silver = then you'll have
plenty/Lm April 8 1858/Dave

Jar (four handles), H. 24 ½ in. (62.2 cm), Crystal Bridges Museum of
American Art, Bentonville, Arkansas
A very Large Jar which has 4 handles =/pack it full of fresh meats—then
light candles—/Lm April 12 1858/Dave

Jar (two handles), H. 22 ⅝ in. (57.5 cm), The Metropolitan Museum of
Art, New York
this Jar is to Mr Segler who keeps the bar in orangeburg/For Mr Edwards a
Gentle man—who formly kept/Mr thos bacons horses/April 21 1858/when
you fill this Jar with pork or beef/Scot will be there; to Get a peace,—/Dave

Jar (two handles), H. 20 ¼ in. (51.4 cm), Greenville County Museum of Art,
Greenville, South Carolina
the sun moon and—stars =/in the west are a plenty of—bears `'/Lm
July 23 1858/Dave

Jar (two handles), H. 24 ¼ in. (61.6 cm), Museum of Early Southern
Decorative Arts, Winston-Salem, North Carolina
I saw a leppard, & a lions face,"/then I felt the need of—Grace/L.m.
nover 3 · 1858/Dave

Jar (two handles), H. 21 in. (53.3 cm), Private collection
nineteen days before Christmas—Eve—/Lots of people after its over,
how they will greave,/Lm December 6. 1858/Dave

Jar (two handles), H. 15 in. (38.1 cm), National Museum of American
History, Smithsonian Institution, Washington, D.C.
· Mark and/· —Dave—/L · m · March 10 · 1859

Jar (two handles), H. 21 in. (53.3 cm), Private collection
I made this out numer, & cross `'/if you do not listen at the bible you'll
be lost—/Lm march 25th 1859/Dave

Jar (two handles), dimensions unknown, Private collection
Over noble Dr. Landrum's head/May guardian angels visit his bed/
April 14 1859

Jar (two handles), H. 19 ½ in. (49.5 cm), Private collection
here is eight teen; hundred · & fifty nine/unto you all I fell in, cline"/Lm
April 18 1859/Dave

Jar (two handles), H. 26 ½ in. (67.3 cm), Philadelphia Museum of Art
Good for lard—or holding—fresh meats =/blest we were—when peter
saw the folded sheets/Lm may 3d 1859/Dave

Jar (four handles), H. 25 ¾ in. (65.4 cm), Charleston Museum, South
Carolina
Great & Noble Jar/hold Sheep goat or bear/Lm ·/May 13 · 1859/Dave
&/Baddler

Jar (four handles), H. 28 ¾ in. (73 cm), Charleston Museum, South Carolina
made at Stoney bluff;/for making dis old gin enuff/May 13 · 1859 ·
Dave &/Baddler

Jar (two handles), H. 24 in. (61 cm), Atlanta History Center
the fourth of July—is Surely come/to blow the fife = and beat the drum
///Lm July 1859/Dave

Jug (two handles), H. 16 ¼ in. (41.3 cm), Private collection
Rev. W. A. Lawton/July 19 1859

Jar (two handles), H. 16 ¾ in. (42.5 cm), Private collection
I Saw a leopard, & a lions face/then I felt, the need of Grace/Lm August 7
1860/Dave

Jar (two handles), H. 21 ½ in. (54.6 cm), Private collection
A noble Jar, for pork or beef—/then carry it. a round to the indian
chief/Lm November 9 1860/Dave

Jar (two handles), H. 20 ½ in. (52.1 cm), National Museum of American
History, Smithsonian Institution, Washington, D.C.
I, made this Jar, all of cross/If, you dont repent, you will be, lost =/Lm
May 3 - d 1862/Dave

Jar (two handles), ca. 1835, H. 14 ⅛ in. (35.9 cm), Greenville County
Museum of Art, Greenville, South Carolina
Dry

Jar (two handles), 1850s, H. 15 in. (38.1 cm), Princeton University Art
Museum, New Jersey
Princeton College in New Jersey

Jar (two handles), 1850s, H. 12 ⅝ in. (32.1 cm), Charleston Museum,
South Carolina
H. Panzerbieter/Groceries/King & Columbia/Charleston/S.C.

Jar (two handles), 1850s, H. 12 ⅝ in. (32.1 cm), Private collection
H. Panzerbieter/Groceries/King & Columbus Street/Charleston/S.C.

Jug (two handles), 1850s, H. 14 ¼ in. (37.5 cm), Private collection
Panzerbider/Groceries/King and Columbus Streets/Charleston/S.C.

Jar (two handles), ca. 1860, H. 15 in. (38.1 cm), Greenville County
Museum of Art, Greenville, South Carolina
Think of me when/far away Rosa D G Wever/Mr Milton Miles/Edgefield

Jug (one handle), H. 8 ¾ in. (22.2 cm), Private collection
New/X

NOTES

Preface
Adrienne Spinozzi

1 Janeen Bryant et al., "The White Supremacy Elephant in the Room," *Museum* (American Alliance of Museums) 100, no. 1 (January–February 2021), p. 44.

2 Kelli Morgan, "A Seat at the Table of Systemic Racism in Art Museums," TEDxIndianaUniversity, March 2021, https://www.ted.com/talks/kelli _morgan_a_seat_at_the_table_of_systemic_racism_in_art_museums.

The Art of Enslaved Labor
Vincent Brown

The author wishes to thank Michael J. Bramwell, Manuelita Brown, Dan Byers, Jayne Kuchna, Ethan W. Lasser, Briana Parker, Adrienne Spinozzi, Ajantha Subramanian, Nurdan Yildirim, and Jason R. Young for helpful comments and suggestions regarding earlier drafts of this essay.

1 "Buttermilk," *Edgefield Advertiser*, April 1, 1863, p. 2. Arthur Simkins was the editor of the newspaper.

2 For the definition of slavery as the "permanent, violent domination of natally alienated and generally dishonored persons," see Orlando Patterson, *Slavery and Social Death: A Comparative Study* (Cambridge, Mass.: Harvard University Press, 1982), p. 13.

3 Cinda K. Baldwin, *Great and Noble Jar: Traditional Stoneware of South Carolina* (Columbia: McKissick Museum, University of South Carolina; Athens: University of Georgia Press, 1993), pp. 76, 89. On the practice of dishonoring the enslaved by renaming them, see Ira Berlin, *Many Thousands Gone: The First Two Centuries of Slavery in North America* (Cambridge, Mass.: Belknap Press of Harvard University Press, 1998), pp. 95–96. On emancipated people renaming themselves, and sometimes adopting the names of former slaveholders, see Ira Berlin, *Generations of Captivity: A History of African-American Slaves* (Cambridge, Mass.: Belknap Press of Harvard University Press, 2003), pp. 105–6, 121, 260–61.

4 Interview with Theaster Gates, Milwaukee Art Museum, February 16, 2010, https://www.youtube.com/watch?v=DbHWOOR8rps.

5 Jori Finkel, "The Enslaved Artist Whose Pottery Was an Act of Resistance," *New York Times*, June 17, 2021, https://www.nytimes.com /2021/06/17/arts/design/-enslaved-potter-david-drake-museum.html.

6 James A. McMillin, *The Final Victims: Foreign Slave Trade to North America, 1783–1810* (Columbia: University of South Carolina Press, 2004); Rachel N. Klein, *Unification of a Slave State: The Rise of the Planter Class in the South Carolina Backcountry, 1760–1808* (Chapel Hill: University of North Carolina Press for the Omohundro Institute of Early American History and Culture, Williamsburg, Va., 1990).

7 "Trans-Atlantic Slave Trade: Estimates," SlaveVoyages, Rice University, accessed August 31, 2021, http://www.slavevoyages.org/estimates /jXbkf4Lk.

8 Orville Vernon Burton, *In My Father's House Are Many Mansions: Family and Community in Edgefield, South Carolina* (Chapel Hill: University of North Carolina Press, 1985), p. 20, table 1-1; Steven Deyle, "The Irony of Liberty: Origins of the Domestic Slave Trade," *Journal of the Early Republic* 12, no. 1 (Spring 1992), pp. 37–62; "Trans-Atlantic Slave Trade: Estimates," SlaveVoyages, Rice University, accessed August 31, 2021, http://www.slavevoyages.org /estimates/ZIlEcooS.

9 Frantz Fanon, *The Wretched of the Earth*, trans. Richard Philcox (1961; New York: Grove Press, 2004), p. 133.

10 It is often said that creativity is choice, an axiom that makes more sense in a liberal democracy than in a slaveholder tyranny.

11 Walter Johnson, *River of Dark Dreams: Slavery and Empire in the Cotton Kingdom* (Cambridge, Mass.: Belknap Press of Harvard University Press, 2013), pp. 164–65.

12 John Michael Vlach, "David Drake: Potter, Poet, Rebel," in *The Individual and Tradition: Folkloristic Perspectives*, edited by Ray Cashman, Tom Mould, and Pravina Shukla (Bloomington: Indiana University Press, 2011), p. 351.

13 Vlach, "David Drake," p. 347. On slaveholders' anxiety over British emancipation, see Edward Bartlett Rugemer, *The Problem of Emancipation: The Caribbean Roots of the American Civil War* (Baton Rouge: Louisiana State University Press, 2008).

14 Baldwin, *Great and Noble Jar*, p. 79.

15 Edwin AtLee Barber, *The Pottery and Porcelain of the United States: An Historical Review of American Ceramic Art from the Earliest Times to the Present Day*, 2nd edition (1893; New York: G. P. Putnam's Sons, 1901), p. 466; also quoted in Baldwin, *Great and Noble Jar*, p. 79.

16 Baldwin, *Great and Noble Jar*, pp. 80–83; Sebastian Smee, "A Thing of Beauty," *Washington Post*, July 22, 2020.

17 Vlach, "David Drake," pp. 343–44, 347–48. On the denial of kinship and affective ties as a foundational element of hereditary racial slavery, see Jennifer L. Morgan, *Reckoning with Slavery: Gender, Kinship, and Capitalism in the Early Black Atlantic* (Durham, N.C.: Duke University Press, 2021).

18 Glenda R. Carpio, *Laughing Fit to Kill: Black Humor in the Fictions of Slavery* (New York: Oxford University Press, 2008), p. 231.

19 Vlach, "David Drake," p. 347.

20 "Buttermilk," p. 2; also quoted in Vlach, "David Drake," p. 344.

21 Carpio, *Laughing Fit to Kill*, p. 4.

22 Carpio, *Laughing Fit to Kill*, p. 7.

Confronting, Collecting, and Celebrating Edgefield Stoneware
Adrienne Spinozzi

1 "State Pottery Interesting: Museum Staff Members Recently Completed Survey of Kilns," *Charleston Evening Post*, July 22, 1930, p. 2.

2 Paul M. Rea, "History of Culture," *Bulletin of the Charleston Museum* 15, no. 3 (March 1919), p. 35. In 1915, the museum, one of the oldest collecting institutions in the country, separated from the College of Charleston, becoming the Charleston Museum.

3 Paul M. Rea, "Report of the Director of the Museum for the Year 1919," *Bulletin of the Charleston Museum* 16, no. 1 (January 1920), pp. 9–10.

4 This storage jar (Charleston Museum, South Carolina, 1919.5) was acquired for the museum in February 1919 by Captain Samuel G. Stoney, trustee and former president of the museum's board. Captain Stoney purchased the jar for ten dollars from John Klenke of Charleston, who was also affiliated with the institution. Receipt of purchase, February 11, 1919, and notes on the acquisition on receipt for incoming packages, February 11, 1919, bursar's office, Charleston Museum, in the Directors' Correspondence, Paul M. Rea, Charleston Museum Records Collection, Charleston Museum Archives.

5 Paul M. Rea, "Recent Accessions," *Bulletin of the Charleston Museum* 15, no. 3 (March 1919), p. 36.

6 This storage jar (Charleston Museum, 1920.39) was acquired in June 1920, given to the museum by the Carwile family of Ridge Spring, South Carolina. According to documentation in the museum archives, the Carwile family purchased it from the estate of James Sullivan of Edgefield. Sullivan's wife had inherited it from her grandfather Col. Richard Griffin of Greenwood. The jar was brought to Rea's attention by a letter: "These utensils were used to keep fresh meat in and the verse on the jar bears this out. They would bury it in the 'smoke-house' and pack charcoal around it to keep the meat cool. . . . They were also used for pickling meat." J. M. Eleazer, county agent of Saluda County, South Carolina, to Paul M. Rea, April 15, 1919, Directors' Correspondence, Paul M. Rea, Charleston Museum Records Collection, Charleston Museum Archives. See also Paul M. Rea, "Solution of the Puzzle of the Jar," *Bulletin of the Charleston Museum* 15, no. 4 (April 1919), pp. 44–46.

7 Louise Anderson Allen, *A Bluestocking in Charleston: The Life and Career of Laura Bragg* (Columbia: University of South Carolina Press, 2001), pp. 76, 80, 237, n. 29.

8 Laura M. Bragg, "Report of the Director of the Museum for the Year 1920," *Bulletin of the Charleston Museum* 17, no. 1–2 (January–February 1921), p. 2.

9 Helen von Kolnitz, "South Carolina Culture Exhibit," *Bulletin of the Charleston Museum* 16, no. 6–7 (October–November 1920), p. 53. Accession paperwork in the Charleston Museum Archives lists objects coming into the museum with descriptions that are often limited to the plantation from which they originated. Notes on accession

memorandum, June 19, 1919, bursar's office, Charleston Museum, in the Directors' Correspondence, Paul M. Rea, Charleston Museum Records Collection, Charleston Museum Archives.

10 In 1930 Bragg brought 252 pottery sherds into the collection. Jennifer McCormick, chief of collections and archivist, Charleston Museum, email message to the author, September 14, 2021.

11 Laura M. Bragg to O. B. Anderson, August 31, 1927, Directors' Correspondence, Laura M. Bragg, Charleston Museum Records Collection, Charleston Museum Archives.

12 Pearle Felder Danner, wife of Rev. Samuel Winfield Danner, descended from a long line of Orangeburg Felders; her paternal great-great-great grandfather, Henry Felder, was a Revolutionary War hero. National Society of the Daughters of the American Revolution, *Lineage Book*, vol. 74 (Washington, D.C.: Judd and Detweiler, 1924), pp. 362–63.

13 Pearle Felder Danner to Laura M. Bragg, February 20, 1930, Directors' Correspondence, Laura M. Bragg, Charleston Museum Records Collection, Charleston Museum Archives.

14 Laura M. Bragg to Pearle Felder Danner, February 21, 1930, Directors' Correspondence, Laura M. Bragg, Charleston Museum Records Collection, Charleston Museum Archives.

15 "Notes Collected on Trip to Various Potteries. Miss L.M.B & E.B.C., June 24–26, 1930" (quotation on page 2); see also "Notes Made on Trip to Seigler's Pottery, near Eureka, S.C., October 4, 1930." Reports prepared by E. Burnham Chamberlain. Directors' Correspondence, Laura M. Bragg, Charleston Museum Records Collection, Charleston Museum Archives.

16 Pearle Felder Danner to Laura M. Bragg, June 11, 1930, Directors' Correspondence, Laura M. Bragg, Charleston Museum Records Collection, Charleston Museum Archives.

17 The clay deposits across the region (in areas of present-day Georgia, North Carolina, South Carolina, and Virginia) have been known for centuries and are still mined for clay today. In 1767–68 Thomas Wedgwood of Britain's Staffordshire industry sent for clay samples from the settlement of Keowee in North Carolina, an indication of the area's rich resources. See Brooke Elizabeth Kenline, "Capitalist Entrepreneurs and Industrial Slavery in the Rural Antebellum South" (master's thesis, University of South Carolina, 2012), p. 23.

18 *Augusta Chronicle*, July 15, 1809, as cited in Carl Steen, "Alkaline Glazed Stoneware Origins," *South Carolina Antiquities* 43 (2011), p. 22; this article also appeared in the *Charleston Gazette*, July 25, 1809, as cited in George W. Calfas, "Nineteenth Century Stoneware Manufacturing at Pottersville, South Carolina: The Discovery of a Dragon Kiln and the Reinterpretation of a Southern Pottery Tradition" (PhD diss., University of Illinois at Urbana-Champaign, 2013), p. 41. For a detailed overview of the origins of stoneware production in the region, see Steen, "Alkaline Glazed Stoneware Origins," pp. 21–31.

19 Calfas, "Nineteenth Century Stoneware Manufacturing," pp. 66–68.

20 Steen, "Alkaline Glazed Stoneware Origins," pp. 25–26, 28; Kenline, "Capitalist Entrepreneurs," p. 26.

21 For a comprehensive account of the history of Edgefield, see Orville Vernon Burton, *In My Father's House Are Many Mansions: Family and Community in Edgefield, South Carolina* (Chapel Hill: University of North Carolina Press, 1985).

22 The definitive source on the Pottersville kiln site is Calfas, "Nineteenth Century Stoneware Manufacturing." Further interpretations, including several conjectural reconstructive drawings, can be found in Robert Hunter and Oliver Mueller-Heubach, "Visualizing the Stoneware Potteries of William Rogers of Yorktown and Abner Landrum of Pottersville," *Ceramics in America* (Chipstone Foundation, Milwaukee, Wisc.), 2019, pp. 113–34. For a contemporaneous description of Pottersville, see Robert Mills, *Statistics of South Carolina, including a View of Its Natural, Civil, and Military History, General and Particular* (Charleston, S.C.: Hurlbut and Lloyd, 1826), pp. 523–24.

23 Calfas, "Nineteenth Century Stoneware Manufacturing," pp. 240–41.

24 Carl Steen and Corbett E. Toussaint, "Who Were the Potters in the Old Edgefield District?," *Journal of African Diaspora Archaeology and Heritage* 6, no. 2 (2017), p. 78.

25 See Steen and Toussaint, "Potters in the Old Edgefield District," p. 81, table 1, and p. 82, fig. 3.

26 Jill Beute Koverman, "Searching for Messages in Clay: What Do We Really Know about the Poetic Potter, Dave?," in *I Made This Jar . . . : The Life and Works of the Enslaved African-American Potter, Dave*, ed. Jill Beute Koverman, exh. cat. (Columbia: McKissick Museum, University of South Carolina, 1998), p. 23; Kenline, "Capitalist Entrepreneurs," p. 8.

27 Burton, *In My Father's House*, pp. 35–38.

28 Burton, *In My Father's House*, pp. 34, 40, 44.

29 For figures on the population of Edgefield from 1790 to 1900, see Burton, *In My Father's House*, p. 20, table 1-1.

30 Claudia A. Mooney, April L. Hynes, and Mark M. Newell, "African-American Face Vessels: History and Ritual in 19th-Century Edgefield," *Ceramics in America* (Chipstone Foundation, Milwaukee, Wisc.), 2013, pp. 15–16.

31 The stoneware production at Lewis Miles's potteries Stony Bluff Manufactory (ca. 1848–67) and Miles Mill Pottery (1867–85) was on a massive scale. Notes taken by Laura M. Bragg in July 1930 provide some sense of the size of the properties: "Big plantation house. 50 negro houses. Had 250 slaves. About 5000 acres." "Pottery: Information Given by Mr. G. U. Flesher, 7/8/30," p. 2; typescript prepared by E. Burnham Chamberlain from handwritten notes taken by Laura M. Bragg, Directors' Correspondence, Laura M. Bragg, Charleston Museum Records Collection, Charleston Museum Archives.

32 Kenline, "Capitalist Entrepreneurs," p. 3. For a detailed account of the enslaved labor at Buffalo Forge, an ironmaking enterprise in Virginia, see Charles B. Dew, *Bond of Iron: Master and Slave at Buffalo Forge* (New York: W. W. Norton, 1994).

33 The announcement appeared in the *Edgefield Advertiser* on April 2, 1840, p. 3; also cited in Cinda K. Baldwin, *Great and Noble Jar:*

Traditional Stoneware of South Carolina (Columbia: McKissick Museum, University of South Carolina; Athens: University of Georgia Press, 1993), p. 46.

34 By 1825 it was reported that there were at least fourteen "principal Wholesale Merchants" and "two hundred shop-keepers and traders" in Hamburg; as quoted in Tom Downey, *Planting a Capitalist South: Masters, Merchants, and Manufacturers in the Southern Interior, 1790–1860* (Baton Rouge: Louisiana State University Press, 2006), pp. 77–78.

35 Kenline, "Capitalist Entrepreneurs," p. 25.

36 See an 1866 Freedmen's Bureau agreement between Benjamin Franklin Landrum and Simon, Dave, Sam, Selia, Kittie, and Ann; Corbett E. Toussaint, "Edgefield District Stoneware: The Potter's Legacy," *Journal of Early Southern Decorative Arts* 41 (2020), p. 292, and p. 294, fig. 21. Other documentation includes a lease agreement from 1866 between Lewis J. Miles and Willis Harrison, Pharaoh Jones, and Mark Miles; Leonard Todd, *Carolina Clay: The Life and Legend of the Slave Potter Dave* (New York: W. W. Norton, 2008), pp. 170–71, and ill. of the lease agreement following p. 144; Toussaint, "Edgefield District Stoneware," p. 292, and p. 293, fig. 20.

37 See Toussaint, "Edgefield District Stoneware," appendix A, p. 320.

38 For more on the Wilson potteries, see Michael K. Brown, *The Wilson Potters: An African-American Enterprise in 19th-Century Texas*, exh. cat. (Houston: Bayou Bend Collection and Gardens, Museum of Fine Arts, 2002).

39 Stephen T. Ferrell and Terry M. Ferrell in *Early Decorated Stoneware of the Edgefield District, South Carolina*, exh. cat. (Greenville, S.C.: Greenville County Museum of Art, 1976), n.p. The storage jar in The Met collection (2020.7, pl. 33) weighs 82 pounds.

40 See the essay by Jason R. Young in this volume.

41 Victoria Dailey, "The Wilde Woman and the Sunflower Apostle," *Book Collector* 68, no. 4 (Winter 2019), pp. 639–40; also published as "The Wilde Woman and the Sunflower Apostle: Oscar Wilde in the United States," *Los Angeles Review of Books*, February 8, 2020, https://lareviewofbooks.org/article/the-wilde-woman-and-the-sunflower-apostle-oscar-wilde-in-the-united-states/.

42 The earliest published reference to Edgefield face vessels as "monkey jugs" appears in an article by noted ceramics collector and historian Edwin AtLee Barber, "Some Curious Old Water Coolers Made in America," *Clay-Worker* 34, no. 5 (November 1900), pp. 352–53; the article is accompanied by a hand-drawn illustration of a face vessel. The same image is reproduced in Edwin AtLee Barber, *The Pottery and Porcelain of the United States: An Historical Review of American Ceramic Art from the Earliest Times to the Present Day*, 2nd edition (New York: G. P. Putnam's Sons, 1901), p. 466. The previous edition of Barber's book, from 1893, did not mention face vessel production.

43 John A. Burrison, "Fluid Vessel: Journey of the Jug," *Ceramics in America* (Chipstone Foundation, Milwaukee, Wisc.), 2006, pp. 109–10. It is unclear when the term "monkey" was first used for this jug design.

44 Referring to Edgefield face vessels, Edwin AtLee Barber writes, "I have seen no less than five of them, all of the same type and appearance, varying only in size." Barber, "Some Curious Old Water Coolers," p. 352.

45 Mary H. Ravenel to Bessie P. Ravenel, April 16, 1919, Directors' Correspondence, Paul M. Rea, Charleston Museum Records Collection, Charleston Museum Archives.

46 Charleston Museum, 1902.11 (HC 1249), 1902.11 (HC 1258), and 1920.25 (HC 1256).

47 Memorandum, "Edgefield County Pottery," n.d. (ca. 1919), Directors' Correspondence, Paul M. Rea, Charleston Museum Records Collection, Charleston Museum Archives.

48 Philadelphia Museum of Art (1904-36, 1904-37, and 1917-196); The Metropolitan Museum of Art, New York (22.26.4 [pl. 39]); National Museum of American History, Smithsonian Institution, Washington, D.C. (324313 [pl. 50], 324314, and 379677); New York Historical Society (1937.1409 and 1937.1410).

49 Examples of Edgefield face vessels have been linked to the following individuals: George S. McKearin (1874–1958) of New York; Henry Chapman Mercer (1856–1930) of Doylestown, Pennsylvania; Horace J. Smith (1832–1906) of Philadelphia (see pl. 45); Col. Alfred Wagstaff Jr. (1844–1921) of New York (see pl. 48); and Lura Burgess Woodside Watkins (1887–1982) of Middleton, Massachusetts. Research on early collectors of face vessels is ongoing. For the example formerly in the Horace J. Smith collection (pl. 45), see Robert Hunter, "Made in Africa: Origins of the Edgefield Face Vessel," *Ceramics in America* (Chipstone Foundation, Milwaukee, Wisc.), 2022 (forthcoming).

50 Dr. John Eldon Hoar (1937–2022), of Huntsville, Alabama, a dentist and longtime Edgefield collector, became a serious student of the face vessels and was the first to systematically locate, document, and catalogue every known example. His more than thirty years of research will appear in a forthcoming book by Philip Wingard, anticipated for publication by the Greenville County Museum of Art, Greenville, South Carolina, in 2023.

51 For example, in the first half of the twentieth century, various donors gifted pieces of Edgefield pottery to the University of South Carolina. When the university established McKissick Museum in 1976, it transferred this pottery from the South Caroliniana Library to the museum. Christian M. Cicimurri, curator of collections, McKissick Museum, email message to the author, October 12, 2021.

52 The first professional archaeologists to survey Old Edgefield sites include Mark M. Newell and Stanley South, then of the South Carolina Institute of Archaeology and Anthropology. Serious avocational archaeologists include Dr. Fred E. Holcombe and Joe L. Holcombe.

53 Stephen T. Ferrell and Terry M. Ferrell in *Early Decorated Stoneware*, n.p.

54 John Michael Vlach, *The Afro-American Tradition in Decorative Arts*, exh. cat. (Cleveland: Cleveland Museum of Art, 1978).

55 Robert Farris Thompson, "The Structure of Recollection: The Kongo New World Visual Tradition," in Robert Farris Thompson and Joseph Cornet, *The Four Moments of the Sun: Kongo Art in Two Worlds*, exh. cat. (Washington, D.C.: National Gallery of Art, 1981), pp. 157–59.

56 Regenia A. Perry, *Spirits or Satire: African-American Face Vessels of the 19th Century*, exh. cat., Gibbes Art Gallery, Charleston, S.C. (Charleston, S.C.: Carolina Art Association, 1985).

57 Todd, *Carolina Clay*, p. 253. Todd has deposited archival records on the Landrum family at the James B. Duke Library, Furman University, Greenville, South Carolina.

58 Arthur F. Goldberg and James P. Witkowski, "Beneath His Magic Touch: The Dated Vessels of the African-American Slave Potter Dave," *Ceramics in America* (Chipstone Foundation, Milwaukee, Wisc.), 2006, pp. 59–92; James P. Witkowski, Arthur F. Goldberg, and Deborah A. Goldberg, "Marking Time: The Dated Vessels of David Drake," in *The Words and Wares of David Drake: Revisiting "I Made This Jar" and the Legacy of Edgefield Pottery*, ed. Jill Beute Koverman and Jane Przybysz (Columbia: University of South Carolina Press, 2022) (forthcoming).

59 See Toussaint, "Edgefield District Stoneware," appendix A, pp. 318–55.

60 April L. Hynes identified descendants of David Drake and Caroline and Mark Jones in 2017. Hynes is currently working on *The Wanderer Project*, part of a multiyear effort to uncover information about African connections to nineteenth-century Edgefield, with a focus on face vessel traditions. For more information, see https://thewandererprojects.com.

61 In July 2021, a large poem jar by David Drake (pl. 32) sold at auction to the Crystal Bridges Museum of American Art, Bentonville, Arkansas, for $1.56 million, establishing a new record for American ceramics. According to the auction house, four museums were bidding on the jar. See Greg Smith, "Meaning Is Everything: New Highs for American Pottery Push a Landmark Crocker Farm Sale," *Antiques and the Arts Weekly* (Newtown, Conn.), updated August 18, 2021, https://www.antiquesandthearts.com/meaning-is-everything-new-highs-for-american-pottery-push-a-landmark-crocker-farm-sale/ (a version of the article appeared in print on August 27, 2021, p. 45).

62 See James A. Miller, "Dave the Potter and the Origins of African-American Poetry," in *I Made This Jar*, pp. 53–60.

63 Michael A. Chaney, ed., *Where Is All My Relation? The Poetics of Dave the Potter* (New York: Oxford University Press, 2018). See Koverman and Przybysz, *Words and Wares of David Drake*, for new perspectives on the subject.

Incidents in the Life of an Enslaved Abolitionist Potter Written by Others
Michael J. Bramwell and Ethan W. Lasser

The authors would like to thank Vincent Brown, Edward Cooke, Theaster Gates, the late Arthur F. Goldberg, Briana Parker, Jon Prown, Adrienne Spinozzi, James P. Witkowski, and Jason R. Young.

1 Jill Beute Koverman, "The Ceramic Works of David Drake, aka, Dave the Potter or Dave the Slave of Edgefield, South Carolina," *American Ceramic Circle Journal* 13 (2005), p. 84.

2 Zora Neale Hurston, *Dust Tracks on a Road: An Autobiography* (Philadelphia: J. B. Lippincott, 1942), p. 36.

3 W. E. B. Du Bois, *The Souls of Black Folk: Essays and Sketches* (Chicago: A. C. McClurg, 1903), p. 3.

4 For a list of 169 wares attributed to Dave, see Arthur F. Goldberg and James P. Witkowski, "Beneath His Magic Touch: The Dated Vessels of the African-American Slave Potter Dave," *Ceramics in America* (Chipstone Foundation, Milwaukee, Wisc.), 2006, pp. 67–70, table 1. A forthcoming essay by James P. Witkowski, Arthur F. Goldberg, and Deborah A. Goldberg, "Marking Time: The Dated Vessels of David Drake," in *The Words and Wares of David Drake: Revisiting "I Made This Jar" and the Legacy of Edgefield Pottery*, ed. Jill Beute Koverman and Jane Przybysz (Columbia: University of South Carolina Press, 2022), will list some three hundred attributions; James P. Witkowski, email message to Michael J. Bramwell and Ethan W. Lasser, September 28, 2021. Fragments indicate that Dave inscribed many objects beyond the surviving corpus of intact wares.

5 Robert Hunter and Oliver Mueller-Heubach discuss the operational sequence of pottery production in "Visualizing the Stoneware Potteries of William Rogers of Yorktown and Abner Landrum of Pottersville," *Ceramics in America* (Chipstone Foundation, Milwaukee, Wisc.), 2019, pp. 130–32.

6 Aaron De Groft, "Eloquent Vessels / Poetics of Power: The Heroic Stoneware of 'Dave the Potter,'" in "Race and Ethnicity in American Material Life," special issue, *Winterthur Portfolio* 33, no. 4 (Winter 1998), pp. 249, 252.

7 James C. Scott, "Everyday Forms of Resistance," *Copenhagen Papers in East and Southeast Asian Studies* 4 (1989), pp. 33–62.

8 Audre Lorde, "The Master's Tools Will Never Dismantle the Master's House," in *Sister Outsider: Essays and Speeches* (Trumansburg, N.Y.: Crossing Press, 1984), pp. 110–13.

9 Cinda K. Baldwin, *Great and Noble Jar: Traditional Stoneware of South Carolina* (Columbia: McKissick Museum, University of South Carolina; Athens: University of Georgia Press, 1993), p. 1. One pot is marked "Edgefield District," an indication of origin likely offered in the hopes of future orders. Others are dedicated to patrons in other cities: to a barkeeper in Orangeburg, a grocer in Charleston, to Rosa who is invited to "think of me when / far away."

10 We borrow the term "imagined community" from Benedict Anderson, *Imagined Communities: Reflections on the Origin and Spread of Nationalism*, rev. edition (1983; London: Verso, 2006).

11 Calvin Schermerhorn, *Unrequited Toil: A History of United States Slavery* (Cambridge: Cambridge University Press, 2018), p. 73.

12 Janet Duitsman Cornelius, *"When I Can Read My Title Clear": Literacy, Slavery, and Religion in the Antebellum South* (Columbia: University of South Carolina Press, 1991), p. 37: "Of all the Southern states which restricted black literacy, South Carolina passed the harshest law." See also Goldberg and Witkowski, "Beneath His Magic Touch," p. 91, n. 40; Schermerhorn, *Unrequited Toil*, p. 71. Michael J. Bramwell discusses the traumatic conditions under which Dave lived and worked in South Carolina, and the way they were designed to prevent the full realization of his personhood and potential. See Michael J. Bramwell, "Potter's Field: Trauma and Representation in the Art of David Drake," in *Where Is All My Relation? The Poetics of Dave the Potter*, ed. Michael A. Chaney (Oxford: Oxford University Press, 2018), pp. 197–208.

13 William Grimes, *Life of William Grimes, the Runaway Slave* (New York, 1825), p. 18; also quoted in Michael A. Chaney, "Signifying Marks and the 'Not Counted' Inscriptions of Dave the Potter," *Arizona Quarterly* 72, no. 4 (Winter 2016), p. 2.

14 Account quoted in Janet Duitsman Cornelius, "'We Slipped and Learned to Read': Slave Accounts of the Literary Process, 1830–1865," in *Literacy and Historical Development: A Reader*, ed. Harvey J. Graff, rev. edition (Carbondale: Southern Illinois University Press, 2007), p. 317.

15 This claim originated in the 1930s when Laura M. Bragg (the director of the Charleston Museum, South Carolina) spoke with Carey Dickson, an eighty-five-year-old formerly enslaved man who had heard it secondhand: "They say he got drunk and layed on the railroad track." "Notes Made on Trip to Seigler's Pottery, near Eureka, S.C., October 4, 1930," report prepared by E. Burnham Chamberlain, Directors' Correspondence, Laura M. Bragg, Charleston Museum Records Collection, Charleston Museum Archives; also quoted in Jill Beute Koverman, "Searching for Messages in Clay: What Do We Really Know about the Poetic Potter, Dave?," in *I Made This Jar . . . : The Life and Works of the Enslaved African-American Potter, Dave*, ed. Jill Beute Koverman, exh. cat. (Columbia: McKissick Museum, University of South Carolina, 1998), p. 20. This account has been repeated in the scholarship ever since; see, for example, Leonard Todd, *Carolina Clay: The Life and Legend of the Slave Potter Dave* (New York: W. W. Norton, 2008), pp. 68–73.

16 Baldwin, *Great and Noble Jar*, p. 23, discusses practices of marking.

17 See Koverman, "Ceramic Works of David Drake," pp. 91–92, and p. 93, figs. 11a, 11b; Koverman, "Searching for Messages in Clay," p. 29.

18 One exception, according to Jill Beute Koverman, is Thomas Chandler, who was also producing large vessels; Koverman, "Ceramic Works of David Drake," p. 91. For a list of Dave's known vessels with dimensions, see Witkowski, A. F. Goldberg, and D. A. Goldberg, "Marking Time."

19 The large crack running between the base and the first coil of the jar indicates some separation did take place. Koverman, "Searching for Messages in Clay," p. 29.

20 Schermerhorn, *Unrequited Toil*, p. 148.

21 See, for example, the advertisement in the *Edgefield Advertiser*, April 2, 1840, p. 3; also cited in Baldwin, *Great and Noble Jar*, p. 46.

22 Banter and one-upmanship at potteries were real; see, for example, Dave's inscription, "Lm says this handle / will crack."

23 Nicole R. Fleetwood, *Marking Time: Art in the Age of Mass Incarceration* (Cambridge, Mass.: Harvard University Press, 2020), p. 3.

24 Michel de Certeau, *The Practice of Everyday Life*, trans. Steven Rendall (1980; Berkeley: University of California Press, 1984), p. 25. See also James C. Scott, *Domination and the Arts of Resistance: Hidden Transcripts* (New Haven, Conn.: Yale University Press, 1990).

25 Koverman, "Ceramic Works of David Drake," p. 92.

26 Corbett E. Toussaint, "Edgefield District Stoneware: The Potter's Legacy," *Journal of Early Southern Decorative Arts* 41 (2020), p. 267, and pp. 268, 269, figs. 1, 2.

27 One 1859 verse mourning the death of Abner Landrum, who enslaved Dave as a young man, even evokes a gravestone inscription: "Over noble Dr. Landrum's head / May guardian angels visit his bed."

28 He emphasized the size of his pots, spoke of his inner life ("Making this Jar = I had all thougts"), quoted the Bible, and in the "all my relation" jar and a small group of related objects, engaged in the work of bearing witness.

29 Flannery O'Connor, *Mystery and Manners: Occasional Prose*, ed. Sally Fitzgerald and Robert Fitzgerald (New York: Farrar, Straus and Giroux, 1969), p. 44.

30 David Walker, *Walker's Appeal, in Four Articles; Together with a Preamble, to the Coloured Citizens of the World, but in Particular, and Very Expressly, to Those of the United States of America*, 3rd edition (1829; Boston: David Walker, 1830), p. 49.

"But Oh the Clay Is Vile": Edgefield Pottery in Life and Death
Jason R. Young

I would like to thank Adrienne Spinozzi, Ethan W. Lasser, Vincent Brown, Michael J. Bramwell, Briana Parker, and Amy Chalmers for providing a kind and generous audience for earlier drafts of this essay.

1 Ambrose Elliott Gonzales, *The Black Border: Gullah Stories of the Carolina Coast (with a Glossary)* (Columbia, S.C.: State Company, 1922), pp. 129–30.

2 Gonzales, *Black Border*, p. 131. The accounts in this volume are recorded in Black vernacular speech. In standard English, the comment quoted in the text reads: "To put atop his grave after he's dead."

3 Hein Vanhee, "The Land of the Dead," in *Kongo across the Waters*, ed. Susan Cooksey, Robin Poynor, and Hein Vanhee (Gainesville: University Press of Florida, 2013), p. 189.

4 E. J. Glave, "Fetishism in Congo Land," *Century Magazine* 41, no. 6 (April 1891), p. 835.

5 Vanhee, "Land of the Dead," p. 191.

6 H. Carrington Bolton, "Decoration of Graves of Negroes in South Carolina," *Journal of American Folk-Lore* 4, no. 14 (July–September 1891), p. 214. These funerary practices were common in the broader region and, indeed, throughout the South. See, for example, T. J. Woofter Jr., *Black Yeomanry: Life on St. Helena Island* (New York: Henry Holt, 1930), p. 79.

7 "A Southern Cemetery: How the Negroes of Aiken, S.C., Adorn Their Graves," *Brooklyn Daily Eagle*, May 14, 1899, p. 18.

8 Jason R. Young, *Rituals of Resistance: African Atlantic Religion in Kongo and the Lowcountry South in the Era of Slavery* (Baton Rouge: Louisiana State University Press, 2007), pp. 82, 113.

9 Newbell Niles Puckett, *Folk Beliefs of the Southern Negro* (1926; repr., New York: Negro Universities Press, 1968), p. 104; see also Bolton, "Decoration of Graves of Negroes," p. 214.

10 *Drums and Shadows: Survival Studies among the Georgia Coastal Negroes* (1940; repr., Athens: University of Georgia Press, 1986), pp. 130–31. The narratives in this volume are based on interviews collected by the Savannah Unit of the Georgia Writers' Project of the Works Progress Administration (WPA), later called the Work Projects Administration (1939–43). The interviewers were not, generally speaking, trained as linguists or folklorists. And they followed no standard methods for transcribing Black vernacular speech. As a result, much of the material published under the auspices of the WPA carries a heavy taint of White paternalism and racism. In standard English, the comment quoted in the text reads: "You see, the one person is dead and if you don't break the things, then the others in the family will die too. They will follow right along."

11 Edwin AtLee Barber, *The Pottery and Porcelain of the United States: An Historical Review of American Ceramic Art from the Earliest Times to the Present Day*, 2nd edition (1893; New York: G. P. Putnam's Sons, 1901), p. 466.

12 Robert Farris Thompson, "The Structure of Recollection: The Kongo New World Visual Tradition," in Robert Farris Thompson and Joseph Cornet, *The Four Moments of the Sun: Kongo Art in Two Worlds*, exh. cat. (Washington, D.C.: National Gallery of Art, 1981), pp. 157–58.

13 John Michael Vlach, *The Afro-American Tradition in Decorative Arts*, exh. cat. (Cleveland: Cleveland Museum of Art, 1978), p. 86.

14 Vincent Brown, *The Reaper's Garden: Death and Power in the World of Atlantic Slavery* (Cambridge, Mass.: Harvard University Press, 2008), p. 5.

15 Young, *Rituals of Resistance*, p. 115.

16 John A. Burrison, *Global Clay: Themes in World Ceramic Traditions* (Bloomington: Indiana University Press, 2017), p. 112.

17 Laurel Thatcher Ulrich et al., *Tangible Things: Making History through Objects* (New York: Oxford University Press, 2015), p. 2.

18 George W. Calfas, "Nineteenth Century Stoneware Manufacturing at Pottersville, South Carolina: The Discovery of a Dragon Kiln and the Reinterpretation of a Southern Pottery Tradition" (PhD diss., University of Illinois at Urbana-Champaign, 2013).

19 Paul Laurence Dunbar, "We Wear the Mask" (1895), in *The Complete Poems of Paul Laurence Dunbar* (New York: Dodd, Mead, 1913), p. 71.

Archival Sources

Charleston Museum Records Collection. Charleston Museum Archives, South Carolina.

Edgefield County Archives, Edgefield, South Carolina.

Todd Family Papers. Special Collections and Archives, James B. Duke Library, Furman University, Greenville, South Carolina.

Published Sources

Absentee Auction: The Georgeanna H. Greer Collection of American Stoneware. Sale cat., Harmer Rooke Galleries, New York, November 18, 1992, and January 13, 1993.

Allen, Louise Anderson. *A Bluestocking in Charleston: The Life and Career of Laura Bragg.* Columbia: University of South Carolina Press, 2001.

Baldwin, Cinda K. *Great and Noble Jar: Traditional Stoneware of South Carolina.* Columbia: McKissick Museum, University of South Carolina; Athens: University of Georgia Press, 1993.

Barber, Edwin AtLee. *The Pottery and Porcelain of the United States: An Historical Review of American Ceramic Art from the Earliest Times to the Present Day.* 2nd edition. New York: G. P. Putnam's Sons, 1901.

———. "Some Curious Old Water Coolers Made in America." *Clay-Worker* 34, no. 5 (November 1900), pp. 352–53.

Bridges, Daisy Wade. *Ash Glaze Traditions in Ancient China and the American South.* Journal of Studies of the Ceramic Circle of Charlotte 6. Robbins, N.C.: Southern Folk Pottery Collectors Society, 1997.

Brown, Vincent. *The Reaper's Garden: Death and Power in the World of Atlantic Slavery.* Cambridge, Mass.: Harvard University Press, 2008.

Burrison, John A. "Afro-American Folk Pottery in the South." *Southern Folklore Quarterly* 42, nos. 2–3 (1978), pp. 175–99. [Reprinted in *Afro-American Folk Art and Crafts*, edited by William Ferris, pp. 332–50. Perspectives on the Black World. Boston: G. K. Hall, 1983.]

———. "Alkaline-Glazed Stoneware: A Deep-South Pottery Tradition." *Southern Folklore Quarterly* 39, no. 4 (December 1975), pp. 377–403.

———. "Carolina Clay: The Rise of a Regional Pottery Tradition." In George D. Terry and Lynn Robertson Myers, *Carolina Folk: The Cradle of a Southern Tradition*, pp. 1–9. Exh. cat.; 1985. Columbia: McKissick Museum, University of South Carolina, 1985.

———. "Fluid Vessel: Journey of the Jug." *Ceramics in America* (Chipstone Foundation, Milwaukee, Wisc.), 2006, pp. 93–121.

———. *Global Clay: Themes in World Ceramic Traditions.* Bloomington: Indiana University Press, 2017.

———. "South Carolina's Edgefield District: An Early International Crossroads of Clay." In "The South in the Age of Obama." Edited by Alfred Hornung. *American Studies Journal*, no. 56 (2012). DOI 10.18422/56-09.

———. "Traditional Stoneware of the Deep South." *American Ceramic Circle Bulletin*, no. 3 (1982), pp. 119–32.

Burton, Orville Vernon. *In My Father's House Are Many Mansions: Family and Community in Edgefield, South Carolina.* The Fred W. Morrison Series in Southern Studies. Chapel Hill: University of North Carolina Press, 1985.

Calfas, George W. "Asian Inspired Kilns in South Carolina?" *South Carolina Antiquities* 43 (2011), pp. 76–77.

———. "Nineteenth Century Stoneware Manufacturing at Pottersville, South Carolina: The Discovery of a Dragon Kiln and the Reinterpretation of a Southern Pottery Tradition." PhD diss., University of Illinois at Urbana-Champaign, 2013.

———. "Pottersville: Site Interpretation and Early Artifact Analysis." *South Carolina Antiquities* 44 (2012), pp. 102–3.

Calfas, George W., Christopher C. Fennell, Brooke Elizabeth Kenline, and Carl Steen. "Archaeological Investigations, LiDAR Aerial Survey, and Compositional Analysis of Pottery in Edgefield, South Carolina." *South Carolina Antiquities* 43 (2011), pp. 33–39.

Castille, George J., et al. *Archaeological Survey of Alkaline-Glazed Pottery Kiln Sites in Old Edgefield District, South Carolina.* Columbia: McKissick Museum, University of South Carolina, 1988.

Chaney, Michael A. "The Concatenate Poetics of Slavery and the Articulate Material of Dave the Potter." *African American Review* 44, no. 4 (Winter 2011), pp. 607–18.

———. "Dave the Potter and the Churn of Time." *Michigan Quarterly Review* 53, no. 1 (Winter 2014). http://hdl.handle.net/2027/spo .act2080.0053.103.

———. "Signifying Marks and the 'Not Counted' Inscriptions of Dave the Potter." *Arizona Quarterly* 72, no. 4 (Winter 2016), pp. 1–25.

———. "Throwing Identity in the Poetry-Pottery of Dave the Potter." In *Fugitive Vision: Slave Image and Black Identity in Antebellum Narrative*, pp. 176–208, 230–33. Bloomington: Indiana University Press, 2008.

———, ed. *Where Is All My Relation? The Poetics of Dave the Potter.* New York: Oxford University Press, 2018.

Dailey, Victoria. "The Wilde Woman and the Sunflower Apostle." *Book Collector* 68, no. 4 (Winter 2019), pp. 627–46. Also published as "The Wilde Woman and the Sunflower Apostle: Oscar Wilde in the United States." *Los Angeles Review of Books*, February 8, 2020. https://lareviewofbooks.org/article/the-wilde-woman-and-the -sunflower-apostle-oscar-wilde-in-the-united-states/.

David Drake: Potter and Poet. With essays by Leonard Todd, Carl Steen, Corbett E. Toussaint, Gary Dexter, and Mark A. Zipp. Exh. cat.; 2016. Vero Beach, Fla.: Vero Beach Museum of Art, 2016.

De Groft, Aaron. "Eloquent Vessels/Politics of Power: The Heroic Stoneware of 'Dave the Potter.'" In "Race and Ethnicity in American Material Life." Special issue, *Winterthur Portfolio* 33, no. 4 (Winter 1998), pp. 249–60.

Early Decorated Stoneware of the Edgefield District, South Carolina. With contributions by Stephen T. Ferrell and Terry M. Ferrell. Exh. cat., Gibbes Art Gallery, Charleston, S.C.; Greenville County Museum of Art, Greenville, S.C.; and Columbia Museum of Art, S.C.; 1976. Greenville, S.C.: Greenville County Museum of Art, 1976.

Ewen, Charles R., ed. "Crosses to Bear: Crossmarks as African Symbols in Edgefield Pottery." Forum of thematic articles. *Historical Archaeology* 45, no. 2 (2011), pp. 132–87.

Fennell, Christopher C. "Early African America: Archaeological Studies of Significance and Diversity." *Journal of Archaeological Research* 19, no. 1 (March 2011), pp. 1–49.

———, ed. "The Stoneware Pottery Communities and Heritage of Edgefield, South Carolina." Pts. 1 and 2. Special issues, *Journal of*

African Diaspora Archaeology and Heritage 6, no. 2 (July 2017); 6, no. 3 (November 2017).

The Ferrell Collection of American Southern Stoneware. Sale cat., Wooten and Wooten, Camden, S.C., January 25, 2014.

Goldberg, Arthur F., and James P. Witkowski. "Beneath His Magic Touch: The Dated Vessels of the African-American Slave Potter Dave." *Ceramics in America* (Chipstone Foundation, Milwaukee, Wisc.), 2006, pp. 59–92.

Greer, Georgeanna H. "Alkaline Glazes and Groundhog Kilns: Southern Pottery Traditions." *Magazine Antiques* 111, no. 4 (April 1977), pp. 768–73.

———. "Groundhog Kilns: Rectangular American Kilns of the Nineteenth and Early Twentieth Centuries." *Northeast Historical Archaeology* 6 (1977), pp. 42–54.

Hall, Michael D. "Brother's Keeper: Some Research on American Face Vessels and Some Conjecture on the Cultural Witness of Folk Potters in the New World." In *Stereoscopic Perspective: Reflections on American Fine and Folk Art*, pp. 195–225. Contemporary American Art Critics 11. Ann Arbor, Mich.: UMI Research Press, 1988.

Hewitt, Mark, ed. *Great Pots from the Traditions of North and South Carolina*. With essays by Charles (Terry) Zug, Linda Carnes-McNaughton, and Philip Wingard. Exh. cat.; 2017. Seagrove: North Carolina Pottery Center, 2017.

Holcombe, Joe L., and Dr. Fred E. Holcombe. "South Carolina Potters and Their Wares: The History of Pottery Manufacture in Edgefield District's Big Horse Creek Section, Part I (ca. 1810–1925)." *South Carolina Antiquities* 21, nos. 1 and 2 (1989), pp. 11–29.

———. "South Carolina Potters and Their Wares: The Landrums of Pottersville." *South Carolina Antiquities* 18, nos. 1 and 2 (1986), pp. 47–62.

Horne, Catherine Wilson, ed. *Crossroads of Clay: The Southern Alkaline-Glazed Stoneware Tradition*. Exh. cat.; 1990. Columbia: McKissick Museum, University of South Carolina, 1990.

Hughes, Katherine C. "A Vessel of Memory: Thomas Chandler's Eastern Shore Landscape." *Journal of Early Southern Decorative Arts* 38 (2017). https://www.mesdajournal.org/.

Hunter, Robert, and Oliver Mueller-Heubach. "Visualizing the Stoneware Potteries of William Rogers of Yorktown and Abner Landrum of Pottersville." *Ceramics in America* (Chipstone Foundation, Milwaukee, Wisc.), 2019, pp. 113–34.

Joseph, J. W., and Nicole Isenbarger. "Marks in Common: Current Research on African American Marks on Colonoware and Edgefield Stoneware." *South Carolina Antiquities* 43 (2011), p. 80.

Kenline, Brooke Elizabeth. "Capitalist Entrepreneurs and Industrial Slavery in the Rural Antebellum South." Master's thesis, University of South Carolina, 2012.

———. "Searching for Enslaved Laborers at the Reverend John Landrum Site (38AK497)." *South Carolina Antiquities* 43 (2011), pp. 78–79.

Koverman, Jill Beute. "The Ceramic Works of David Drake, aka, Dave the Potter or Dave the Slave of Edgefield, South Carolina." *American Ceramic Circle Journal* 13 (2005), pp. 84–98.

———, ed. *I Made This Jar . . . : The Life and Works of the Enslaved African-American Potter, Dave*. Exh. cat., McKissick Museum, University of South Carolina, Columbia, and other institutions; 1998–2000. Columbia: McKissick Museum, University of South Carolina, 1998.

Landreth, Gerald K. "Archaeological Investigations at the Trapp and Chandler Pottery, Kirksey, South Carolina." Master's thesis, University of Idaho, 1986.

Landsmark, Theodore C. "Comments on African American Contributions to American Material Life." In "Race and Ethnicity in American Material Life." Special issue, *Winterthur Portfolio* 33, no. 4 (Winter 1998), pp. 261–82.

Lowry, Sarah. "Using Ground-Penetrating Radar to Map the Historic Pottersville Kiln, Edgefield, South Carolina." *Technical Briefs in Historical Archaeology* 7 (2013), pp. 31–39.

Making Faces: Southern Face Vessels from 1840–1990. Exh. cat.; 2000. Columbia: McKissick Museum, University of South Carolina, 2001.

Meyer, George H., and Kay White Meyer. *Early American Face Jugs*. Exh. cat., Fenimore Art Museum, Cooperstown, N.Y.; 2019. Bloomfield Hills, Mich.: Sandringham Press, 2019.

Mills, Robert. *Statistics of South Carolina, including a View of Its Natural, Civil, and Military History, General and Particular*. Charleston, S.C.: Hurlbut and Lloyd, 1826.

Montgomery, Charles J. "Survivors from the Cargo of the Negro Slave Yacht *Wanderer*." *American Anthropologist*, n.s., 10, no. 4 (October–December 1908), pp. 611–23.

Mooney, Claudia A. *Face Jugs: Art and Ritual in 19th-Century South Carolina*. Exh. cat., Milwaukee Art Museum, Wisc., and other institutions; 2012–13. Milwaukee, Wisc.: Milwaukee Art Museum; Chipstone Foundation, 2012.

Mooney, Claudia A., April L. Hynes, and Mark M. Newell. "African-American Face Vessels: History and Ritual in 19th-Century Edgefield." *Ceramics in America* (Chipstone Foundation, Milwaukee, Wisc.), 2013, pp. 3–37.

Newell, Mark M. "Mark Baynham and Creative Marketing." *South Carolina Antiquities* 45 (2013), pp. 79–81.

———. "The Search Continues: New Insights into Old Edgefield Folk Potters." *Ceramics in America* (Chipstone Foundation, Milwaukee, Wisc.), 2002, pp. 224–26.

———. "A Spectacular Find at the Joseph Gregory Baynham Pottery Site." *Ceramics in America* (Chipstone Foundation, Milwaukee, Wisc.), 2001, pp. 229–32.

Newell, Mark M., with Peter Lenzo. "Making Faces: Archaeological Evidence of African-American Face Jug Production." *Ceramics in America* (Chipstone Foundation, Milwaukee, Wisc.), 2006, pp. 123–38.

Perry, Regenia A. *Spirits or Satire: African-American Face Vessels of the 19th Century*. Exh. cat., Gibbes Art Gallery, Charleston, S.C.; 1985. Charleston, S.C.: Carolina Art Association, 1985.

South, Stanley. "Early Research and Publication on Alkaline-Glazed Pottery." *South Carolina Antiquities* 23, nos. 1 and 2 (1991), pp. 43–45.

Steen, Carl. "Alkaline Glazed Stoneware Origins." *South Carolina Antiquities* 43 (2011), pp. 21–31.

———. *An Archaeological Survey of Pottery Production Sites in the Old Edgefield District of South Carolina*. Columbia, S.C.: Diachronic Research Foundation, 1994.

———. "Archaeology at the Rev. John Landrum Site, 2011–2013." *South Carolina Antiquities* 46 (2014), pp. 21–34.

———. "Industrial Pottery in the Old Edgefield District." *Ceramics in America* (Chipstone Foundation, Milwaukee, Wisc.), 2001, pp. 226–29.

———. "The Last Dave Pot." *Ceramics in America* (Chipstone Foundation, Milwaukee, Wisc.), 2011, p. 177.

———. "Progress Report 2014: The B. F. Landrum Kiln Site (38AK496)." *South Carolina Antiquities* 46 (2014), pp. 86–94.

———. "Summertime in the Old Edgefield District." *South Carolina Antiquities* 43 (2011), pp. 74–75.

———. "What's in a Name? Two Inscribed Face Vessels from the Old Edgefield District." *South Carolina Antiquities* 45 (2013), pp. 94–99.

Swag and Tassel: The Innovative Stoneware of Thomas Chandler. With contributions by Philip Wingard, Carl Steen, Lindsay Bloch, James P. Witkowski, and Robert Hunter. Exh. cat.; 2018–19. Columbia: McKissick Museum, University of South Carolina, 2018.

Thompson, Robert Farris. "African Influence on the Art of the United States." In *Afro-American Folk Art and Crafts*, edited by William Ferris, pp. 27–63. Perspectives on the Black World. Boston: G. K. Hall, 1983. [Originally published in *Black Studies in the University: A Symposium*, edited by Armstead L. Robinson, Craig C. Foster, and Donald H. Ogilvie, pp. 122–70. New Haven, Conn.: Yale University Press, 1969.]

———. *Flash of the Spirit: African and Afro-American Art and Philosophy*. New York: Random House, 1983.

———. "Kongo Influences on African-American Artistic Culture." In *Africanisms in American Culture*, edited by Joseph E. Holloway, pp. 148–84. Blacks in the Diaspora. Bloomington: Indiana University Press, 1990.

Thompson, Robert Farris, and Joseph Cornet. *The Four Moments of the Sun: Kongo Art in Two Worlds*. Exh. cat.; 1981–82. Washington, D.C.: National Gallery of Art, 1981.

Todd, Leonard. *Carolina Clay: The Life and Legend of the Slave Potter Dave*. New York: W. W. Norton, 2008.

Toussaint, Corbett E. "Edgefield District Stoneware: The Potter's Legacy." *Journal of Early Southern Decorative Arts* 41 (2020), pp. 267–357.

———. *Just North of Southern: Historic Research, Genealogy and Decorative Arts* (blog). http://www.justnorthofsouthern.com.

Vlach, John Michael. *The Afro-American Tradition in Decorative Arts*. Exh. cat., Cleveland Museum of Art and other institutions; 1978–79. Cleveland: Cleveland Museum of Art, 1978. [Repr., Athens: University of Georgia Press, 1990.]

———. "David Drake: Potter, Poet, Rebel." In *The Individual and Tradition: Folkloristic Perspectives*, edited by Ray Cashman, Tom Mould, and Pravina Shukla, pp. 343–52. Special Publications of the Folklore Institute 8. Bloomington: Indiana University Press, 2011.

Wingard, Philip. "From Baltimore to the South Carolina Backcountry: Thomas Chandler's Influence on 19th-Century Stoneware." *Ceramics in America* (Chipstone Foundation, Milwaukee, Wisc.), 2013, pp. 39–76.

Young, Jason R. *Rituals of Resistance: African Atlantic Religion in Kongo and the Lowcountry South in the Era of Slavery*. Baton Rouge: Louisiana State University Press, 2007.

INDEX

ACKNOWLEDGMENTS

This project is the culmination of countless relationships that have developed over the better part of a decade, partnerships that I hope will continue to deepen long after this catalogue is printed and the show tours the country. It has been a collaborative effort at every stage, and I express my deepest appreciation to and admiration for the exhibition's co-curators, Ethan W. Lasser and Jason R. Young. Each brought expertise and acumen to the project, and I thank them for their wisdom, perspective, unwavering dedication, and vision as it evolved. I also thank the additional catalogue authors, Michael J. Bramwell, Vincent Brown, and Katherine C. Hughes, for their insightful contributions, as well as Simone Leigh for thoughtfully discussing her practice. Their essays, entries, and interview signal a new framework for understanding Edgefield stoneware, exposing underexplored issues within the art historical canon and pointing to paths forward.

The Museum of Fine Arts, Boston, organized the exhibition with The Met, and I am grateful for their full support, under the leadership of Matthew Teitelbaum, Ann and Graham Gund Director. Special thanks are due to our partner institutions for the show's tour: University of Michigan Museum of Art (UMMA), Ann Arbor, and the High Museum of Art, Atlanta. The four-venue tour would never have been possible without the unstinting generosity of the lenders, including private collectors who selflessly agreed to part with their works for almost two years (see p. 13 for the full list). A debt of thanks is also owed to our colleagues at peer institutions, galleries, and artists' studios who enthusiastically assisted us with objects under their care: R. Ruthie Dibble, Jon Prown, and Tina Schinabeck (Chipstone Foundation); Claire Oliver (Claire Oliver Gallery); Ronald Hurst, Angelika Kuettner, Courtney Morfeld, and Kaitlyn Weathers (Colonial Williamsburg Foundation); Austen Barron Bailly, Mindy Besaw, Rod Bigelow, Miquel Geller, and Jen Padgett (Crystal Bridges Museum of American Art); Lisa Kohli (Glenn Ligon Studio); Alexia Boyd, Jay Owens, and Thomas W. Styron (Greenville County Museum of Art); Frances R. Francis, Katherine Jentleson, Monica Obniski, Amy Simon, Randall Suffolk, and Kevin W. Tucker (High Museum of Art); Jennifer Bindman (Jessica Silverman Gallery); Chloe Carberry and Jacqueline Tran (Matthew Marks Gallery); Christian M. Cicimurri and Jane Przybysz (McKissick Museum); Daniel Ackermann, Jessie Harris, and Frank Vagnone (Museum of Early Southern Decorative Arts); Nonie Gadsden, Erin Jansen, Jill Kennedy-Kernohan, Valentine Lescar, Patrick McMahon, and Janet Moore (Museum of Fine Arts, Boston); Margaret Grandine, Anthea M. Hartig, and Bonnie Campbell Lilienfeld (National Museum of American History, Smithsonian Institution); Kathleen A. Foster, Hannah Kauffman, Alexandra Kirtley, Timothy Rub, and Hyunsoo Woo (Philadelphia Museum of Art); Rebecca Adib and Katherine Driscoll (Simone Leigh Studio); Robyn Adams, Amy Bartow-Melia, Amy Chalmers, and Paul Matheny (South Carolina State Museum); Emma German (Theaster Gates Studio); Christopher C. Fennell (University of Illinois, Urbana-Champaign); Laura De Becker, Roberta Gilboe, and Christina Olsen (University of Michigan Museum of Art); and Juliana Malzoni, Robert Owen, and Soraya Rodriguez (White Cube).

Sylvia Yount, Lawrence A. Fleischman Curator in Charge of the American Wing, embraced the early ideas for this exhibition, and it was developed under her guidance and encouragement. I thank her for championing this endeavor, as well as the consequential acquisition of a storage jar by David Drake. My deepest gratitude to Dita Amory, Curator in Charge of the Robert Lehman Collection, for her support of this exhibition from the very beginning, and for welcoming its creative presentation in the Robert Lehman Wing. I am grateful to Daniel H. Weiss, President and Chief Executive Officer, for his endorsement, and to Max Hollein, Marina Kellen French Director, for his enduring interest and tireless efforts in securing important loans. Andrea Bayer, Deputy Director for Collections and Administration, and Quincy Houghton, Deputy Director for Exhibitions, were instrumental in their support and stewardship. Lavita McMath Turner, Chief Diversity Officer, offered invaluable advice at many stages, and thanks are also due to Inka Drögemüller, Deputy Director for Digital, Education, Publications, Imaging, Library, and Live Arts, for her commitment to the show's vision.

The project was significantly augmented by external expertise, advocacy, and feedback in a number of critical discussions, including several in-person advisory convenings at The Met and UMMA, conference panels, and formal and informal conversations. To those who participated in these and are not listed elsewhere, I extend my thanks: Lisa Borgsdorf, Dana Byrd, Woody De Othello, Theaster Gates, Adebunmi Gbadebo, Earline Green, Leslie Harris, Kristin Hass, Brenda Hornsby Heindl, Joyce M. Hunter, Robert Hunter, Jim Leija, Roberto Lugo, Tonya Matthews, Kelly Maxwell, Makeeba McCreary, Jim McDowell, Tiffany Momon, Jen Padgett, Nii O. Quarcoopome, Jennifer Scott, Mark Shapiro, Alexandra Minna Stern, Ozi Uduma, Maureen Warren, and Kevin Young.

On numerous research trips over the past five years, collectors, stewards, scholars, and historians opened their doors to us to share their objects, knowledge, and stories. A huge thank you to McKissick Museum and their staff for hosting us for a hands-on study day, and to the collectors who traveled from near and far with their face vessels, including Gerald and Vivian Gowitt, Doug and Brenda Howard, L. A. Rhyne, Jason Shull, Frank Williamson, Philip Wingard, and others listed elsewhere. McKissick Museum, Augusta Museum of History, and a private collector are due thanks for permitting us to examine and sample organic residue on select vessels. Others who took time to share their knowledge and/or collections and are not listed elsewhere include Martha Bates, Shannon Browning-Mullis, Tony Carr Jr., Ken Cherry, Ken Fechtner, Stephen Ferrell, Rick and Willie Green, Justin Guy, Tonya Guy, Michael Hall, Sally Hawkins, John Eldon Hoar, Vanessa Jean, Stan and Becca Johnson, J. Drew Lanham, Robert Leath, Deanne Levison, Grahame Long, Roddy Moore, Wayne O'Bryant, Sam Phillips, Bettis C. Rainsford Sr., Brad Rauschenberg, Tony Riley, Tony Shank, Carl Steen, Leonard Todd, James and Agnes Williams, Frank Williamson, George Wingard, Jeremy Wooten, Jim Yates, Luke Zipp, and Mark A. Zipp, as well as those who wish to remain anonymous. A special note of thanks to archaeologist Sean Taylor of the South Carolina Department of Natural Resources, who escorted us to numerous pottery sites in Edgefield and Aiken Counties and provided invaluable insight.

This exhibition and catalogue are the work of dozens of incredibly talented people from across the Museum, and I am immensely grateful for and in awe of their unwavering commitment. In the American Wing, research by Katherine C. Hughes, former Peggy N. Gerry Research Scholar, shaped this exhibition in its early stages. Kate's two-year position was supported by the Decorative Arts Trust, and I thank the organization for its generous funding during the critical research phase. My deepest

appreciation to Catherine Mackay, Lexi Asnes, Lauren Ritz, and Lily Paulson for their administrative support, to Barbara Glauber for her research assistance, and to Laura Wile, Sean Farrell, Dennis Kaiser, Chad Lemke, and Arthur Polendo for art handling, transport, and care. I am grateful to Alice Cooney Frelinghuysen, Anthony W. and Lulu C. Wang Curator of American Decorative Arts, who shares a deep interest in and knowledge of ceramics, for her advice and steadfast support.

The Publications and Editorial Department, led by Mark Polizzotti, with Michael Sittenfeld and Peter Antony, deserves singular recognition for their early encouragement and support that have sustained me throughout. My deepest thanks to Briana Parker for her outstanding editing and guidance on the content and organization, and her substantive feedback regarding language and interpretation. Bibliographic editor Jayne Kuchna is due credit for her assiduous attention to detail and invaluable editorial support. Elizabeth De Mase undertook the monumental effort of overseeing new photography for this publication as well as sourcing the additional images, and Adrian Kitzinger created two illuminating maps. The book's production was handled with extraordinary care and sensitivity by Christina Grillo. The content has been immeasurably augmented by Jean Wilcox's sharp design.

My deepest gratitude to Scott Geffert, General Manager, and the staff of the Imaging Department, who recognized the potential of this publication and wholeheartedly backed it. A profound thanks is due to Eileen Travell, Senior Photographer, whose incredibly sensitive and beautiful photography has set a new standard for documenting Edgefield stoneware. I am forever grateful for her exacting eye that brought these objects to life in print, and to Heather Johnson and Peter Zeray for their assistance. Chris Heins performed detailed postproduction work on hundreds of image files, and Wilson Santiago oversaw 3-D scanning. A huge thank you to the institutions and their staffs who accommodated our requests to photograph their objects: Jennifer McCormick, Sean Money, and John Parker (Charleston Museum); Alexia Boyd, Jay Owens, and Jillian Sims (Greenville County Museum of Art); Christian M. Cicimurri (McKissick Museum); and Robyn Adams, Amy Chalmers, and Paul Matheny (South Carolina State Museum). We are also indebted to the institutions that reshot their objects for this book, and to the many lenders who either sent their objects to the Museum early to have them photographed or welcomed Eileen and her extensive equipment into their homes. A special thank you to C. Philip and Corbett Toussaint for allowing us to store equipment at their home between trips.

In Exhibitions I owe thanks to Katy Uravitch and Jason Kotara for their attention to every detail and moving part in their roles as project managers. Marci King was instrumental in preparing loan paperwork and contracts, and Sharon H. Cott and Amy Desmond Lamberti in the Counsel's Office assisted with the legal documentation. I thank registrar Elsie Alonso for her work coordinating the safe movement of the vessels and managing the loan agreements. My heartfelt thanks to Lin Sen Chai, Kamomi Solidum, Alexandre Viault, Sarah Parke, Grace Mennell, and Chelsea Garunay, under the astute direction of Alicia Cheng, for their bold yet sympathetic design for the exhibition and graphics, and to Kayla Elam for closely editing the labels and managing the overall didactic program, with input from Jenny Bantz. The exhibition would not have happened without considerable contributions from our colleagues in the Departments of Objects Conservation and Scientific Research, under the direction of Lisa Pilosi, Sherman Fairchild Conservator in Charge, and Marco Leona, David H. Koch Scientist in Charge, respectively. Wendy Walker in particular provided invaluable technical insight and undertook considerable conservation work on a number of the objects. Sampling and analysis of residue from select vessels were painstakingly performed by Research Scientist Adriana Rizzo, aided by Julie Arslanoglu. I owe a great debt of thanks to our amazing team of preparators, including Frederick J. Sager, Warren Bennett, Matthew Cumbie, Andrew Estep, and Jacob Goble. Equally involved was the team in Buildings under Tom Scally. Taylor Miller, Matt Lytle, and Maria Nicolino are due many thanks for the extensive casework and for the coordination of the specialized shops involved.

The Digital Department, under the direction of Douglas C. Hegley, deserves acknowledgment for the integral digital components of the exhibition. Nina Diamond and Bryan Martin, along with Sarah Ott and John Simoniello at Acoustiguide and writer Ann Lewinson, brought the complexities of Edgefield to life in a beautifully produced audio guide supported by Bloomberg Philanthropies. I also express my deepest appreciation for our collaborators who shared their perspectives on these objects for our audiences: Brooke Bauer (Catawba), Vincent Brown, George W. Calfas, Adebunmi Gdabebo, Glenn Ligon, David Mack, Tonya Matthews, and Wayne O'Bryant. I thank Paul Caro for the in-gallery visual content and slideshow, and Peter Berson, Melissa Bell, Kate Farrell, Skyla Choi, and the website team for making this information widely accessible.

Colleagues working under the leadership of Heidi Holder, Frederick P. and Sandra P. Rose Chair of Education, have helped bring these objects and the issues at the exhibition's core to wider audiences. Thanks are due to Suhaly Bautista Carolina, Emily Blumenthal, Rebecca McGinnis, Mary Jaharis Senior Managing Educator, Darcy-Tell Morales, and Marianna Siciliano for developing a range of accessible and stimulating programs. In External Affairs, Alexandra Kozlakowski, along with Kenneth Weine, Gretchen Scott, and Ann M. Bailis, contributed communications expertise. For the crucial role they played in fundraising, I graciously thank Kimberly McCarthy and Katherine Lester Thompson for their tireless efforts, as well as their colleagues Jason Herrick and Evie Chabot, all under Clyde B. Jones III's leadership, for their support. Deepest thanks are also due to Emma Rose Rainville at the Museum of Fine Arts, Boston, for her work on behalf of this project.

For their recognition of this project's merits, I am deeply grateful to the donors who made this exhibition possible—Kathryn Ploss Salmanowitz, The Met's Fund for Diverse Art Histories, Anthony W. and Lulu C. Wang, and The Peter Jay Sharp Foundation, as well as Thelma and AC Hudgins, who helped us bring our educational programs to life. My appreciation goes to the Terra Foundation for American Art and the Henry Luce Foundation for extending their generosity, not only to The Met but to our partners at the Museum of Fine Arts, Boston. Contributions from Esther Goldberg are graciously acknowledged. As ever, the William Cullen Bryant Fellows of The Metropolitan Museum of Art brought this beautiful publication to fruition, with the additional support of Bridget and Al Ritter. I would also like to acknowledge that the Museum of Fine Arts, Boston, received critical funding from the National Endowment for the Arts and the Wyeth Foundation for American Art.

Lastly, a heartfelt thanks to my colleagues across the Museum and beyond who unselfishly shared their experiences and guidance, and for the many urgent conversations about making meaningful changes in the work we do.

Adrienne Spinozzi
Associate Curator, The American Wing

PHOTOGRAPHY CREDITS

Unless otherwise noted, all images are © Metropolitan Museum of Art, photo by Eileen Travell.

Fig. 3: Courtesy of the South Caroliniana Library, Columbia, South Carolina

Fig. 4, left: The Colonial Williamsburg Foundation, C. Thomas Hamlin III Fund and Museum Purchase, The Friends of Colonial Williamsburg Collections Fund

Figs. 5, 38: Image © Metropolitan Museum of Art

Fig. 7: Photo: Minneapolis Institute of Art

Figs. 8, 11: Courtesy of the Charleston Museum, South Carolina

Fig. 15: Image © Metropolitan Museum of Art, photo by Teri Aderman

Figs. 20, 21, pls. 4, 45, 48: Photo by Jamie M. Stukenberg, Rockford, Illinois

Fig. 22: Photo by John R. Glembin

Figs. 23, 24: Courtesy of Krannert Art Museum at the University of Illinois, Urbana-Champaign

Fig. 27: Artwork © Kara Walker, courtesy of Sikkema Jenkins & Co., New York and Sprüth Magers, Berlin

Fig. 30: © Theaster Gates

Fig. 31: Courtesy of Singleton Bailey

Fig. 34: Courtesy of the South Carolina State Museum

Fig. 35, pls. 37, 50: Photo by Jaclyn Nash, National Museum of American History, Smithsonian Institution

Fig. 36: US 5274.5.3. Houghton Library, Harvard University

Fig. 37: From the *Century Illustrated Monthly Magazine*, November 1890–April 1891, T. Fisher Unwin, London, 1891, p. 827. Image © Metropolitan Museum of Art, photo by Eileen Travell

Fig. 39: Library of Congress, Prints & Photographs Division, FSA/OWI Collection (Reproduction number: LC-DIG-fsa-8c05004)

Fig. 40: Library of Congress, Prints & Photographs Division, Photo by Muriel and Malcolm Bell, Jr. (Reproduction number: LC-USZ62-137160)

Fig. 41: Library of Congress, Prints & Photographs Division (Reproduction number: LC-DIG-det-4a27273)

Fig. 44: Image © Metropolitan Museum of Art, photo by Wilson Santiago, Wendy Walker, and Manu Frederickx

P. 76, pls. 64, 65: © Simone Leigh. Courtesy of the artist and Matthew Marks Gallery. Image © Metropolitan Museum of Art, photo by Eileen Travell

Fig. 45: Photo by Michael Harvey, courtesy of Oxford Ceramics Gallery

Fig. 46: © Magdalene A.N. Odundo

Fig. 47: © Simone Leigh. Courtesy of the artist and Matthew Marks Gallery. Photo by Timothy Schenck. Courtesy of the High Line

Pl. 6: Photo by Michael McKelvey / Courtesy of the High Museum of Art

Pl. 14: The Colonial Williamsburg Foundation, Museum Purchase

Pls. 30, 53, 54: Photo © 2022 Museum of Fine Arts, Boston

Pl. 32: Photography by Edward C. Robison III

Pl. 34: Image courtesy of the Philadelphia Museum of Art

Pl. 46: Image courtesy of the University of Michigan Museum of Art

Pl. 47: Photo by Gavin Ashworth

Pl. 59: Photo by Jeffrey Machtig

Pl. 60: © Theaster Gates. Photo © White Cube (Theo Christelis)

Pl. 61: © Robert Pruitt 2019. Photo by Adam Reich. Image courtesy of the artist and Koplin Del Rio Gallery

Pls. 62, 63, back cover: Photo by Aaron Wilson Watson

This catalogue is published in conjunction with *Hear Me Now: The Black Potters of Old Edgefield, South Carolina*, on view at The Metropolitan Museum of Art, New York, from September 9, 2022, through February 5, 2023; the Museum of Fine Arts, Boston, from March 6 through July 9, 2023; the University of Michigan Museum of Art, Ann Arbor, from August 26, 2023, through January 7, 2024; and the High Museum of Art, Atlanta, from February 16 through May 12, 2024.

The exhibition is made possible by Kathryn Ploss Salmanowitz, The Met's Fund for Diverse Art Histories, the Terra Foundation for American Art, Anthony W. and Lulu C. Wang, The Peter Jay Sharp Foundation, and the Henry Luce Foundation.

It is organized by The Metropolitan Museum of Art and the Museum of Fine Arts, Boston.

This publication is made possible by the William Cullen Bryant Fellows of The Metropolitan Museum of Art.

Additional support is provided by Bridget and Al Ritter.

Published by The Metropolitan Museum of Art, New York
Mark Polizzotti, Publisher and Editor in Chief
Peter Antony, Associate Publisher for Production
Michael Sittenfeld, Associate Publisher for Editorial

Edited by Briana Parker
Production by Christina Grillo
Designed by Wilcox Design
Bibliographic editing by Jayne Kuchna
Image acquisitions and permissions by Elizabeth De Mase
Maps by Adrian Kitzinger

All photographs are by Eileen Travell, Imaging Department, The Metropolitan Museum of Art, unless otherwise noted.

Additional photography credits appear on page 199.

Typeset in Milo, Museo, and Sabon by Amy L. Storm and Matt Mayerchak
Printed on 150 gsm Arctic Volume White
Separations by Professional Graphics, Inc., Rockford, Illinois
Printing and binding by Ofset Yapımevi, Istanbul

Cover illustrations: front, Dave (later recorded as David Drake), Stony Bluff Manufactory. Storage jar, 1857 (pl. 29); back, Adebunmi Gbadebo. *K. S.*, 2021 (pl. 62)
Page 1: Benjamin Franklin Landrum, Benjamin Franklin Landrum Pottery. Jug, ca. 1850–70 (detail of pl. 19)
Pages 2–3: Unrecorded potter, Collin Rhodes Factory. Storage jar, ca. 1846–53 (pl. 11); Unrecorded potter, attributed to Collin Rhodes Factory. Jug, ca. 1850 (pl. 13); Unrecorded potter. Face pitcher, ca. 1850–80 (pl. 58)
Pages 4–5: Unrecorded potter. Face jug, ca. 1850–80 (pl. 43)
Page 8: Dave (later recorded as David Drake), Stony Bluff Manufactory. Storage jar, 1858 (detail of pl. 33)
Page 16: Dave (later recorded as David Drake), Stony Bluff Manufactory. Jug, 1853 (detail of pl. 28)
Page 26: Unrecorded potter, Collin Rhodes Factory. Jug, ca. 1846–53 (pl. 12)
Page 50: Dave (later recorded as David Drake), Stony Bluff Manufactory. Storage jar, 1858 (detail of pl. 31)
Page 64: Unrecorded potter. Face cup, ca. 1850–80 (detail of pl. 57)
Page 76: Simone Leigh. *Jug*, 2022 (detail of pl. 64)
Pages 84–85: Unrecorded potter, probably Thomas M. Chandler Jr., Thomas M. Chandler Pottery. Storage jar, ca. 1850 (pl. 17); Unrecorded potter. Face jug, ca. 1850–80 (pl. 42); Benjamin Franklin Landrum, Benjamin Franklin Landrum Pottery. Jug, ca. 1850–70 (pl. 19); Unrecorded potter, Collin Rhodes Factory. Jug, 1847 (pl. 10); Dave (later recorded as David Drake), Stony Bluff Manufactory. Storage jar, 1858 (pl. 33)
Page 172: Unrecorded potter, probably Thomas M. Chandler Jr. Pitcher, ca. 1838–52 (pl. 16); Unrecorded potter. Face cup, ca. 1850–80 (pl. 57); Unrecorded potter. Face jug, ca. 1850–80 (pl. 43)

The Metropolitan Museum of Art
1000 Fifth Avenue
New York, New York 10028
metmuseum.org

Distributed by
Yale University Press, New Haven and London
yalebooks.com/art
yalebooks.co.uk

Cataloguing-in-Publication Data is available from the Library of Congress.
ISBN 978-1-58839-726-3